Unvarnished

Also by Kathryn Bridge

Henry & Self
An English Gentlewoman at the Edge of Empire
Second edition, Royal BC Museum, 2019

By Snowshoe, Buckboard and Steamer
Women of the British Columbia Frontier
Second edition, Royal BC Museum, 2019

Emily Carr in England
Royal BC Museum, 2014

A Passion for Mountains
The Lives of Don and Phyllis Munday
Rocky Mountain Books, 2006

Unvarnished

Autobiographical Sketches by Emily Carr

Emily Carr

Edited by Kathryn Bridge

 ROYAL **BC** MUSEUM
VICTORIA, CANADA

Unvarnished
Autobiographical Sketches by Emily Carr
Copyright © 2021 by Kathryn Bridge

Published by the Royal BC Museum, 675 Belleville Street, Victoria,
British Columbia, V8W 9W2, Canada.

The Royal BC Museum is located on the traditional territories of the Lekwungen
(Songhees and Xwsepsum Nations). We extend our appreciation for the
opportunity to live and learn on this territory.

Cover and interior design and typesetting by Lara Minja
Index by Catherine Plear

See pages 44 and 99 for credits and descriptions of cover illustrations.

Library and Archives Canada Cataloguing in Publication

Title: Unvarnished : autobiographical sketches by Emily Carr / Emily Carr ; edited by
 Kathryn Bridge.
Names: Carr, Emily, 1871–1945, author, artist. | Bridge, Kathryn Anne, 1955– editor. |
 Royal British Columbia Museum, publisher.
Description: Includes bibliographical references and index.
Identifiers: Canadiana (print) 20210308958 | Canadiana (ebook) 20210308966 |
 ISBN 9780772679642 (softcover) | ISBN 9780772679659 (EPUB)
Subjects: LCSH: Carr, Emily, 1871–1945—Notebooks, sketchbooks, etc. |
 LCSH: Artists—Canada—Biography. | LCGFT: Autobiographies.
Classification: LCC ND249.C3 A2 2021 | DDC ON ORDER JULY 2021 | 759.11—dc23

10 9 8 7 6 5 4 3 2 1

Printed in Canada by Hignell.

For Beatrice and Callum

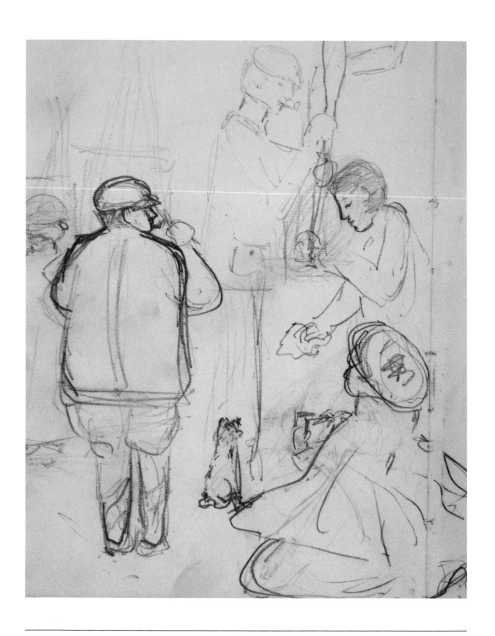

Olsson's studio on a wet day in St. Ives. Emily Carr, 1901 or 1902. PDP05985.

Contents

Emily Carr's Stories 133

List of Illustrations

Plates

Other illustrations

Emily Carr with griffon dogs, 1938. Photographer: Nan Cheney. H-02812.

Preface

"Writing needs only a pencil & a rummage among your thoughts."[1]

OUR INTEREST in Canadian national treasure Emily Carr has not abated in the years since her death in 1945. Carr's presence—and indeed her life story—looms large in Canadian arts and letters because she straddles areas of creative expertise. Carr's name recognition has never been stronger than it is now, as younger generations discover points of connection to her, whether it be an affinity for the forests and other natural spaces of the Canadian West Coast or an appreciation for the strength of character Carr demonstrated throughout her life, refusing to limit her personal choices or define the boundaries of her creativity and keeping her core self intact despite adverse circumstances and blows from life. She articulated views about the natural world, Indigenous peoples and modern art that reflected an independent spirit—a spirit that in her time did not always reflect the views of the white, mostly British, settler society within her home town of Victoria, her province of British Columbia or her country, Canada.

Fame eluded Emily Carr until later in life, and she had to work hard for everything she achieved. She lost real estate investments in the depression before the First World War, struggled through the Great Depression of the 1930s, and had to undertake various means to pay the bills, such as raising

purebred dogs, building an apartment house, and being a landlady, cook and janitor. In her childhood, and after the early deaths of her parents, she lived in fear of a domineering older sister. Later, she rejected romantic relationships at great emotional cost and suffered from debilitating illnesses while trying to further her artistic training in London and Paris. She met with hostility and mockery in Victoria and Vancouver when she adopted a post-impressionist art style. And beginning in middle age, she suffered increasing infirmity—angina, heart attacks, stroke—that eventually led to her death. She had to make hard choices in her personal life to maintain her own self-definition as an artist. By sheer force of character, Emily Carr survived to see herself recognized as both artist and author.

Emily Carr kept various personal writings, sketches and photographs (although she burned many letters and diaries over her lifetime) and gifted them to her literary heir, Ira Dilworth.[2] These materials, subsequently saved by his heirs, together with many materials treasured by friends and the recipients of her correspondence, are held within the large Emily Carr archive in the BC Archives, a part of the Royal British Columbia Museum. These documents have enabled biographers, art historians, environmentalists, Indigenous researchers and others to dig deep into Carr's private life, trying to get at what defines her. Her identities remain multiple and fluid, likewise our interpretations of her. Over the decades since her death, each generation characterizes her differently, while shifting societal values provide new lenses through which to view her. Does Carr represent the colonizer, an artist who appropriated Indigenous art for her own gain? Or is she a trailblazing opponent of residential schools? An early environmentalist and advocate for natural places? She clearly loved animals, yet by purchasing a Javanese monkey and various parrots, she contributed to something we now view as controversial, the worldwide exotic animal trade.

Carr was a complex figure even in her own time, breaching societal norms by smoking, riding astride a horse, using swear words, remaining unmarried and creating impressionist-style paintings. She was also opinionated and held wide-ranging perceptions of non-white people and communities who were often at odds with the majority of the white British settlers. In this aspect, and in retrospect, she comes across as less prejudiced than many of her peers. But in some of her private writings and early drafts of stories, she employs colloquialisms and descriptors that sit uncomfortably

with us, as they hold evidence of ingrained perceptions, bias and prejudice. These include references to cultural practices of Indigenous peoples and descriptions of Indigenous individuals, people of cultural backgrounds not her own or the developmentally disabled. Her attempts to delineate cultural difference through dialogue are perhaps the most awkward to read, especially her "embarrassing attempts to replicate Native speech patterns"[3] and her renditions of regional dialects and of the pronunciations of English words by people of non-English heritage, which now tend to come across as mocking.

Yet Carr is not easily pigeonholed. While her white society friends would not have considered such actions, Carr cultivated and maintained decades-long friendships with Indigenous people and was particularly proud to hold true—despite the ups and downs of both their lives—to a special bond of friendship with Sewinchelwet, whom she knew as Sophie Frank (d. 1939), a Skwxwú7mesh woman whom Carr first met in Vancouver around 1905, and with whom she corresponded and visited over a 30-year period.[4] Carr kept her 1914 watercolour portrait of Sophie Frank on her bedroom wall and later her studio mantlepiece, where it remained after Carr's death. Her first book, *Klee Wyck*, was dedicated to Sophie Frank, a very public acknowledgement of the importance Carr placed on their friendship. Also included in Carr's private papers are watercolour portraits she made of her Haida guides Clara and William Russ, who enabled her to visit the southern villages, and of Gamlakyeltxw (Miriam Douse), the Gitxsan chief/elder who gave her permission to visit Gitanyow (Kitwancool) in 1928.[5]

Carr's writings also reveal when she saw injustices and made a stand. In the story "Friends" in *Klee Wyck*, she writes about her personal intervention while in Haida Gwaii against the removal of children from their home to residential school. This important scene in the story was expurgated after Carr's death in subsequent editions of the book and only restored in the 2003 republication.[6] Carr was not a fan of missionary interference. The original *Klee Wyck* stories are replete with lively adjectives describing the physical attributes and actions of missionaries, conveying her repugnance; again, editors removed these words in subsequent editions, and they were only restored in 2003. In consequence, generations of Carr readers did not know they were missing any text and did not realize how Carr had used her book to clearly position her views.

When she recognized inappropriate views or prejudicial actions in others, Carr could be strategic and quick to act. She admired the Chinese artist Lee Nam, who lived in Victoria's Chinatown, and advocated for his inclusion into the local art club, very much against the grain of white society. She wrote letters and also mounted an exhibition of his work at her house, making clear her advocacy.[7] Even in the midst of the Great Depression, when jobs in the forest meant food on the table for loggers and their families, she demonstrated an awareness of the environment and of the negative effects of the forest industry, often in advance of her peers. Some of her writing in this volume reveals sensitivities that challenge ideas of progress equating with technological capability.

Carr is often contradictory; she doesn't fit easily into a mould, nor does she wholly define the historical times in which she lived, or ideas of modernity. She remains a point of conversation, a catalyst for discussions of presentism, cultural appropriation, Indigenous reconciliation and restitution, Modernism, Feminism and of the right of all individuals to be themselves. One scholar notes, "Carr remains an enigma yet to be more fully defined," and that quality is what continues to hold our interest in Carr today.[8]

Despite regular cleanouts and burnings as she moved houses, Carr held on to some mementos including early sketchbooks from her days in England (1899 to 1904), cartoons and caricatures from her Vancouver days (1905 to 1913) and some of her earliest attempts at writing (1931 to 1934). She also kept some of her later story writing (1943 to 1944). Thank goodness friends kept the letters they received, because in them we can see the everyday relationships, frustrations and joys of living and the workings of a strong, multi-layered person. It is a rich archival record, albeit incomplete, and it has been largely unpublished. Some material has served as research documentation for previous biographical studies or sidebars in art gallery exhibitions, but most is almost forgotten.

In conceiving this book, my intentions were fourfold. Firstly, to use Emily Carr's own private writings to make available new information about her private world before she began to publish her own stories and write award-winning books. The unpolished qualities of these earlier writings bring a wealth of detail—little nuggets of biographical information that might well have been edited out had she polished and pruned for publication. Secondly, to bring forward new Carr stories to add to her oeuvre and really mine the archival record including her earliest sketchbooks.

Thirdly, to contextualize her writings via explanatory notes. Who were the people she mentions and what were the situations and circumstances? Carr aficionados might recognize some names, but many are newly introduced. Research has revealed the identities of some people Carr had previously written about using pseudonyms. Fourthly, the original versions of the writings in this book are often fragile. Although they are available on site to researchers via microfilm, they are not readily available to the general public. This book is a way to share these writings with a wider audience, offering an *unvarnished* look at Carr herself.

Note on the Transcription

Carr's unvarnished writings have been transcribed with minimal grammatical tidying to preserve her unique word creations and misspellings, and to retain their feel as drafts not polished for publication. Minor edits include very occasionally inserting commas where clarity was required, and inserting line breaks to clarify dialogue. I resisted the desire to overlay her text with further punctuation, and in consequence sentences may run on or be incomplete, just as Carr wrote them. I applied consistent and correct spellings to personal names (even if Carr misspelled them). Thus "Olsen" is corrected to "Olsson" with endnote explanation. I also standardized when she interchanged spellings of names, for instance "Billie" and "Billy" for her dog. Particular indecipherable handwritten words are indicated by square brackets []. In just a few instances, for completeness and comprehension, I used what appeared to be the strongest sections of separate drafts of a story, and I have indicated this in the endnotes. At times, Carr's multiple versions offered confusing options in selection.

In the two scribbler notebooks, Carr seldom paused as she poured out remembrances, moving, often abruptly, from one to another and leaving few headings or section delineations. Only rarely did she use a line beneath a final sentence to indicate the end of one episode. The next episode on the page was then often quite separate and not necessarily chronologically linked. She moves back and forth in time. Memory sometimes provided Carr with great detail and completeness, which she then narrated, but when afterthoughts occurred, she did not pause to reorder but placed them as they came to her, pages later. For the reader, especially one not familiar with Carr's biography, this disjointed aspect might be confusing. I have made an intervention. Without changing Carr's words, I reunited dangling parts

of the same story and provided headings (when Carr had just used a line separator) to allow the reader to see the beginnings and ends of episodes and to enable a chronological ordering.

Carr titled her individual short stories, and these titles are retained, indicated by quotation marks. But, as the episodes written in the notebooks rarely had any titles, headings without quotation marks are mine. The same holds true for the illustrations. Those titles that Carr herself wrote on the artwork are indicated by quotation marks. General descriptive titles are without quotes.

Facing: "Over & over down she rolls on top of the dog who squeals & scholds" (detail). Emily Carr, 1904–1905. PDP06148.

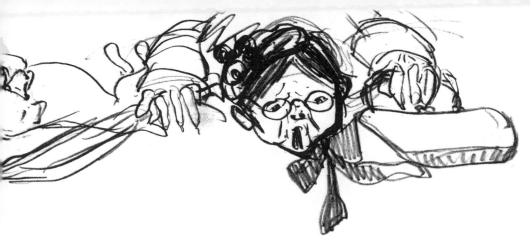

Introduction

Definition of *unvarnished*

1a: not adorned or glossed: plain, straightforward
 //told the unvarnished truth
1b: artless, frank
 //the unvarnished candor of old people and children
2: not coated with or as if with varnish: crude, unfinished[9]

"Unvarnished me"[10] is a phrase Emily Carr used to describe her personal writings and private papers, objects that she believed revealed her honest self. *Unvarnished* therefore seems a perfect title for a book that publishes for the first time not simple reminiscences, but important stories and autobiographical remembrances artfully shaped by Emily Carr that fit this definition, being plain, straightforward and not adorned.[11] Some are drafts that were later reworked for publication. Others are stories written once but never followed up, for which she ran out of time or that were not considered priorities as she worked on others. Almost all of the stories and remembrances included in this book exhibited handwritten edits, insertions, cross-outs, underlines and arrows indicating Carr's changes to the text as she reread and reworded for clarification or specificity (see plates 1 and 2). Together these stories and remembrances allow the reader to reflect on the creative process by comparison to some of Carr's published and polished

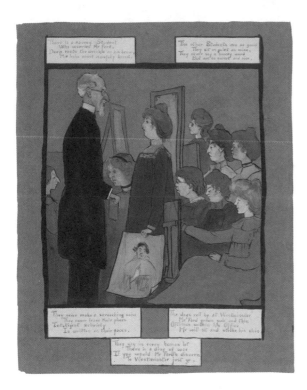

There is a saucy student
Who worries Mr Ford,
Deep rests the wrinkle on his brow
He looks most awefully bored.

The other Students are so good
They sit as quiet as mice,
They never say a saucey word
But are so sweet and nice.

They never make a screeching noise
They never leave their places
Intelligent sobriety
Is written on their faces.

The days roll by at Westminster
Mr Ford grows pale and thin
Oftimes within his Office
He will sit and stroke his chin

They say in every human lot
There is a drop of woe
If you would Mr Ford's discern
To Westminster just go.

Westminster School of Art. Carr is depicted seated in front, second from right (see plate 9). Emily Carr, 1901. PDP06152.

versions, or to appreciate the extra detail—lost when Carr later refined and reduced, working toward a wide audience.

Unvarnished also describes the private drawings and photographs that exist in the Carr archive either within sketchbooks or albums or as stand-alone items Carr squirrelled away with her mementos (see plates 3 and 4). Although these are digitally available in the BC Archives online database, they aren't generally linked to the written stories nor to the rhyming verses Carr paired with sketches. Pulling together these photographs, verses and sketches or matching them with written stories places them in context,

resurrecting the relationships between these materials and providing some of the connectivity for this book.

These *unvarnished* Emily Carr remembrances and retrospective stories have been plucked from the mass of Carr's records held by the BC Archives. They were located through file-by-file review and often found alongside drafts of stories eventually published. The titles on the archival file folders, created decades ago, delineated general topics but did not itemize each sheet of paper, so it is only natural that errant pieces hid within them, a situation complicated by the original microfilming. Some of the handwritten stories are not mentioned on the finding aids for the records because they exist in the backs of notebooks used for her 1937 and 1939 journals. Never one to waste paper, Carr flipped the notebooks around so this writing is upside down to the other contents. Each of these upside-down pages has been pencilled over with scrawls by Carr as if in dismissal, and this, in addition to their location in her journal notebooks, may have misdirected researchers over the years (see plate 5).

A lengthy handwritten manuscript comprising two separate scribbler notebooks forms the major text for this book. On the front covers of each, Carr pencilled a title, "Growing pains," and doodled over the printed cover illustrations (see plates 6 and 7). Written as a single narrative, it moves through a series of individual incidents or events and flows in a roughly chronological manner to recount almost forty years of her life. The manuscript has been known to scholars[12] who examined Carr's archive, but many assumed that it was Carr's book *Growing Pains: The Autobiography of Emily Carr.* Like the scrawled-over pages in the backs of her journals, it was generally dismissed as a draft and not really examined in relation to Carr's other edited versions in the files or to Carr's published books. Upon re-examining the two notebooks, I found that they contained much original content, very worthy of publication in its own right. And then, matching these episodes side by side with some of the scrawled-over pages in the backs of Carr's journals, we can see further versions and more new material. Some stories are common to both yet differently presented, and each manuscript has its own unique stories. Carr scrawled over the pages in the notebooks that she had reworked and now considered superseded. It becomes clear that the scrawled-over manuscripts precede the two notebooks, and also, that one notebook (describing the earlier years of her life) is absent.

In an almost stream-of-consciousness outpouring, Carr recounted episodes that do not appear in her published autobiography, *Growing Pains*. For instance, we learn much more about the English art schools she attended and her fellow students in Bushey and St. Ives than is written elsewhere, an important trip to Sweden during her stint in France, nine months spent in San Francisco in 1916 and 1917, her caravan sketching trips and her studio life in Vancouver. The manuscript is heavily weighted toward the middle years of her life but includes new information on life after her "discovery" and the importance of Lawren Harris.

A handful of lengthy episodes are not included here because they are so close to the published versions, therefore adding little to the historical record. Other stories may seem familiar to readers of Carr's books, but almost always the wording and the events described are quite different. Carr is more candid and *unvarnished*; we are privy to Carr's innermost thoughts and emotions in ways that were later polished out of the published versions. When discussing the evolution of her autobiography, which she completed in late 1941 as a Christmas present for Ira Dilworth (with the proviso that it not be published in her lifetime), Carr referenced the earlier handwritten manuscript, maintaining that she found it useful only for organizational reference.

> Its first writing was superficial—afraid to let go & show myself. A very dull document. I utterly ignored that M.S. in writing this. The only thing I bothered to follow was the headings. I had decided in the first edition what places & people I was going to write about & I have done so—parts may seem to you superfluous—cut out if so. Parts I may want to rewrite yet again. But I want to get it complete while my wits are clear and before the effort becomes impossible.[13]

Carr must have consulted this manuscript more than she admitted to Dilworth, because at times the published episodes are similar. However, in the majority of cases the manuscript diverges greatly from any of her published stories. Carr herself stated when polishing these later versions, "I have so reduced the parts that would squirm & feel silly. . . . I don't think I've left myself too naked."[14] Indeed, the handwritten manuscript is so valuable precisely because it candidly reveals many more details regarding Carr's circumstances. The manuscript flows from one episode to the next and introduces new connective explanations rather than existing as a series of

stand-alone vignettes. Carr has not yet stripped out the background to events or her frank commentary and opinions about people she interacts with and about her own state of mind. It seems that her intention in writing this narrative was to get it all down as it came to mind, recalling conversation and thoughts as best she could, and that she was less concerned about a reader.

The other writings included in *Unvarnished*, extracted as they are from her archival papers, represent different chronological moments in Carr's writing activities and include individual stories, some written closely together in time and others divergent, some retrospective and others recording her at-the-moment thoughts. Emotion seeps through the pages as Carr recalls her most beloved dog, Billie, revealing not just his antics but how she dealt with his misbehaviour and later the difficult decision she made when he aged. Two other dogs feature in stories that emphasize their capacity to love and their faithfulness. A series of five stories are in-the-moment compositions written in 1943 and 1944 while in hospital. In the midst of cardiac pain and high anxiety, her writing spews anger and venom, "a candor at times almost brutal"[15] critical of the hospital and staff—writing as catharsis. The subject matter was raw, perhaps too raw to relive through successive edits or rewrites. Yet Carr saved them. These are Carr at her most *unvarnished*.

As *Unvarnished* reveals, Carr was a visual storyteller for most of her life. Adding quick sketches to letters to friends or illustrating her "doggerel"[16] verses, she created amusing or noteworthy reports of incidents shared with friends. Carr drew comical faces such as the animated "kisses" in a child-hood letter or depicted life as a swirling tornado. Her creativity flowed from the visual to the written. Carr relied on humour and often used satire, lampooning herself and others in verses and sketches. This is the case in "Arithmatic," composed while at high school, where Carr drew herself as a donkey and the subject of arithmetic as a pig. Not only is this the earliest example of Carr's lifelong misspellings, but it demonstrates that her "doggerel" verse-sketch method of storytelling began early in life.

From 1899 through 1910, Emily Carr created a series of "funny books" about adventures she shared with friends while on vacation, at art school, or in everyday living. She paired rhyming verses with cartoon-like illustrations, which were the visuals upon which the words hung. Most of these funny books have been published—a trip to Alaska, train travel across Canada en route to France, adventures living in a London boarding house, sketching en plein air as well as the fifteen months spent in an English sanatorium.[17]

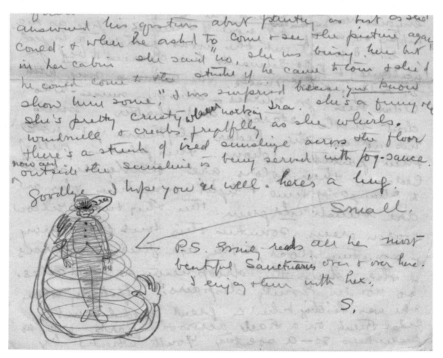

(*Top*) Emily Carr to Maud Cridge, 1888. City of Victoria Archives PR-0076 26e5 7, pages 1 and 4 shown.

(*Bottom*) Swirling tornado. Emily Carr to Ira Dilworth, between May and December 1942. MS-2181 Box 1 File 3.

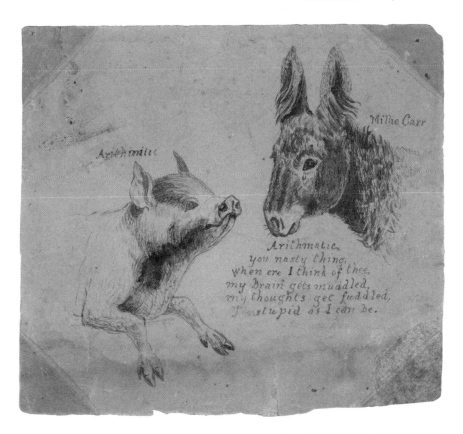

"Arithmatic." Emily Carr, ca. 1883–1886. PDP09011.

 Pages within her sketchbooks contain rough *unvarnished* versions of funny books and also individual sketch-poems not previously published, including one about a sleepy fellow student, another imagining a politically correct sketching class, or the joys of a wooden walkway, the charms of a stray cat, and another about the death of a cat named Little Potatoes. The Carr papers also include cartoon sequences, such as one depicting encounters between pedestrians. Carr was employed twice in her life as a political cartoonist. In 1905 she contributed to the *Week*, a magazine in Victoria, and in 1918 to 1919 to the *Western Women's Weekly*, published in Vancouver. One political cartoon appearing in the *Week* is included here, along with an unpublished one about cockroaches on steamers (see plate 8). When appropriate, sketches and text have been integrated as Carr originally conceived.

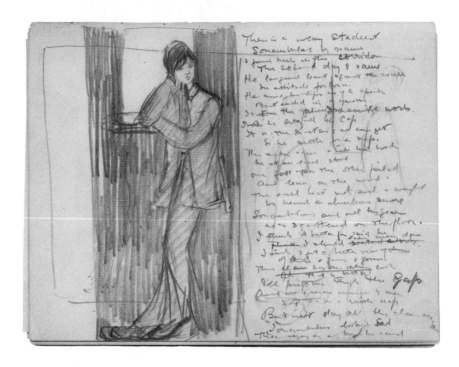

"There is a weary student." Emily Carr, ca. 1899 or 1900. PDP05727 and poem.

There is a weary student
Somnambulis[t] by name
I found him in the corridor
The second day I came
He languished bent against the wall
In attitude forlorn
He moved his lips as if to speak
But ended in a yawn
Is this the sphinx I see at work?
As we [illegible] his cap
It is: the master 'as not come yet
So he settle[s] for a nap
The master came & took his work
He at an easel stood
One foot upon the other piled
And leaning on the wood.
The easel best not such a weight
We heard a slumbrous snore
Sonambul[ist] and all his gear
Was scattered on the floor. . . .

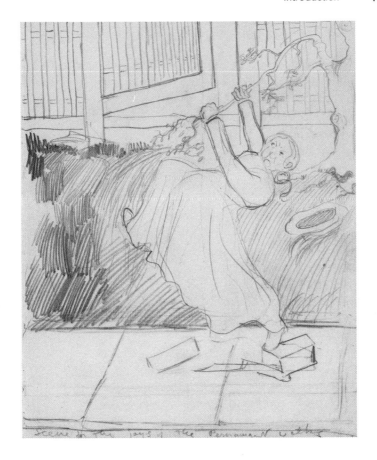

(*Series of three*) Sketches captioned by Carr as "Scene for the joys of the Permanent walks," "The de[s]cent by plank," and "Over & over down she rolls on top of the dog who squeals & scholds," and transcribed poem. Emily Carr, 1904–1905. PDP05994, PDP05995 and PDP06148 (sequence is longer).

Our late plank walk
From our gate up to our Maison
Ran a measly old plank walk.
And the misery that it caused us
Was enough to make us talk
Dangerous crooked & uneven
Then it lay its hideous state
Causing pitfalls stumblings swearings
From the door unto the gate

All the soaking rain from heaven
Which is always falling here
Warped rotted its foundations
Till it rocked and made you queer
Some of us are big & heavy
Some of us are small & slight
Some upon their feet unsteady
When they come home late at night
Then the crash came all of a sudden
One side suddenly sat down
Aunt Fan seeing it was the crisis
On a carpenter did frown
You must do it at your cheapest
Work and work at lowest price
For a sum just next to nothing
Make it fine & strong & nice
Use the old nails don't buy new ones
Old boards to[o] when'er you can
I suggested you cause they told me
You're quite the cheapest man
Save the odds & ends & pieces
Every rotted post & pole
They will make a fire for mother
Always grumbling with the cold
So they saved that wretched plank walk
And it forms our fuel each night
All the blowing & the poking
Cannot cause it to ignite
Sodden bugs & rot & water
If you call that firewood—fuel
My opinion is of you friend
That you are a wopping fool
Sitting through the chilly evening
Electric light (2 candle power)
Can you blame us if we're tickled
When it comes to slumber hour?

Ginger Pop.

At Prince Rupert the hotel refused to

take me because I had a dog.

"But," Look at the size of him I said.
My hotel he say No Dog No big dog no little dog Some small dog very bad
It is the rule, no dog.

I opened GingerPop's travelling-box they had taken it
Rule just as big for little dog as for large one The Chinese Proprietors
for a hat-box and box it up along with the other luggage. how the
hotel staff circled on their knees peering at box in Hotel
box by Pop
Ginger's comic face was peering out of the wire opening. He was a very
dog
small Belgian Griffon with great, almost human eyes and a snub nose
apprensive
worried
and the most glorious beard any grown man might have been proud of.

His coat was firy red and so was his spirit. I opened the lid of his
little
box. The man looked in and laughed. Him heap funny dog!"

What name
The Prince Rupert Hotel was run by a Chinaman. I
pander
from his Royalty
special
was told He had been servant to the railway boss during the constr-

uction of the C. N. R. railway The Official thought very much of this

man, and when the offices were disbanded and the railway finished,
this Hotel
he set the Chinaman up in buisness. The Office staff were Ocidental
was Chineese
low living
but the Host and manager was Chinaman, and a very coerteous
gentleman he was. His was the only hotel in Prince Rupert and well
run.

Ginger evidently took the men's fancy. "Me think,"
"I go"

he said and disposed of the rest of the passengers luggage to under-
with a furrow between his slant eyes
lings who took it away there was a furrow between the Bosses slant
eyes his eyes now on Ginger still and hopeful to while
Sign, he said so. I went to the desk, and he sent

my luggage (all but Ginger) up to my room.

"I show, he said. what that dog."

the sun beat fiercely down & threw myself down
~~...~~ slept

I was awaked by violent barking and the
~~paws~~ (Pounding upon my chest) amazedly
sharp tap, tap, of Ginger Pop's scraping nails, Half dazed I sat up and saw
Indians
that I was completely encircled by wild cattle. Indians do not keep
cows as milk producers, they use condensed milk and raise all the cattle
for beef. Milk cows would spoil while they were away at the canneries or
hop-picking or fishing. I knew this, but I had not realized that the
half cleared strip of land between the forest and the village was alive
these beasts
grazing in the Bush stood over me
with wild cattle. Sixteen beasts, with lowered heads, snorting breaths,
(they)
and blood-shot, morose eyes, were staring at Ginger Pop and at me.
being lying on the earth
It must have been strange for them to see a human on the flat. It was
for them the creatures
not strange to see dogs from that angle. Dogs were a natural teasing enemy
Ginger into the earth
of cattle, they would have kicked and horned if he had not been moun-
(and their beast weight would have crushed
ted on me. their sharp heavy hooves the weight of the beasts crushed into the
earth shod (hooves)
down on the could have cut and crushed our bodies, pulped us into the
broken that
us
soil, so broken as you could not have told Ginger from me.

The human
Faithfulness of a dog to a human was something
beasts
beyond the comprehension of these dull heavy creatures. A domestic cow
does often acquire affection for the human who tends her, In farming

Plate 3. Page from Carr's photo album showing a collage of images from 1912 through 1936. 198011-002.

Plate 4. Page from Carr's photo album showing a collage of images from 1912 through 1936. 198011-002.

Plate 5 (facing). Scribbled-over page upside down in journal. MS-2181 Box 3 File 7.

recapture them. The Police babe was toted
to see us at the age of 10 days by his Police, who
told us the majestic faced bully was exzackelty
like 'is Pa & I thoyt him a poor replica of that big
brass bottond man

Mr Martin. I cood not see much difference
between the majestic faced bully & the tall
fine man in brass buttons but they mother
said they were as exactly like as two beans.

One Saturday on entering her whileup studio
~~Take it seriously & the door keyped, & so one~~
~~screamed the model to a pose there~~
I saw a fryyd up girl in sox & to her
fuzzy apron. Sitting at an easel and as close
as possible to an old lady knitting. every few
moments she laid her work down & changed the
girls charcoal and brushed the bread
& charcoal from her lap.

I kicked Little Canary. "who?"

"At recess" —

It seemed this was an old pupil
of mrs whileup just returned from abroad, & her
~~this~~ elderly ~~person~~ ~~her chaperone~~, at twelve a
coachman came strapped their bags & boxes tyther
the girl was taken off of her apron & dressed for the street
& they nured their way other wants frouyhaus.

I leyped all day thinky of any chaperoyn being
necessary in mrs whileup serious mudel studio.

Plate 6. Cover of the second notebook scribbler. MS-2181 Box 4 File 14.

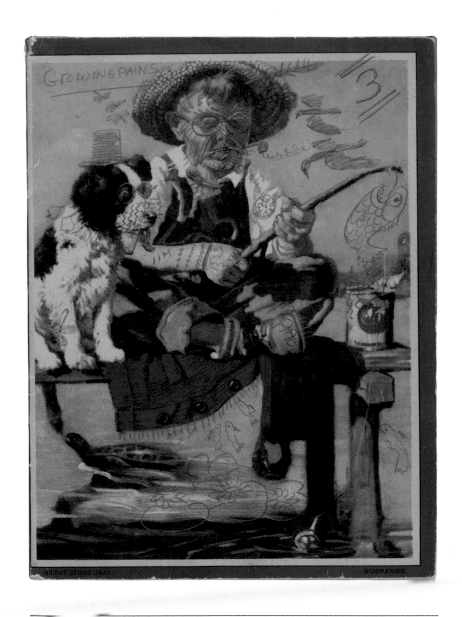

Plate 7. Cover of the third notebook scribbler. MS-2181 Box 4 File 15.

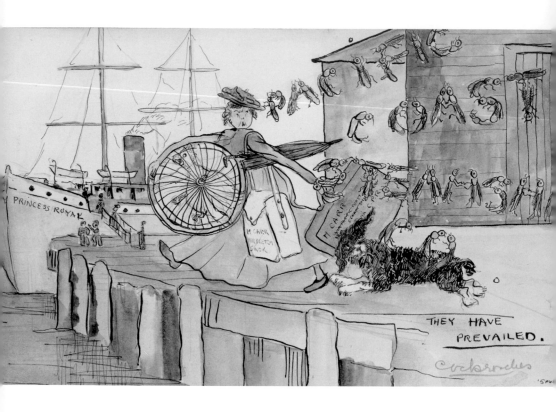

Plate 8. "They Have Prevailed" is Carr's title. She depicts herself, pets and luggage trying to escape cockroaches encountered on the Pacific Coast Steamships. Unpublished political cartoon by Emily Carr, ca. 1905. PDP09012.

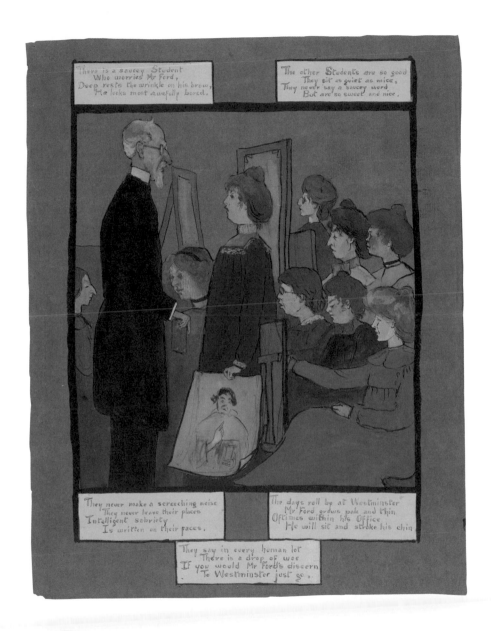

There is a saucey Student
Who worries Mr Ford,
Deep rests the wrinkle on his brow,
He looks most awfully bored.

The other Students are so good
They sit as quiet as mice,
They never say a saucey word
But are so sweet and nice.

They never make a screeching noise
They never leave their places
Intelligent sobriety
Is written on their faces.

The days roll by at Westminster
Mr Ford grows pale and thin,
Oftimes within his Office
He will sit and stroke his chin.

They say in every human lot
There is a drop of woe
If you would Mr Ford's discern
To Westminster just go.

Plate 9. Westminster School of Art. Carr is depicted seated on the right in dark blue. Emily Carr, 1901. PDP06152.

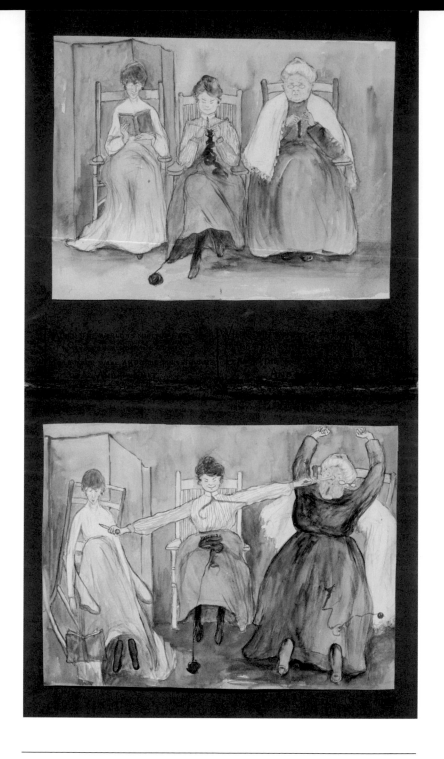

Plate 10. Carr's titles are "When the world is mid[d]ling fair" and "When the world gets one too much." Emily Carr, 1900–1901. Possibly depicting Marion Redden and Sophia Mortimer alongside a frustrated Carr. PDP09026.

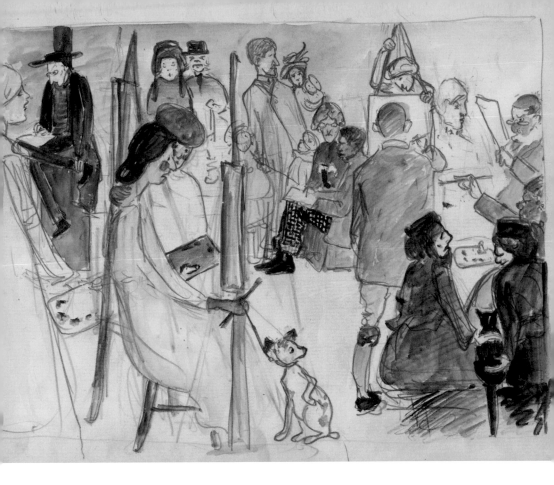

Plate 11. Sketch and poem imagining chaperones in art class. Emily Carr, 1902. PDP06140.

In a model studio
Awefully propper don't you know
I'll tell you how it came about
For we were not always so . . .

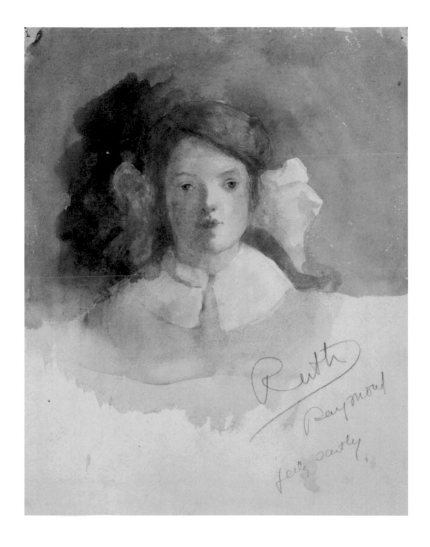

Plate 13. Possibly one of Carr's pupils. Carr's title is "Ruth Raymond." Emily Carr, ca. 1906. PDP08006

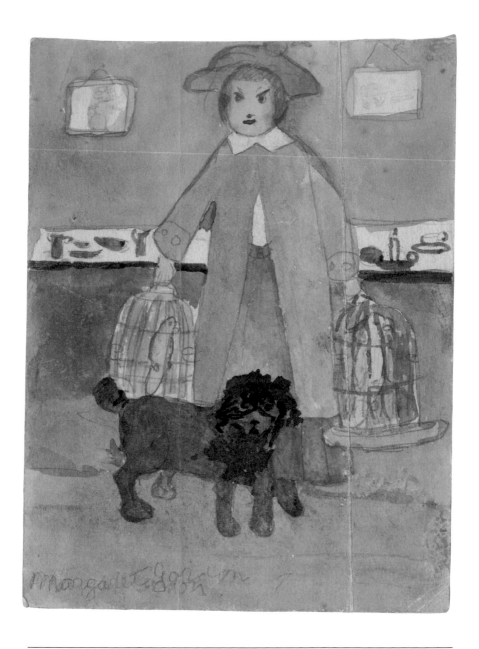

Plate 14. Portrait of teacher Emily Carr by student Margaret Gordon, ca. 1909 (pencil outlines by Carr). PDP10102.

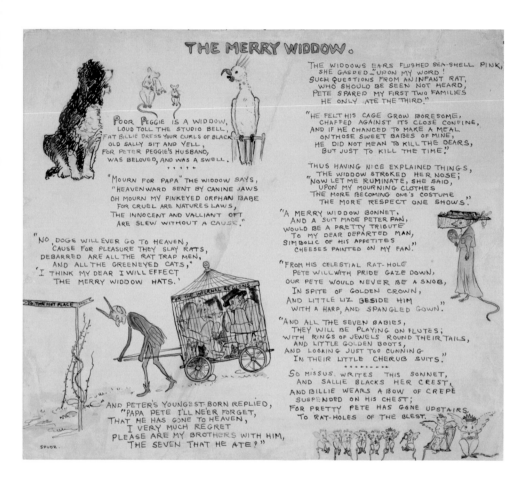

Plate 15. "The Merry Widdow." Emily Carr, ca. 1908–1910. PDP06150.

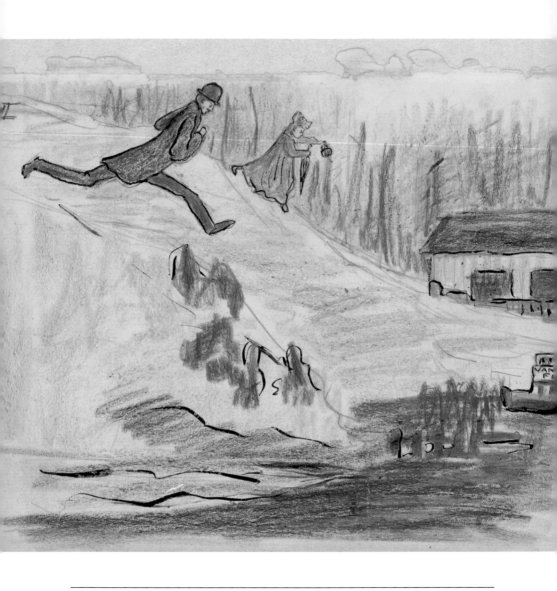

Plate 16. Carr racing to catch the sailing from North Vancouver to Vancouver City. Emily Carr, ca. 1905–1910. PDP09023.

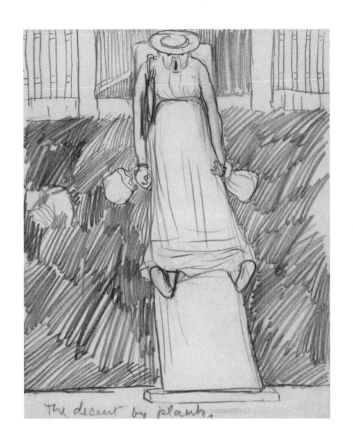

The descent by plank.

Over & over down she roll
on top of the day when spring o when

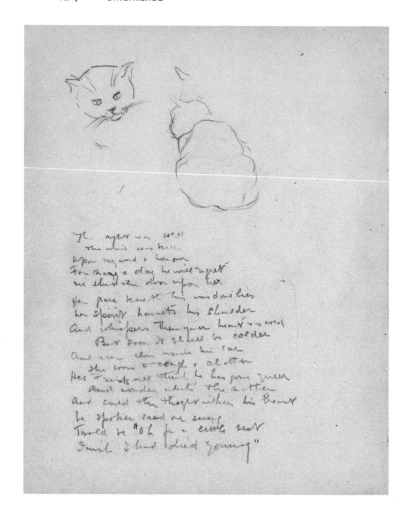

The night was cold
The wind was keen.
Upon my word & honour
For many a day he will regret
He shut the door upon her.
Her grave beneath his window lies
Her spirit haunts his shoulder
And whispers "Then your heart was cold
But soon it shall be colder."
And ever close beside his ear
She comes to cough & chatter

His friends all think he has gone queer
And wonder whats the matter
And could this thought within his breast
Be spoken said or sung
T'would be "Oh for a little rest
I wish I had died young."

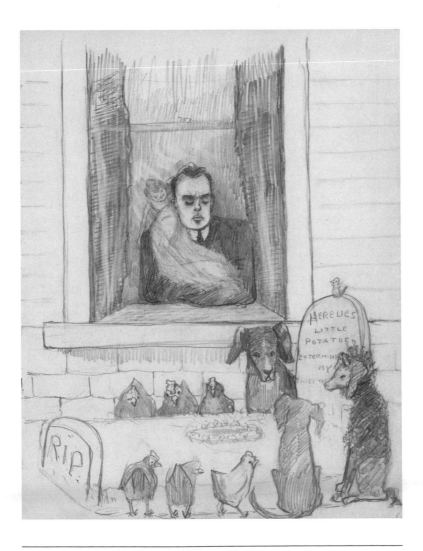

The death of the cat Little Potatoes. Carr as a sprite sits on the shoulder of "Sweetie," the man responsible. Emily Carr, ca. 1905–1910. PDP05991 and PDP05992 and transcription (page includes poem).

"Tommy Darling." Emily Carr, ca. 1900–1904. PDP06088, PDP06090 (sequence is longer).

"SEEMS A PITY SISTER TO SIT ON THAT HARD BENCH
WITH TWO EASY CHAIRS AND CUSHIONS AND ANTIMACASAS
IN THE ROOM."

"JANE I WONDER AT YOU! WHEN HE IS
SLEEPING SO COMFORTABLE."

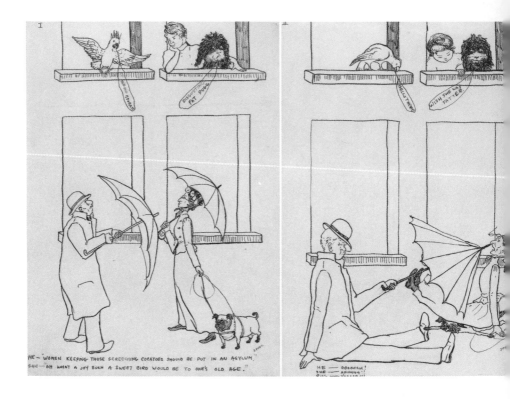

Two characters meet on the sidewalk; Carr and animals look on. Emily Carr, Vancouver, BC, ca. 1906–1910. PDP06170–PDP06172.

So how did famous artist Emily Carr begin to write the stories of her life? And when did she get serious and work toward publication? It seems she had always enjoyed creating humorous poetry and recounting her adventures in letters to friends and family, but to take that writing to the next level? Carr was well aware of her inadequacies—grammar being a weak point along with spelling—and recognized that she would benefit from formal training, but it wasn't until she was middle-aged that she had the confidence that she could tell stories and connect with readers, believing her life experiences provided ample subject matter because she was "over the top of life's fence and [able to] note the funny things on the other side."[18]

In 1926 to 1927, at the age of fifty-four, Emily Carr began taking a correspondence course at an American school, the Palmer Institute of

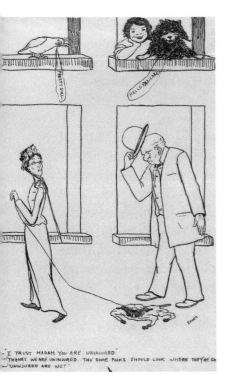

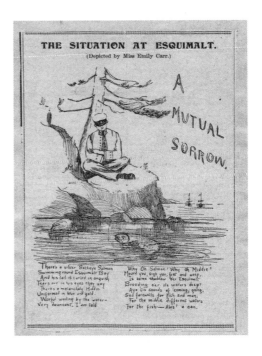

The Situation at Esquimalt: A Mutual Sorrow.
Political cartoon by Emily Carr published in the
Week, February 25, 1905, regarding the navy's
closing of the Graving Dock at Esquimalt, BC.
From scrapbook in MS-2181 Box 8 File 9.

Authorship,[19] and submitted stories to the instructors to receive feedback.
One of the course textbooks she kept in her library for lifelong reference.
Her story "In the Shadow of the Eagle," posthumously published in *The
Heart of a Peacock*, began life as an assignment in this course. At the time
Carr titled it "The Nineteenth Tombstone." In 1929, Carr's essay "Modern
and Indian Art of the West Coast" appeared as a supplement to the *McGill
News*, published by McGill University. A few years later, in 1934, she and
her friend Flora Burns[21] enrolled in short-story courses at Victoria College.
There, an assignment titled "The Hully-Up Paper"[22] was read at the closing
exercises, and another composition[23] was read before the Provincial Normal
School the following year. In July 1934, midway through the summer school
course, she recorded in her journal: "I'd like to make little daily incidents

ring clean cut and clear as a bell, dress 'em up in gowns simple and yet exquisite like Paris gowns,"[24] and "Life is cram full of things, millions of things to think back on, to wonder about, to expect. Its great fun trying to word them."[25] Integrity was key, she reminded herself in her journal: "Be careful that you do not write or paint anything that is not your own, that you don't know in your soul."[26]

Encouraged by feedback from her instructors, Carr now regularly set writing times amid seeing to the flurry of landlady chores, raising purebred dogs and going on sketching trips in her caravan. "I would sit among the sleeping creatures in the van my feet on a biscuit tin that contained a hot brick the little lamp above me and write."[27] The act of writing soon became like her art, "the something that feeds longing."[28] From the first, Carr, or others on her behalf, submitted short stories to publishers yet met with little success.[29] It was important for Carr to surmount her perceived weaknesses, to connect with the reader, to come across as genuine.

> I do know my mechanics are poor. I realize that when I read good literature, but I know lots of excellently written stuff that says nothing. Is it better to say nothing politely or to say something poorly? I suppose only if one says something ultra-honest, ultra-true, some deep realizing of life, can it make the grade, ride over the top having surmounted mechanics.[30]

Beginning in 1926 she read stories out loud to Flora Burns, who later typed and retyped revisions, then to friends Ruth Humphrey (then professor of English at Victoria College) and Margaret Clay (head librarian at the Greater Victoria Library).[31] These women together, yet separately, as Carr interacted with them individually, were her "listening ladies." Soon Carr taught herself to type and was able to prepare carbon copies to share with these friends and later others who provided feedback.

During the 1930s and right up until just days before her death on March 2, 1945, Carr escaped from her daily stresses—cash flow problems, being a landlady, the burden of her boarding house, framing and shipping costs, delinquent returns on her loaned paintings, the death of a sister, the increasingly serious state of her health, hospital bills—through writing. In 1934, even before enrolling in the short story course and despite the hard slog of being a landlady, she found time to write, even if "I must write for

the bottom drawer . . ."[32] She was writing about her childhood, dipping deep into memory. She wrote that she "lived the whole thing over"[33] while polishing "The Cow Yard" that February, a story that would later be central in the series of stories later published as *The Book of Small*. As "listening lady" Ruth Humphrey recalled, "Most of the stories of her childhood . . . had knocked on the doors of various publishers in England, as well as Canada," but to no avail.[34] Nevertheless, Carr continued to create new stories, developing an impressive ocuvre from which she would draw in later years.

After her first heart attack in 1937, the weeks in hospital followed by months of quiet living curtailed painting, which her doctor considered too physically stressful and which Carr herself confessed she had little strength to undertake. She spent one day each week in bed, writing or typing.

Ira Dilworth came into Carr's life in 1939, and it quickly became apparent that his literary background as an English teacher, his support for her writings, his "enthusiastic advocacy"[35] and his professional connections could move Carr's writing forward to publication. Dilworth shepherded three of Carr's books during her lifetime: the 1941 Governor General Award–winning *Klee Wyck*, followed by *The Book of Small* and *The House of All Sorts*. Posthumously, he published her autobiography, *Growing Pains*, as well as *The Heart of a Peacock* and *Pause: A Sketchbook*. *Hundreds and Thousands: The Journals of Emily Carr* was not yet ready when Dilworth died in 1962 but was published four years later.[36]

Carr was intensely self-critical about her art and writing. With her painting, she had the confidence born of years of formal training and practice behind her, which strengthened her resolve during the decades before she achieved critical acceptance. In 1927, she met members of the Group of Seven and exhibited alongside them in an important Ottawa exhibition,[37] finally connecting with Canadian artists who accepted her as one of them. This was not only a confidence generator, but also gave her a sense of belonging, and importantly, friendships grounded in shared artistic pursuits—friendships with fellow artists with whom she could have wide-ranging conversations. In particular, Carr's friendship with Lawren Harris would prove crucial to both her art and her writing.

As early as 1931, after hearing from Carr that she was writing a story, Lawren Harris wrote, "Well that is thrilling . . . why don't you plan and do an entire book of them. There would be nothing like it and it would be a real contribution . . . writing and painting help one the other and the individual

who does both has a wider base to stand upon and to work from it will give you another realm to live in."[38] Now that the seed was planted, Carr initially focused on stories based on her early travels to Indigenous villages, the people she met there, the friendships she made and the situations she encountered. (Years later, these first stories would form the core stories in *Klee Wyck*.) She also delved farther back to her childhood and memories of animal friends. In 1933 Harris brought up the topic of autobiography. He wrote,

> I fancy that if you were to write your story, fully, comments on people, things and situations—somewhat as you write your letters it would be very much worth doing . . . you would have a very great deal that would be of real value. The thing should be very frank, direct and natural and that should be easy for you. A book of nearly three hundred pages written whenever you feel like it. It might take a few years that doesn't matter. . . . I am dead certain it would be worth while doing. Would it interest you?[39]

It was soon after that Eric Brown of the National Gallery of Canada advised the same. Initially Carr rejected both their suggestions; it seems she just felt odd about it. "I do not feel eligible for a biography. In the first place I'm not DEAD & I don't think these things should be wrote till one is. . . ."[40] But by 1938 she had surreptitiously handwritten in three old-fashioned scribbler notebooks the lengthy and largely chronological narrative of life incidents and adventures, remembrances both large and small, presented here. Although the first book has not survived through time, the second and third books total more than 60,000 words.

By 1941 Carr had reworked this life story into a series of greatly streamlined vignettes, heavy on situational events, using dialogue to develop plot and characterization, much in the ways her story writing courses had taught her. She remained secretive about this achievement, still feeling awkward about its suitability. When a friend at the time suggested she consider a potential biographer, she had to confess.

> I have written (one of a sort). . . . It needs revising and rewriting. Maybe some day I'll get to it maybe not, what checked it was really that I read the first part to Alice & she was so white-hot-furious she did not speak for weeks, & has never mentioned it since. I would only

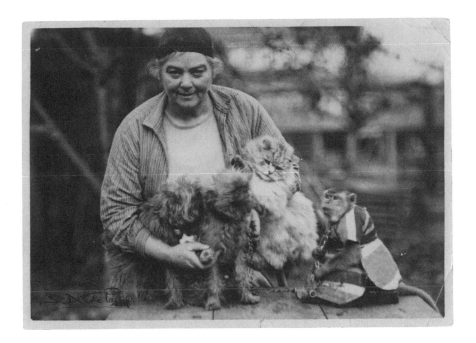

Emily Carr with Woo, Adolphus the cat and two griffons, 1934.
Photographer: John Delisle Parker. G-00414.

write the thing if I <u>could</u> be honest & show bits of our home life as <u>it was after our parents died</u> (pretty hellish). . . . An <u>Auto</u>biog. is the only Biog. that can truthfully be done, I think & Alice would not tollerate it & I'd feel a FOOL if I wasn't dead.[41]

Three days later, obviously worried that her secret project might inadvertently become public knowledge, Carr followed up with "Don't mention what I told you about my having written of the Biog. It may never be finished. Never in my time will it be <u>public</u> I'll keep my insides <u>in</u> till my breath is <u>out</u> thank you!"[42]

It is fortuitous that the handwritten early versions of her life story exist at all, for it was only a few years later, when Carr was trying to clear out and organize her papers, that she asked Dilworth his opinion regarding retention of drafts. "Can I destroy old copies of unpublished & uncontested M.S.?" she wrote. "I use them for preliminary writing paper but see no sense

in keeping even decently typed copies. . . ."[43] Dilworth replied, "Be careful of destroying papers etc that may be of interest. . . . Things that have not been finished should be kept however fragmentary and incomplete. You never know when you may be inspired to go back to an idea and develop it."[44]

So why read the *unvarnished* writings if they don't represent Carr's best work? Why look at sketches and poems she made for her own amusement, never intending they be widely distributed? One answer is that they provide insight into the workings of one of the most creative figures in Canadian arts and letters: "They give us, both as scholars and as general audience, the opportunity to see the world with her eyes, thus enabling us to gain some insight into her perspective and, perhaps, then understand her reasoning."[45] Together with Carr's published writings and the several hundred paintings she gave to the people of British Columbia via the Emily Carr Trust,[46] these *unvarnished* pieces help us reconstruct the inner life, the self that believed in her own worth despite hardships, that pursued creativity in all she did, and that held friendships fast. A complex self, but one that has given joy to viewers and readers alike. Emily Carr kept and treasured these drafts and sketches and bequeathed them to her literary executor, Ira Dilworth. She clearly believed that at some future day they might hold importance for those who strive to understand her multifaceted creative life force.

Facing: One of Carr's classmates at St Ives, 1901 or 1902 (detail). PDP05910.

Emily Carr's Notebooks

England, 1899 to 1904

London, 1899 to 1901

"Mrs Simpson's"

OPPOSITE THE ART SCHOOL[47] Mrs Simpson[48] a widdow had her little shop—groceries etc. She was a real old timer spare & grey rosy cheek bones placed high a tidy onion-like knot of hair composed of wisps which strain as they did could not pull the long wrinkles out of her forehead. Her gentle knobby little hands took pennies & handed little packages mostly of newspaper across the counter to dirty little urchins. The boy students slipped over & helped her get her accounts in order sometimes.

The shop was only part of Mrs Simpson's business. Behind in a small room with an open fire a foggy window and a number of cats was the lunch room Mrs Simpson kept for the students the kettle boiled on the hob—the table—was spread with cans of potted meat slices of bread, butter, jam apples & sardines there was cocoa & there was tea. At twelve the dim little room hummed with chatter and loud patterned smocks. In the centre of the table stood a heavy cup with no handle. Mrs Simpson left everything to honor. The students helped themselves out of the cans & threw a penny or a hapenny into the cup as the case might be. Tea ha'penny, cocoa penny, two sardines ha'penny. Heaven knows where the water came from there was no supply on the premises when the kettle had to be filled Mrs Simpson

ascended 2 creaking steps & opened a tiny door into small bedroom almost dark. The water stood on the floor in pitchers how it got there I don't know.

Everyone loved the saddish little woman in rusty black. When any one was suspected of defrauding the delft cup she was indignation. We could if we wanted take over our lunches & supplement with hot tea.

"3 London Men" and Mrs. Redden

NEARLY EVERY SUNDAY I went to Mrs Redden's[49] at tea time. How hospitable and warm she was she always wore black with some bit of white fuss at the throat, her hair was grey and she had a large mouth and lots of wrinkles. Her eyes were brown & stared when she was thinking—like caged things that had reached their limit. Some people's eyes turn back & back into themselves when they think, others come forward and glaze the thought over, do it up in cellophane preserving the thought as it was but it can't grow any more. Mrs Redden's mind was stocked with preserved thoughts, she preserved them from the newspapers they were nearly all war[50] preserves which she carted down to the Abbey war services every day.

"Do you not think Klee Wyck that you should spare time from your studies to pray daily for our soldiers. The school is so close to the Abbey."

"But Mrs Redden I could not run into the Abbey in my paint apron by the time I had changed and run across & prayed & run back, it would be a big hole in [the] days work."

"It makes a big hole in the men's lives going out to fight for us."

"I can pray for them night & morning does it have to be in the Abbey?"

"The historic Abbey of all places should rouse ones patriotism." Mrs Redden wallowed in the South African war, she bought every paper & every special and read & wept and prayed.

Every Sunday I went to tea at Mrs Redden's, hot buttered muffins, cake and three young men. Eddie and Freddie in their longest blackest coat tails and Sammy Blake who was not nearly so etiquette though his Father was a member or something[51] he had bright color & was delicate in body & more robust in ways than Eddie & Freddie. These men of English parentage had been friends out in Eastern Canada. When they went back to English universities Eddie & Freddie re-made themselves into ultra English. But Canada still peeped out of Sammy. I don't remember him in silk hats & frock coats and I don't remember Fred & Ed out of them. All three were lawyers & close friends.

I liked Sammy Blake, he treated me as a normal girl. The other two stroked as if I were a senseless kitten, perhaps it was my own fault if I turned and found my fur stroked backwards.

Both Fred and his mother were very fond historically of Art. Fred had huge volumes of excellent photos of great pictures. Arranged according to Century. Dates & schools were more vital to Fred than expression. I could not argue I knew so little was completely ignorant of the Old Masters. I knew when a picture expressed something that touched bottom but the school or century meant nothing to me. I would see Fred & his Mother exchange looks that made me go red & uncomfortable & feel ignorant and they seemed to have an eternal string of artistic cousins who bounced through their Art Schools with great velocity & won all kinds of certificates & hangings & medals. I always felt particularly stupid over Art in their presence. I never showed them anything I did, just a few times in answer to their "How are you getting on at Art School?".*

"All right. My life drawing was the best of the month." They made a very foolish fuss to encourage me but it was not anything really. The work of each month was stuck up and judged. That was all.

Eddie did not care about my work at all, he cared about me and I used to wish very much that he did not.[52] Mrs Mortimer[53] used to tramp me all over London to see History. It was something to write home about but very wearisome for my body. The horse guard surprised me, beautiful horses & men frozen into show off statuary.

"If we hurry we can see the change of guards."

"Why should we want to?"

"My dear! The dignity of our traditions."

She was a pretty little lady dainty & romantic with 3 white curls in front of each ear wore widdows bonnets & widdow colors & cuffs though her husband had been dead more years than she had known him alive when he died she had become a widdow-for-good swathed inside her weeds. The same as she would always be a woman of old England swathed in its traditions.**

Mrs Redden & Mrs Mortimer shook their heads in duette over me very often. They would like to have turn[ed] me into a dignified religious English woman fit to marry Eddie. They did not think my art studies were serious

* See transcription, page 2, and plate 9.

** See plate 10.

for I seldom spoke of them. They loved me and wanted to make me nice. Sammy Blake was the only one in the little circle who accepted me as a sane Adult and did not try to teach me things. I was always glad when he came to the Sunday tea parties. He spoke of Canada with a quiet affection without bouncing some superior English quality down on her.

One Saturday Mrs Redden Fred & a French cousin of his, Sammy Blake & I went up the Thames from St James to Windsor. Fred his mother & "Jatty" went in Fred's big canoe & Sammy took me in his small one. That is one of my loveliest memories of England.

Two turbulent Canadians floating in the little canoe down the calm river without talk. We pressed through beds of waterlilies it looked as if there was no way for the canoe to press between the big smooth leaves but they made way & clos[ed] together after us. Swans were swimming away then they came close & stuck their heads into our canoe.

"Look out there," shouted Fred "those brutes can be rough & ugly apt to overturn the canoe."

Sammy pushed him gently back with the paddle the Swan's angry hiss was the most real thing in all the pretty softness of it all.

"Jan 23 1901"

THERE WAS SPECIAL REASON for London's heaviness. Queen Victoria was dying nothing else had been talked about for days. Specials & Bulletins came out one on top of another. London always dreary was utterly woebegone. It was considered impolite to laugh. Mrs. Redden sat snowed over by papers she wore her bonnet having just come in from Buckingham Palace. She haunted the bulletin boards hanging at the gates. She crushed my cheerful greeting by whispering "she is sinking." London held it's breath and sank with her Majesty.

"Have you passed the bulletin boards?" Was the question every one asked every one else.

About every hour a new bulletin was posted up outside Buckingham Palace gates. You read as you passed single file & police men kept you moving. The passing of a queen who had reigned as long as Victoria was a terrific national event. Every one fell in line. It was impossible to stand aloof.

I had seen the queen several time[s] since I came to London. She had made several public appearances & I will confess these seemed a great deal of public nonsense.

One time Alice[54] & I were walking towards St Pauls we were crossing Cockspur Street dodging traffic when a "Bobby" suddenly halted us for a single carriage. In the carriage was the Queen, a homely old lady in a bonnet. We were close to the wheel and she looked into our faces and smiled. Both of us were pleased. Alice was in ecstacies.

"All to ourselves Carrlight[55] wasn't it wonderful!"

"She looked quite a dear old Mother!"

"Carrlight is that quite respectful?"

"I think a mother is more real than a queen."

"I 'spose its because you are Canadian," said Alice.

"I'm British. Father & Mother were so English that they were too English. Father took his Englishness to Canada & tried to plant it there. He dug the hole so deep it all went to root. The Canadian Air could not get at it to keep it healthy. When I began to see things for myself I wondered it was quite fair. Canada was new & green and raw but she was fine and Father wanted to trim off all her angles and make her copy England. He took the old country with him instead of adapting [to] the new. Canada had not many manufactured things she was too new but the United States had. But Father despised all they made & did because they had broken away from England. The English in Father was hard & aggressive. Mother's English was homey and lovely. I built my ideals on that. The Church of England the country of England the home of England."

"How about it now you are here?"

"I find I am all Canadian. England chafes like a tight shoe."

"But all the wonderful old things centuries old customs and things?"

"That's just what galls me. You are contented to live backwards. Those old things were fine in Season but you've hung onto the fetters too long they are not vital living things now they are tradition."

"That's what makes them so grand and reminds us who we are."

"What live good do the horse guards do. Grand men and grand horses wasting. Look at those silly beefeater men in the Tower of London they are not real they are only remembrances."

"What has Canada got that is real?"

"Bigness—natural resources—and something perfectly enormous to build out of herself. If only the English men in Canada would not try to hold her back to England's pace."

"Why come here to study art?"

"I wonder."

"You've got to admit all the art treasures are over here."

"Yes. Canada has got terrific ones stored up in her natural parts but I 'spose we have to come over & learn from you how to dig them out."

"Shan't you hate going back to dig? Not having the things that others have already thought out and invented to inspire you?"

"It will be awful but it will be grand too. Space instead of people."

The Queen died. London was plunged into the deepest mourning. Black black black every thing draped. Some of the foreign students resented it fiercely but if they wore colors they became conspicuous, laid themselves open to comment. This was brought home to me one Sunday by Marie Hall[56] the great violinist who was boarding at 4 Bulstrode St. under special supervision of [landlady] Mrs. Dodd[57] as she was young & delicate. Mrs. Dodd asked me to take Marie with me to church sometimes. Marie was from Birmingham. Her heart & soul were in her violin. Clothes meant little to Marie. She had topped her pale little face by a bright cherry colored hat just before Queen Victoria died and saw no reason to waste a perfectly good buy. As we went down Oxford & Regents Streets people stared & made remarks. Marie did not care but I confess I wanted to push the hat off Marie.

Mrs. Redden sat behind us in the abbey. She herself in deepest black. Coming out she whispered to me and Mrs. Redden's whisper boiled round her s'es and hob-nobbed with every echo in the vaulted roof. "Scandalous. Get it off her Klee Wyck even if you have to destroy it."

It took a considerable time to bury Her Majesty. People paid tremendous prices to secure seats along the route of the procession.

Little Kendal[58] & I took up positions on St James St at 7 A.M. Kendal was shocked because I carried a little camp stool under my cape. They were forbidden in the crowd. By 9 o'clock we had been forced from first to 6 row[s] back. The stool was no good I would have been crushed down there among the feet of the throng. The worst was when police forced paths to drag seat holders through. People fought tooth & nail to force their way in before the gap closed. The frightful weight of pressing humanity was unendurable. Neither Kendal or I were tall. I'd have given up much sooner only Kendal was English & she wanted to see the last of her queen very ardently. The procession passed at 11. At 10 I whispered "Kendal I've got to get out." I could not breathe the mass of London was on my chest the air could only get into

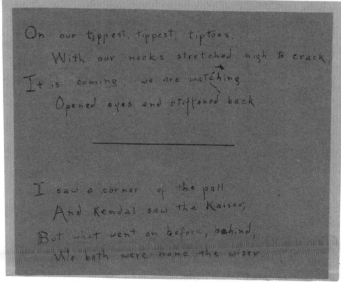

On our tippest, tippest, tiptoes,
 With our necks stretched high to crack,
It is coming, we are watching
 Opened eyes and stiffened back

I saw a corner of the pall
 And Kendal saw the Kaiser,
But what went on before, behind,
 We both were none the wiser.

One of the six pages from Carr's *Kendall & I* funny book. A second page follows. PDP10282 and verse, PDP10283 and verse.

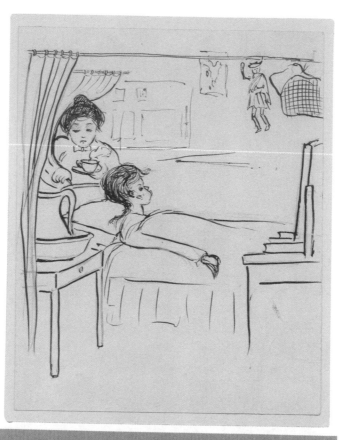

The next few days were very bad
 Both for Kendal and for me
I lay in bed, with an aching head
 She wearily brought me tea,
And we talked it over gravely
 All the squeezing and the pain,
And we said, mid a crowd in London,
 We would never go again.

my mouth it could not squeeze lower. Kendal tapped a Bobby's shoulder dimly I heard "Way! Lady fainting." I came to myself hanging over an area rail in the next street. Kendal stood close looked tearshed & wrung out.

"Where's my stool?"

"Down among the peoples feet. It scooped a vicious mouthful from my shin as it passed too. I think maybe we'd be in time to go down to the Mall lots of space there. Will you?" I felt bruised all over—longed for home, but we went. I remember a scrap from a poem I wrote in the fun book Kendal & I used to giggle over in the silent room at night.

"I saw a corner of the pal[l] and Kendal saw the Kaiser.

But what went on before, behind, we both were none the wiser."

The next few days were very bad for Kendal & for me. I lay in bed with a raging head she wearily brought tea. London got ahead of me again, the two weeks of it & I was bloodless & exhausted.

Bushey, 1901

Sketching Classes

BUSHEY WAS A GOOD DEAL talked of as an art colony in the country. The Herkomer school was there it was in Herts.

When I left the train I rejoiced to see the open fields. "Which is the way to Bushey?" I asked the news agent.

His "Turn round by that 'ere Pub and keep a-goin'" was really a very direct answer.

I kept a-goin' a very long time the road meandered like a dream before it ended in the settlement. First I lodged with a nice woman who was shortly to become a mother and when she had to turn me out because she was expecting a visitor, I lodged with two old maid cats.

Bushey is full of studios & students besides having the Herkomer school.[59] On enquiry I found that if I wanted theatricals dances & good times you went to the school, but if you were out for hard work you went to Mr. Whiteley's studio. I wanted work.

The long unpainted shed-like building sat in a field. These were six studios with a veritable tunnel of draught from end to end of the building containing all their doors. Mr. Whiteley's was No 9. Mr. Whiteley[60] was

very shy, he took about 16 students and used as few words as possible for teaching and none otherwise. The way the English girls adored and idealized their masters disgusted me. They mistook them all for geniuses, whereas it was only the "ungeni"[61] who lowered their dignity enough to teach. Mr. Whiteley was a good teacher. His female students adored him all the more for his reticence, they grovelled.

There was the usual discomfort of strangers, at first nobody told you anything and giggled when you fell through ignorance. After a week of feeling like a fish in a desert I encountered a forlorn boy in the corridor. "Please" he said like a lost pup. "Which is Whiteley's studio?"

"No. 9."

"Please" he said again "when will he be there?"

"Not till the afternoon."

"I'm a new student." He might have been an oldster.

"I'm a new one too. You want to know things?"

I told him all I had found out by my own experience. Where you went to buy material. How you primed canvas. How you got your easel & drew for places. He was very grateful we were soon good friends the boys were nice to him and to me. We left the girls quite alone. By slow degrees they began to push in. English girls adore the male set.

"How long had you known Mr. Brit before he came to Bushey?" they asked later.

"Not at all."

"How did you get acquainted so soon?"

"Doing what you girls did not do for me helping him get the hang of things."

"Introduced yourselves! But he might have been anybody!"

"Guess I've got the eyes and as much common sense as a pup."

There were 4 girls in Mr. Whiteley's studio who hung together. Two were blood sisters & the rest "shared" in a house. By and bye they invited me to tea. One girl called Mack something or other was a horrid snot. She despised me for a Colonial. The "Canaries" as the boys dubbed the sisters, for their yellow hair & staring black eyes wanted to be friends with me because of the boys. Mack disapproved of me going to their house, did not think me up to her standard. This set the devil in me on end, I behaved as badly as I could acting the fool. I ate loud, wiped my mouth on my sleeve, made faces, used bad grammar, sniffed, gulped, behaved abnormally. Mack was

outraged. When she could stand no more she bounced from her chair with "Where were you brought up?"

"In a different country to you thank the Lord."

The Canaries tried to twitter things down but Mack & I remained Antipodes always.[62] The younger of the Canaries I led a pretty dance tearing her through hawthorn hedges till she bled like a stuck pig, forcing her to smoke cigarettes which she hated (and Mack considered a low practice). The Canary was game with agonized black eyes popping she followed [as] tho she had no initiative. The other Canary sat pretty on her own dollish beauty. She and Mack consulted about my bad influence but after all the youngest Canary who had been rather a moper had chirped up and she took no heed of what they said.

One Saturday when I went into the studio I was much surprised to see a fussy little old dame with her knitting setting up an easel duette style beside a fat baby faced damselle any where between 20 to 25 years of age. The girl was done up in a big babyish pinafore trimmed with lace. She was crimped & curled like a baby show infant. The knitter handed her a clean hankie every few moments apparently she had a slight cold. She artfully wiped her nose & the smudges of charcoal from her fingers. The "elderly" removed the young lady's spectacles each time & held them till the nose operation was completed. She looked daggers at me for holding the door wide to bring in a big canvas, took a fluffy shawl out of her receptacle & draped [it] over the girls shoulders.

Kicking the younger Canary I said "who?"

"Wait till rest" she whispered.

It seemed this girl was one of Mr. Whiteley's pupils who had recently returned from abroad. She only came Saturdays in a chariot & pair[63] & the old girl was chaperone.

Chaperoned at 25 in that meek and mild studio, with entirely clothed models, the most serious of Masters and students who were the hardest diggers I ever saw, so tickled my fancy I spent Sunday composing a poem and illustrating it. I was quite foolish. All the students decided they had been most immoral . . . so they all decided they too must bring chaperones. They piled in with sisters Mothers Aunts the curate, each brought some one who could not leave the cats & dogs home & brought them along. It ended up:

And so the room got very full, the air was like to choke.
The Master sighed and said Ah me! This is indeed no joke.
But for the sake of decency, tis very plain to me.
That I, my gentle wife must bring and she our children three.
The model cried I will not sit in solitude alone.
My good old woman too must come and share the model throne!
No one could move. Our art careers were quite completely wrecked.
Yet oh the bliss that bust our hearts.
From feeling so correct.

There were accompanying sketches* caricaturing each one.[64]

Monday morning I took this production to school. The model was posed out in the open field that morning. At rest I was sitting with the boys on the top rail of the fence. We were all laughing over the skit. Suddenly one of the Canaries yipped, "Mr. Whiteley hide it!"

Mr. Whiteley walked up to the boy who held the sketch.

"What's the joke? Can I see?"

Awful silence.

The boy said "it is Miss Carr's."

"May I share it" he asked.

"It's just silly Mr. Whiteley. But certainly if you wish."

"Thank you." At lunch time their rest is up. He took the skit.

The Canaries & Mack had eyes & mouths wide with horror. "You've ridiculed him as well as us. What will he think!"

"Surely he can see a joke."

"I would not have dared to." "Nor I" chipped in the others. "Wonder if he'll ask you to leave the studio."

Mr. Whiteley sat himself down in the studio. Everyone fidgeted round pretending to put their things away.

Peal after peal of chuckles came from the Master. None of us knew he could laugh. He slapped his knee. "Every nail straight on the head" he chuckled, forgetting his shyness.

"May I take this home to show my wife? The chaperone business has always tickled her."

And off he marched with it. "Well! Well!" exclaimed the students.

* See plates 11 and 12.

Next morning the studio divinity said to me, "My wife wouldn't give it up. Wants it."

"She is very welcome to keep it."

"I am going to suggest a trade" he said and handed me a delightful little picture done by himself. A typical Bushey scene.

"Oh Mr. Whiteley mine is not worth that."

"It pleases us" he said. "Soon you'll be off to your West. I'd like you to have it."

I was very proud, everyone was envious. The Canaries asked to take it home to show Mack who was laid up.

Mack remarked, "I only hope that person (indicating me) is capable of appreciating it."

The fields & little woods around Bushey were beautiful. I was there through a Spring. All night the nightingales sang and in day time the woods bubbled with birds. The new foliage the lush grass the Cucoos and blue bells & primroses and anemone were just intoxicating. I used to sing & sing & sing in the woods and the horribles of London faded from my mind but by & bye even the sweet loveliness of Bushey with its tinkling brooks & chortling birds palled. I wanted the roaring rivers the dense forests the fine swooping birds with keen searching eyes. I had been born of English parents with English Ideals, but I was born into Canada what I was was stronger than what I came from. I went back to London.

One thing Mr Whiteley told me that I never forgot, he said. "Remember the going & coming among the trees don't paint flat walls." Perhaps that is where my first notice of tree movement was born.

Bushey, Second Visit, 1902

Milford

A NEW STUDENT blew into the studio from St. Ives, he said "I have a recommendation for mercy from the St. Ives students to you." His name was Milford.[65] He was a delicate boy his mother had remarried & his step father was impatient of the boys desire to become an artist but his mother was in full sympathy. Before long she came to spend a week with her son & I got to know her quite well.

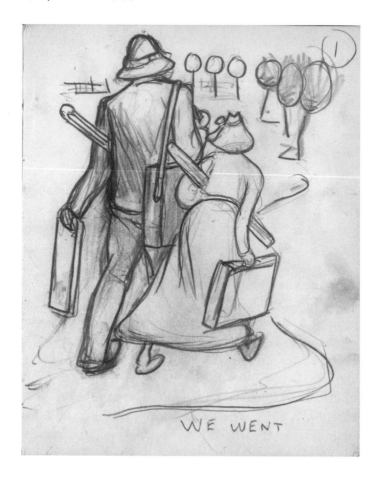

WE WENT

(*Series of three*) Emily Carr depicts herself and Milford Norsworthy sketching with mosquitoes. Carr's titles are "We Went. We Was. We Wasent, They Was." Emily Carr, 1902. PDP06137–PDP06139.

"Look after Milford" she said. "Do see that he eats slowly and take care of his money, he spends it all when he first gets it & then has nothing." So I banked his money. He handed his allowance nearly all to me when it came.

"Can I run up to London this week" he'd say.

"No, funds don't permit Milford." We got on famously. He had lodgings down the street and moved his table by the window where he ate his meals conversing to any students who passed. I would yell in passing. "Milford are you going slow and taking lots of chews?" He'd stick his head out munch

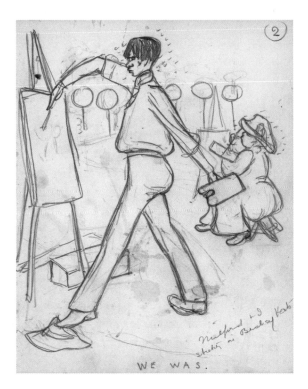

WE WAS.

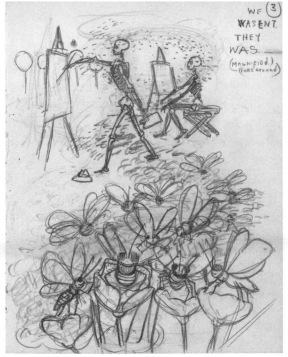

munch munching to show me. We had a lot in common. One night he was on the way to an evening class with some other students when he said afterwards, "You stood right before me in the path & I knew you wanted me."

Milford turned abruptly. "I'm going back for Miss Carr."

"What for? You never call for her on the way to night classes?"

"I'm going to tonight." And back he came.

It was a white faced me he met at the door, a folding chair had crushed my fingers by collapsing. The old Miss Meads[66] were making little dabs at it with a filthy dishcloth and saying "Oh Lor, Oh Lor." Milford put me on the sofa & ran out for brandy. I was deadly faint & the shock gave me a terrible pain in the stomach. Milford gave me the brandy and sat down with his back to me, did not talk or notice that I was crying.

We often went out into the fields together to work. One day I was working one side of a hedge & he on the other. He called across & asked me to give him a crit. To do so I had to walk to the far end of the field to find a gap in the hedge. When I came back a cow had knocked my easel over and was sitting on the canvas. How we laughed.

Lodgings

JUST AS MRS DODD was the only nice London landlady I had, so the Misses Meads were the only mean country landladies I had in England. When they became too impossible and Milford was gone & the canaries had left I moved up to a row of cottages on top of the hill there must have been a dozen of them hitched together by the ribs. It always seemed that the country lane ladies were just going to have a baby and were renting to make a little to help out.

Mrs Martin had the centre cottage she rented the front lower & the upper back keeping upstairs front & downstairs back for herself. The Martins[67] were dreadfully lovey dovey & this was their first baby. Their wedding gifts occupied my parlor. A family bible on which was written on [the] front page:

"Full & complete list of wedding presents received by John & Jane Martin on the occasion of their first marriage." There were vases, bed spreads, spoons, crochet mats candlesticks tablecloths Mrs Jones check 2s 6d Mrs Proud check 2 shillings & Mrs Dilley check 3 shillings. The bible itself was the gift of her former employer.

"You see Miss," said John. "I was seven years cortin' 'er."

"A long time Mr Martin."

"I only seen her onet'a year for five."

"Y'se Miss she were cook an me were gardener at same place. I left an she stayed an I could only get onct a year till we'd saved to marry on. 'Er Mistress give us the bible & with your permission we will point to the articles." So they came into my parlor & "pointed."

"Just one did not come through," said Jane without bitterness. The one written & scratched "counterpane it was but maybe she 'had good cause.'"

Behind each cottage was a tiny patch of earth separated by picket fences where a few lettuces radishes & onions grew the little gardens were assiduously tended & very neat. Up & down the row of gardens you heard lots of gossip flipped over the fence. The policeman's wife, with four under five already, produced a sister while I lived in the row. The four under five were stowed up & down the row. Before the babe was two weeks old Mrs. Police tapped on my door & asked permission to bring the babe through my sitting room to show Mrs. Martin as other wise she would have to lug [him] 6 doors up or six doors back to get round to Mrs. Martins back door "an e's a heavy lunk of a lad" said the new mother.

Next door to us lived a prodigious family, the 3 elder ones were half wits.[68] Mrs. Martin said it was "beer done it." The younger 3 seemed very smart so perhaps the beery lady had turned over a new leaf. The boy next the youngest & I were great chums. He would rush home from school & search the fields for me so as to carry my sketch gear home. Every Saturday his big brother Tim bought a rosebud for his button hole & went to see his girl Sunday. Monday the rosebud was the property of the two half wit girls who quarrelled over it till Ma took & threw it into the ash bin. Tuesday the little boy rescued it pulled off the dusty outer leaves & gave it to me with a sly grin. I wore it to school.

The father was a cow man who tramped five miles night & morning to his work. The looney son at his heels. My small boy's ambition was to be a cow man 'like Father.'"

I watched Jane's layette grow with interest. Later when I was passing through Bushey on my way to pay a visit to Mrs Mortimer who was summering nearby. Mrs Martin brought her baby to the train to see me there was only a few minutes to talk. I shouted above the "Pouf" "Pouf" of the starting engines "whats her name?" "Mary Annnnnne Missus," and the layette I had watched being made and was now full of babe was gently waved in the air.

"St. Ives," August 1901 to March 1902

Art School and Students

OLSSON WAS HISTORY.[69] He lived up on the hill in a fine house. His wife called on all the worth while students and asked them to tea. She never called on me.

Mr. Talmage was quiet.[70] His wife painted too. In looks I was very like Mrs. Talmage. Same build and & coloring. She was very deaf. At first I was very astonished when people caught up to me in the street and roared Hello! in my ear. After a sentence or two they would apologize & fall away. The store people would say, "Send it to Mr. Talmage's studio or the house?" When Xmas came I went to an artist who took photos. [I] thought I'd send some home for Xmas. Hilda Fearon was with me. Mr. Douglas[71] shewed me only one proof. "You took a number" I said "were the others no good?"

He laughed. "Talmage would claim them."

Hilda laughed.

"What is all this?" I said.

"Has no one told you?"

"Told me what?"

"That you are the image of Mrs. Talmage." I had not then met Mrs. Talmage but when I did I saw it myself. We might easily have passed as twins.

I fell on my work with tremendous zest. Olsson & Talmage were both good teachers but quite opposite [and] contradictory what one bade you do the other bade you undo.

The wind of St Ives was boisterous but the sun was glorious. I was going down hill in health. I had dreadful nervous bilious headaches. All I could do was go to bed for a few days & groan and worry because I was missing my work. The strong dazzle of the shore tired me very much & I was always wrestling with Olsson about it. I think he delighted in coming up behind me in the soft sand and suddenly balling in my ear & making me jump & then a bad head would start. If I worked behind in the narrow little streets the wind tore through but the glare was less obvious. Then I discovered Tregenna Wood, a delightful place up on the hill, dark & restful. Olsson went off to Sweden on his yacht for the Xmas vacation he stayed 3 weeks all that time I worked in Tregenna wood very happily. Talmage was very kindly.

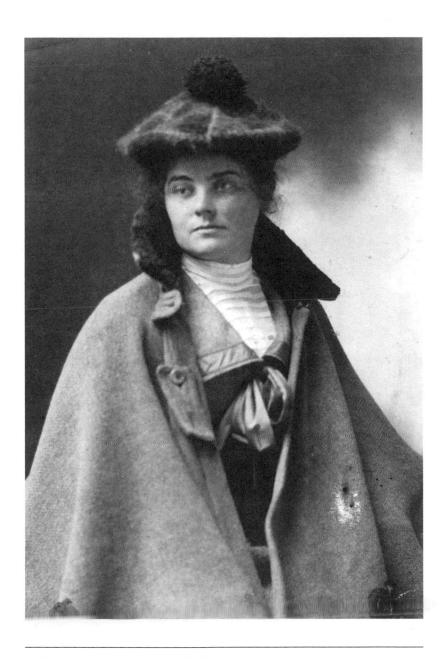

Emily Carr at St. Ives, Cornwall, 1901. Photographer: John Douglas. I-60891.

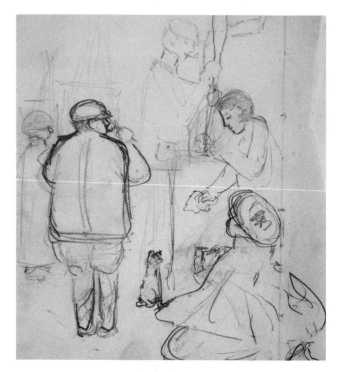

Olsson's studio on a wet day in St. Ives. Emily Carr, 1901 or 1902. PDP05985.

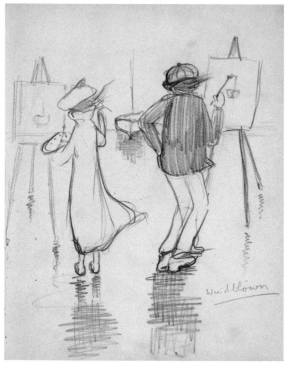

Fellow students Hilda Fearon and Noel Simmons on the beach, St. Ives. Carr's title is "Windblown." Emily Carr, 1901 or 1902. PDP05909.

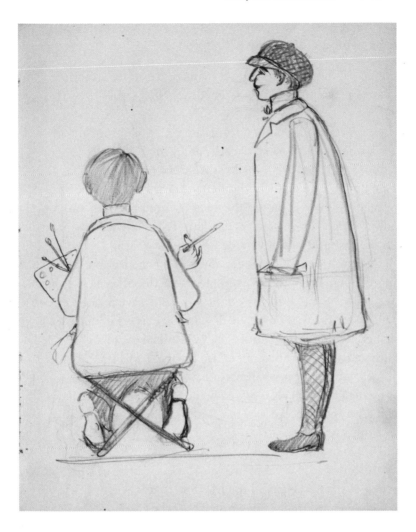

Painting teacher Algernon Talmage visiting a student working
en plein air, St. Ives. Emily Carr, 1901 or 1902. PDP05910.

"Trot off to your woods. I'll come up and give you your lesson."
"Doesn't it take you a long way Mr. Talmage?"
"I don't mind. You do your best work there and are happy."
Happy I was in the calm airy quiet.

Hobnobbing with a Sow[72]

THERE WAS a huge white sow that roamed Tregenna. I carried my lunch and shared pieces with the sow. Sometimes Noel[73] worked up in Tregenna woods too.

One day a frightful thunder storm came with teaming rain. I was trying to sketch under a bush when I heard Noel whistling.

"Hoo Hoo!" I shouted. "Got any shelter?"

"I am under the 2 plank bridge better than nothing come on."

No matter how you moved the water poured between the two planks and always aimed down your coat collar. "Tell you what let's make for that bunch of low buildings other side [of] the brick wall," said Noel. In the lull of the storm we ran. It was easy for Noel's long legs but I had some job scaling the high brick wall we tumbled over the other side to elsewhere. It was pig pens the old sow lay on the straw she gave a grunt or two as we scrabbled over the wall but made no comment as we doubled up & got in beside her. It was so funny to see the very tall elegant Noel doubled down like a concertina out of breath beside the sow. I was warned later that we had done a most dangerous thing.

"Why an old mother pig is safe enough? Besides she was a friend of mine."

"Not always safe by any means" said the farmer. "She had you at her mercy completely."

Mr. Talmage gave me very good lessons on my Woods stuff. I worked very hard & deep. That I suppose was the beginning of a love which has deepened & strengthened all my life. For that is where I determined to learn to express the indescribable depths & the glories of the greenery the coming & going of crowded foliage that still had breath spaced between every leaf.

Jo was coming back & I said to Mr. Talmage "I am very sorry I get so much more from your lessons than his. He will make me work in that horrible glare again—I hate old Olsson enormously!"

"Any way he'll have to admit I've got on while he was away," I said boastfully. "You are ever so much the best teacher."

"Olsson is a genius," said Talmage.

"I've had to grind for what I got so perhaps I can explain easier," Talmage said. "Look out there—remember the sunshine is in the shadows as well." I never forgot that "there is sunshine in the shadows."

Crits

I FELT A BIT PROUD as I ranged my long row of Woods studies before Jo the next morning. He'd have to admit I'd worked & made headway.

Jo stormed into the studio before time he had already finished the French man who sat amid the wreckage of his hopes, blowing his nose & wiping his glasses, all his buoyancy was flat. It was evident he had been dragged & torn through & through. He was dreadful conceited but Jo had utterly crushed him.

"Fetch out," he said to me tersely.

I ranged my canvases in a long row. I knew I'd got on, felt a little braggish. I expected praise before he went away. Jo had admitted that my eye for color was good.

His eye ran over my efforts. He got purpler. "Rubbish utter Rubbish," he roared "take 'em away scrap[e] 'em down re-prime. Go down on the sands & PAINT."

"Newrotic colorless daubs! Scrape" he roared & turned on his heel.

I piled my canvases face to the wall & rushed out of the Studio.

"Hello! What's up?" said Noel & Hilda[74] just entering.

"Jo!" I started to run and I ran on and on till there was a big cabbage field. They were frosted and smelt. There were large stones in the field. I sat on one and put my head into my own lap and cried and cried & cried. It seemed then that my work was no good that I'd been smug and self satisfied about what was bad. Here was I all this time over in England learning & all I had accomplished was messing up canvases that I was told to scrape down and whiten over. Olsson was supposed to be the big man not Talmage. Bye & bye I got to thinking that even if he was big he was horrid. His sympathy always went to the boy students he was nicer to them than to the girls always telling them to drop in to his studio & discussing his pictures with them. Maybe part of his furious behaviour was because I was a girl student. I began to get angry, it did not seem right I got so hot about it the cabbages could have nearly boiled against me.

"I'll go right down & see what he said to them," I decided.

Burgess[75] had a private studio. I knocked no answer— The second knock brought a little "come in" groan.

Burgess sat on a three legged stool in front of the empty grate he threw out a leg & kicked another stool forward. I sat down—Burgess had been crying—his eyes were wet & red.

"Seen Jo" he said.

"Yes."

There was a long silence. Then we looked sheepishly into each other's red eyes and both began to laugh.

Burgess had been working hard on some things he was sending up to the Academy. "Tell me" I said. "Well he could not tear them to pieces hard enough. He stamped & roared called me a fool. Said I had not done a thing in his absence—"

"He said the same of me and if you'd seen the mess he made of poor Frenchie."

"Wonder how Ashton[76] came off. Jo always praises Ashton. Let's go to his studio."

We met the smug Ashton before we got to his place.

"Seen Jo?" We both asked breathlessly. Ashton did not look half as depressed as we hoped he would.

"Shure I've seen Jo."

"Get a good crit?"

"Fine." He passed on with a flourish.

"Don't believe him do you? Ashton always oozes smugness."

Hilda had gone away for Xmas & was not back but we met Miss Horne.[77]

"So Jo's back" she said.

"Yes have you had your crit yet?"

"Not much I haven't only fools take chances with Jo till he's been home a week."

"This time he came home with a toothache to boot."

"Let's go back to work Burgess?"

Jo had had the tooth pulled. The sun was shining down the Dige[y].[78] Jo found me there an hour later I heard his heavy tread on the cobbles paused behind my stool I would not look up.

"Fine! Fine that's color there's sunshine! Why didn't you do work like that when I was away!—dark dismal woods baa! Newrotic morbid."

That was not the first time since I came over to England I had heard that same thing expressed. What was it the English were afraid to face in the woods? They herded together in cities. What would our Western Canadian woods do to them, I wondered. Well, I'd study where they wanted me to while I was in their land but I was going to work it out myself one day—face our Canadian woods the English woods were only

half woods anyway. The deepness had been "prettied" out of them—some day, I vowed.

Term End

AT THE TERM END Julius & Mrs. Olsson gave an evening party the studio was invited en masse.

"I won't go," I said but Hilda prevailed & I went with her.

It was not very nice—our hostess, was saying goodbye to us. "I am sorry I did not get to know you sooner," said Mrs. Olsson.

"Oh I've got along very well," I replied.

"You should not have said that," Hilda told me as we walked home.

"She's an old snob," I retorted.

"It is dreadfully 'colonial' to show her you thought so. Colonials are crude."

"At least we're honest and we pay our debts," I flashed.

Hilda always came with out her purse when we had fisher children in to my sitting room as models and she always forgot to settle for her share of the oil for the extra lamp. The same as the students at Westminster were always having to get some where in a desperate hurry and could you lend them a shilling but it was goodbye shilling forever. I always kept my material supply well up though I have very little to come and go on. I always had a "spare" in reserve for if a canvas was a failure. In England I found I could not keep reserves in the school. They were always borrowed & by the better class students who did not have to scrimp but were indolently careless, & who never dreamed of returning their borrows. In S[an] F[rancisco] we had borrowed & loaned freely but every one remembered to repay. Cruel may it be but the English students were to my understanding in Petty honor, probably it was more selfish indifference than dishonesty, but it boiled me up.

Christmas[79]

IN ST IVES chill and melancholy were always just round the corner you had to be robust. You needed to be robust and meet them squarely not let them get first innings. The fisher people kept tears & head shaking always bravely. Mrs Curnow and the girls fed me tragedy while they set the food for my bodily sustenance on the table and cried [at] the slightest provocation.

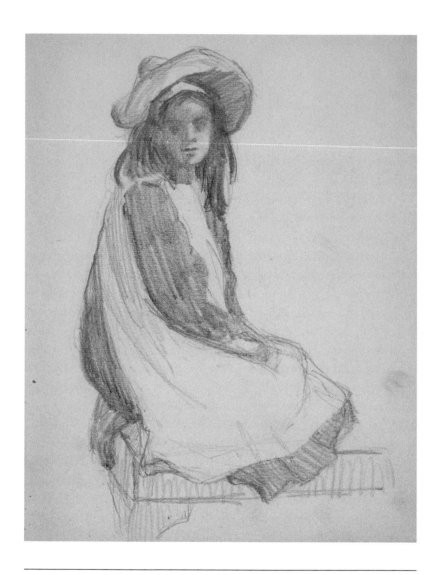

One of several village children who posed as models for Carr and Hilda Fearon.
Emily Carr, 1901 or 1902. PDP05906.

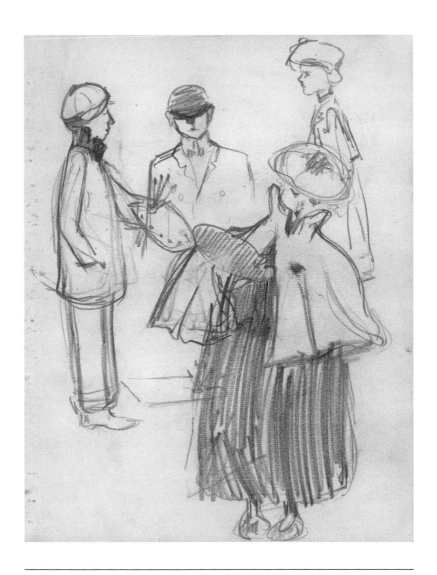

St. Ives students left to right. Arthur Burgess, Will Ashton, Hilda Fearon.
Possibly Emily Carr in the foreground. Emily Carr, 1901 or 1902. PDP05867.

A few days before Xmas I went into the Curnow's kitchen and saw the old woman & eldest daughter stirring up the Xmas pudding and weeping adding salt water which I am sure was not in the recipe.

"What is the matter Mrs Curnow" I asked. "There's always something wrong for we" she moaned. Splosh came two blobs of liquid sorrow & struck the yellow bowl.

"Our Annie's beau in Scotland insists on her Christmassing with them instead of commin 'ome ow the pore child."

"Well I expect she will have a nice time. If she is engaged she will want to get acquainted with his people you know and you four have each other here."

"You be awful cheerful Miss" wailed the old lady as if she was condoling with me over some uncurable malady. Truth was I was trying to boost my own spirits. I had a bilious attack.

All the students were going away for Xmas & the studio was closed.

Noel Simmons came in. He laughed to find me sitting by my fire cutting a piece from under the ribbon of my felt hat with which to patch my felt shoe.[80]

"I say" said Noel "its going to be lonely for you now everybody's gone."

"I'll be all right" I replied. "I just turned down an invite to Xmas at Colchester."

"Why ever?

"Reason number one, expense. Reason number two loathsome people sister of my brother-in-law. Pots of money. Titled and snobby."

"What matter if they have money take their good time and swallow the objectionables. Ever met these people?"

"Yes. The invite came from Mr Money not Lady Gentility."

"How was that?"

"The titled lady widdow with three sticks of daughters remarried into rather vulgar wealth. When my sister [Alice Carr] was over in London she looked them up dragging me with her while Lady Blank exhibited & bragged. Old money bags entertained me, he was what he was, genuine & kindly. I liked him."

"Then why not accept?"

"It is not he who is my brother-in-law's relative. I don't like my in-Law therefore I could not eat his relative's bread."

"You're Crazy! Grab every good times offered. What matter if you don't like the giver?"

"Taking from people means you like them."

"Rats, to sham politely is easy don't be so brutally down right."

Ghosts[81]

MAUDE HORN lived in St Ives always. New Years eve her mother invited me to dinner, there were several guests we fell to discussing ghosts, some very convincing stories were told. Later the men went to the town to celebrate. The new year came solemn & shivery. I said "I must go home." Mrs Horne said "Wait till the men come, they will see you down to the village."

The Horns lived high up by Tregenna forest a long way from the village. I was very tired but kept thinking about the Ghosts. The men did not come. After one o'clock I started declaring I was all right and refusing to let any of the women come with me. It was a black night. Ghost stories trembled over me with quakes, the streets were very narrow & crooked. I had to pass the cemetery there was a ruined house opposite the moon came from behind clouds just as I got there & threw long black shaddows which I hurried thru. Just as I was under the empty window frames a movement made me jump, two firey eyes were staring straight at me. Too scared to squeal I ran. The ghost a friendly red dog bounded after me.[82]

March Leaving

I TOOK SEVERAL EXCURSIONS round about before leaving St Ives in March. I wanted to go to Lands End the very name of it, its stick out on the map appealed to me but the summer excursions were not on but I went to St Earth, the rat hole,[83] and a place whose name has gone from me but that has haunted me ever since. One of the boys & I went. There was a little steamer. In dreams I've boarded her again & again. The little town was huddled together & bleak there was one quaint old place you went down steps under the street it was sort of a ship. You turned round inside & came out on a different street. It was very dark & perplexing inside.

We climbed a rough little mountain and scrambled along the beach rocks holding each other hands to keep from blowing away after big storms there were great bundles of what looked like sheeps wool up in the woods. It was sea foam whipped as dry as powder.[84]

There was a scuttle of fishermen keeping appointments with Tides. And shrewd Cornish children racing about shrieking a gibberish you could not understand. Cornwall is a memory a keen air quaint poor people with a tang of melancholy pervading their stone cottages pink blue or white washed, cobble streets & broken stone walls and always the sea pounding.

London, 1902

Big Cities

ALWAYS AS I APPROACHED LONDON the same feeling flooded over me. As we left the fields & trees and houses began to huddle closer & closer and the breath of the monstrous factories the grime & smut & smell of them came belching towards you by swift degrees you saw the creature solidify from the train window. Spots spread into a smear the smear solidified you slid into the station and were swallowed into the stomach of the fearful monster a grain of fodder to nourish it's cruelty. No more you an individual but you lost in the whole, part of its cruelty, part of its life part of its wonderfulness part of its filth part of its sublimity & wonder though it was not aware of you any more than you are aware of a pore in your skin. People said Marvelous city! Hub of the world. She drew people to her running they came, proud & glad to have her take them. A minute revolting atom like myself was less to the monster than the greying of one of his hairs. I cabbed heavily to Bulstrode St. and established myself in a cubicle, stored my St. Ives studies in the Bulstrode basement at tuppence per trunk per week.

Coronation

LONDON WAS PREPARING for a coronation.[85] Things of gay beauty were peeping from shop windows once more. London under the pall of mourning had been discouraging indeed.

Mrs Redden & Mrs Mortimer were deep in preparations choosing seats for the procession and costumes with great care.

I had seen King Edward close the morning after Queen Victoria died on my way to Westminster across St. James park. I halted as Alice & I had halted in Cockspur street when Queen Victoria's carriage past. This time

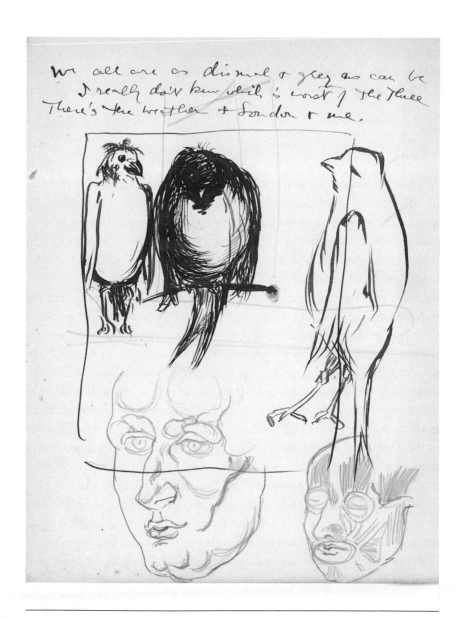

"We are all as dismal & grey as can be." Emily Carr, ca. 1902. PDP06129.

it was a sad face looking out a man who had come to his kingdom late in life. I wonder if he felt a little bitter not that his Mother had lived so long but that she had not trusted the kingdom into the hands of her son sooner not held it till she had supped the last dregs of her rights.

The Abbey was very much cleaned of London Grime. Westminster with the exception of the Architectural Museum and the adjoining slum was shining.

Scotland Visit

I WENT UP TO SCOTLAND. It was bitterly cold. I almost froze on the farm of my friends the daughter of the house rose at 4 A.M. about the time my big four poster bed had accepted enough warmth from my shivering body to enable me to get to sleep. The "girl" donned heavy wool dresses buttoned up to the chin and milked a large herd of cows. The son of the house lay in his bed till 9 or so when he rose & golfed or curled. I was not allowed to rise till eight and then the darling old scotch Mother fed me on scones & porridge in the stone floored sitting room. Only the parlor was floored in wood.

I never was thin, I had color therefore it was understood that I must be healthy. The girls took me for prodigious country walks. After we had dined at 11 A.M. The old lady cried Emmie Emmie I'm awa' and went to her bed for one hour while the "girl" washed up and then the two girls undressed and got right into bed from 12:30 to 3:30. At four we had a meal of beautiful scotch scones jam & marble cake and that ended meals for the day. I was too bashful to tell them I went to bed starved with cold & hunger. I loved them all and they would have done anything for me, the routine of their home life was different from ours they did not understand. At last I did screw courage to ask if I could have a hot water-bottle and a stone "pig" was found however it was filled at 4 in the afternoon when we had tea & was put into my bed and as we did not retire till eleven or so it was worse than cold. They did a great deal of entertaining & going out. I had to be "shewn" to all their friends. The farm was on the edge of the town and had more town than farm life. I came back to London more chilled & weary than ever I was cooped up in one of the stuffy second class unheated compartments with a female who sneezed incessantly.

I was to come back v.i.a. Alice Watts & pay her a visit. I got there shivering with chill & was down with bronchitis & influenza next day. It was mortifying especially as they were terrified that old Mr Watts would "get

it." I was segregated & very ill and mortified. The Doctor came. After two weeks he answered to my begging. He said, "You are not fit to travel but I know how you are fixed and it would be serious if that old gentleman got it." There seemed to be something puzzling the Doctor because he wrote his name & address on a card and said, "If anyone wants to consult me about your case here is the address."

I felt so dreadfully weak I cried at nothing but I went back to school.

Mildred came to school she said "Good Heavens what's the matter Motor?[86] You look awful."

"Flu has taken it out of me. I've got a tonic now & will soon be right." But I dissolved into tears.

"You need cheering up and some fun," said Mildred. "We are off to the country for a week then you must come to us. We'll do theatres & cheerful things." Before the week was up I fainted as I reached the top of the long stair at Bulstrode St. and fell to the bottom. I was bruised & shaken the next morning I could not sit up without vomiting. I wrote Mildred & tried to cancel my visit. I felt too ill, but she would not take no and two days later I was there trying to force myself to go back to school with Mildred.

Her mother said, "Little Motor I want you to do something for me. I want you to let my Doctor see you."

I protested but the Dr. came and that night I was terribly ill. It was all a confused horrible nightmare of Doctors & nurses & comings & goings. Dear Miss Cole's[87] soothing hands and the glacier of beautiful cold as Mrs [Crompton] Roberts hand closed over mine. There was the dead stop of the outside world as the traffic crossed over the straw in front of the house and then the roar went on again.

My life was like that, a great piece was cut out of it. After six weeks I was moved to a convalescent home by the sea. I thought it was going to be splendid but it was not. It was all new paint the smell and glare made me sick & the nurse made me sicker. She talked of nothing but the German royal family their pictures were all round and she kissed them she had nursed twin babies in the royal family somewhere in Germany. She dragged me round and insisted I sit on the glary sand in front of the glary sea which created a torment of headache. The only trees in sight were two stunted old willows in a lane nearby & when I could elude her I stole away & sat in their Shade. I wanted trees & shade more than anything else in the world.

"Morbid very morbid" said the nurse. I pretended I was much better than I was just to get away from her.

Mrs Redden & Fred the Mortimers, Mr Ford,[88] Little Kendal, and Noel's Mother all had made constant enquiries at Belgrave Square but I was not allowed to see anyone. But Noel's mother said I was to come to them as soon as the Dr would permit. "You will soon get well in our garden with my three boys waiting on you" she said.

They lived at Weybridge. I felt my eyes and cheeks burning with fever while that fool babies nurse stood there saying "Such a splendid color we've given you." I collapsed like an empty bag when they met me. It was all to go through again & the relapse was worse than the original. One morning she told me that my sister Lizzie was arriving the next day from Canada.

Sickness, 1902

Lizzie Arrives

"OH WHY ISN'T IT ALICE?" I wailed.

Lizzie & I never did hit it off. She was a very very good woman religion sticking out of her everywhere. She pierced you with sharp little darts of it incessantly. She was much distressed at my condition and wished to read the bible and pray with me all day. She fetched in a miserable curate & had prayers offered for me in the local church. The curate was insufferable and actually seemed disappointed when he said we prayed for three last Sunday all are recovering.

"I 'spose he was counting on the funeral fees" I snapped.

Lizzie was herself on the eve of a nervous breakdown they had sent her thinking the change would brace her. She really was not fit to come. Afterwards she took up nursing but in those days she was quite tactless with the sick. She would creep up behind & suddenly place cold clammy hands on your forehead. She got between my friends & me playfully pretending she was humouring a cranky invalid. What made me really angry was the Hipocracy of making out that we were utterly devoted sisters & kissing & fondling me which I loathed and which was not natural to either of us. When I refused these caresses she was so hurt she would race off to London and be gone hours over time while I was in a fever of anxiety thinking she was lost or run over which was none too good for me and made me hateful if

relieved when she did come in safe and sound. She was desperately home-sick there was more illness at home she tried to hurry me well by fussing and called the Dr a fool in not allowing me to travel. All between us was very very uncomfortable we moved from one part of the county to another. Richmond, Hindhead anywhere except London which the Dr forbade.

I got Lizzie a front seat for the Coronation[89] and she saw that. I am afraid it was really a horrid time for Lizzie and if she only would not have acted up to that beloved pal idea it would not have been half so bad. I did not care if people thought me a crank, or not but I did loathe the hypocracy of pretending all the love and devotions we had never indulged in and I stuck up stark like the pole of a hugging scarlet runner. When we were alone she cried & scholded. She disapproved of my smoking & playing the card game of patience. She urged me to make up my mind I was fit to travel and quarrelled with the Doctor for saying I was not. Those in the boarding houses thought her a saint & a martyr, in their presence she bantered & humoured me playfully. I made no headway.

Doctors

THEN WE HEARD MR LAWSON[90] our guardian was coming to England & I made up my mind to act. First I went to see my doctor who was as firm as ever that I must not travel home.

"Dr." I said "my sister is very anxious to get back she says its all stuff & nonsense I could if I made up my mind about travel."

"Your sister—" Dr. Viney[91] frowned furiously. [Lizzie] had been antagonistic to my Dr & nurses from the first.

"If you go it is on your own head & hers." Any violence like seasickness and—I'd die. Or be permanently paralyzed. My right arm and leg had lost all feeling.

"Suppose I go and see a London specialist that would satisfy her."

"And me too," said Dr Viney.

I said to Lizzie "I am going to make a trip to London." We were staying in Richmond.

"Do you think you should?"

"Otherwise I would not suggest it."

If I had said I could not go up to London her reply would have been "Why of course you can if you make up your mind to it."

I told her I was going to see the Nurses at the home where I had my foot operated on[92] and suggested she go to the London shops which she loved. I wrote to Nurse Hill[93] asking if she would take me to the specialist.

The specialist[94] corroborated all Dr Viney had said. His careful examination took one hour. I was very tired.

"One thing more," said the big man. "Who is looking after you? Have you people in here?"

"One sister and she's driving me silly."

"Ah! I suspected some irritation." He looked at the nurse. "That must stop."

"She is very good to me but she fusses dreadfully" I said feeling very mean.

"She'd fuss me into my grave in a week" remarked the nurse. They seemed to forget me and discussed ways & means and decided that Sunhill Sanatorium[95] was the place. Open air good feeding & quiet.

"Send your sister home and settle down for one year's rest and absolute quiet no work, because you are young that should do it—otherwise—."

A year seems so long at 22.[96] No work! It seemed such a waste I had struggled tooth & nail to earn for the period of study away.

The guard had shouted "All Aboard" before Lizzie rushed gasping onto the platform.

Hurried & fussed I boarded.

Nurse Hill leant forward. "That," she said "is the worst thing possible for your sister."

Lizzie gave her a mind your business look. That night when I told her what the Specialist said she was in a white fury. She would not be sent home leave me alone she did not believe the Doctors but she was not giving up her job she'd stick beside the difficult "me" till she dropped in her tracks, forsake her duty? Never!

Mr Lawson & his wife came. I put the story before him he was like a father to us. He blew his nose and wiped his eyes very often during our interview. Sorry for both his guard children. "The thing is to get you well child."

"What about Lizzie? What about money?" "We will use principal if need be and I will talk it out with Lizzie." I hugged him.

Lizzie & I were lovely to each other when it was all thrashed out. She took me down to the San & saw me settled. She really was glad to go home but what people thought at my being left over there ill and alone concerned her very much.

"Hang! Why worry about peoples thinks, Liz?"

But Lizzie cared a great deal about what people thought. She could not bear my English friends to think her unloving or neglectful. She had kept up that sentimental maukishness of kissing and playful humouring which was not indigenous to our home life and thrown in all the "dears" and kissing indigenous to English homes. It was a fraud and did not work. Now that she was off I could throw my arms around her with very real affection and say "I love you furiously when the land and ocean are between us. I s'pose its touch-loving I can't stand. Sorry!"

Sanatorium

IN THE SANATORIUM we lived by rule disburdened of all responsibility even of the care of our own bodies. As near as possible you became a vegetable sun rain & snow fell upon you. The coming of day and night, feeding & being washed. The past—the struggle of work got dimmer & dimmer, till it was a gone dream. There was only an uneventful forever and forever ahead.

When I was first ill the fever of work obsessed me. The Dr forbad me to talk or think of it. I never had talked much about work. My own people were not particularly interested. They had never asked about it in their letters. They were totally indifferent except that studying from the nude was to them nakedness & scandalous. I doubt for the 3 months she was over my painting was never mentioned between Lizzie and I. The environment at the San was certainly not artistic. The whole thing lay dead in my soul.

The surrounding country was meekly lovely. There were small patches of woods which could not help but be lovely pretty bits that soothed one's hunger after the starvations of London like pretty little cakes but failed to satisfy one who craved the strong meat of western forests. The English birds were a never failing source of pure joy. I devised a scheme to take some out to Canada and was permitted to hand rear some from the nest. The San was open air. It was really a T.B. institution tho they took cases like mine where the treatment fresh air quiet & feeding were the essentials.

I was in the San for 18 months.[97] Every thing in me dormant. Then when all the ambition to work had been smothered out of me I was allowed to return to work, but ordered to keep away from cities, London in particular and I went down to Bushey again. Returning to work after the long dormant state was different to what I expected the shock of solitary independent life

after the sheltered protection of the San nearly knocked me over. I was weak. I took lodgings with a kindly woman but I cried steadily for a fortnight for no reason at all. The classes were not open. There was no one I knew. I wonder what Mrs Lewis[98] thought seeing me cry, cry, cry, the weather was wet. I could not walk far. After one week utterly exhausted from tears I plunged—I got a book and in it wrote and illustrated a ridiculous skit on the San Treatment. The tears were teary down my face all the time I was doing it. I sent it to the little woman house Director at the San. Everyone thought it was very funny—they went into fits of laughter. All but the little Doctor. Afterwards she told me it made her cry. Anyhow it served the purpose of bringing me back to work & filling in that ghastly two weeks before Mr Whiteley's studio re-opened.

Mrs Redden came from London to see me and Mrs Mortimer.

Dear kind Mrs Redden who had paid me occasional embarrassing visits at the San making such awkward remarks about the patients in her penetrating whisper forgetting that this was not London with its rumbling roar but a place of clear air and open windows.

Dear Mrs Redden who in answer to a request that she would purchase me some flannel nighties as the cold nights gave me rheumatism in my hips herself made me two pairs of shapeless pantaloons out of harsh scratchy flannel. They had neither back nor front and sitting meant splitting. They were cut for straight out & rigid. My nurse was so convulsed when she saw me in them & I so uncomfortable that I thanked for, but abandoned the pantaloons.

"Canada again"

AFTER 5½ YEARS ABSENCE from Canada I leant on the deck rail watching the last of the British Isles be sponged out—the Irish coast. A voice at my elbow said, "Your home too?"

"No oh No!" I said & looked up at a nice Irish boy.

He said "Pardon, It's mine. I had an idea it was yours."

"Why?"

"Eyes and voice" he replied.

"I'm going home" I said "—to Canada."

It is good that there is the great ocean between England and Canada the violence of the jump from one to the other would hurt. Of course there is

Carr stopped at the home of her childhood friend Edna (Green) Carew-Gibson in the Cariboo, en route to Victoria, and there began to ride astride a horse rather than sidesaddle, as was conventional for women, 1904. Photographer: Archibald Murchie. I-51569.

[the] rest of Canada to go through as well before you come to B.C. on the west coast but Canada clear aired & big from the moment you go up the rushing St Lawrence. I never tired of staring, absorbing from the train window.

The immensity of the prairies yawning in [the] Centre of the continent the great spaces the little homesteads, and all the time the train rushing shaking jogging & shunting so different from the contented smooth purr of the English trains.

Loathe to go to bed tho' I ached with weariness because in the far distance the blue hills were showing come daylight I'd be in the Rockies with the whistles shrieking round the curves & waking the silences between peaks purple Mountains black trees against snow awe inspiring loneliness measured itself in my mind against the awful loneliness of being in a London crowd. Vancouver & the end of the rails. The fine new Ferry steamer *Princess Victoria*, just out from the old country for the C.P.R. meeting the train the Leaving of the North American Continent and going a step beyond—last bit of land before launching out into tremendous Pacific. Vancouver Island with its little old town Victoria B.C. the first generation of its people superlatively English, the next British, the succeeding generations British Canadian whose children would be Canadian British.

Some things had grown bigger—some things smaller during the 5½ years of my absence the beach & the woods were grand as ever the Beacon Hill Park a wild place with a hill in the middle & the sea below was a stone's throw from our old home. I went into it & breathed & breathed till the last vestige of London was cleaned from my lungs.

There was a lot of re-adjusting to do in myself. Readjustment from invalidism to health readjustment in living readjustment of work over which I felt bitter.

"Canada Again," 1904 to 1910

A Move to Vancouver

THOUGHT I had not learned very much not one half what I had intended to absorb. Once I got into the old country where the opportunities would be so marvelous, where everyone knew so much & had so much history behind them. I was going to learn wonders from these old world people things that I could never learn in our crude West. I came back with a small bundle of weak tired endeavours [under] my arm. Thwarted from the first by bad health & circumstances, disappointed in England, disappointed in the English, I had accumulated reticence & bitterness of soul. The English Artists taught to make a living & lacked inspiration as the Preachers of England in those glorious old churches lovlied by age preached to make a living.

Doctors had said don't work don't think. Suddenly I was aware that the fierce love struggle[99] that had gone on in me for years was dead. I had strangled it after hopeless struggle at last and was glad. While I lay in the sanitorium I had said die, die, die, and at last it had died. It had safeguarded me from many lesser loves & made me suffor furiously. I rejoiced that it was dead at last. But my work the deadness of that was a different manner that must wake again.

I expect I was very cranky & disagreeable in the old home. I had acquired many new habits that they disapproved of very strongly. During my illness I learned to smoke the Doctors approved. They said "In moderation it is

soothing to the nerves" and helped to pass the long dull days. Girls had scarcely begun to smoke in Canada then. It was considered fast & vulgar. My eldest sister[100] forbade me to do it in her house. "If you must do so low a thing go to the barn & smoke with the cow." So to the barn I went to the old hayloft studio. And I went to the woods & beach with my dog. Illness England & love had bruised & deadened me underneath though I did acquire a thin crust of gaitey.

I also used plentifully the lesser swear words, words contained between D-N, which angered & distressed Lizzie beyond measure she had never forgiven me for sending her home, and now my irreligious attitude aggravated her indignation against me.

Alice was entirely preoccupied by her private school and went with a set of youngsters who bored me to tears. My greatest pleasure at the time was a beautiful thorobred horse which my oldest sister owned & allowed me to ride. I scandalized Victorians by being the first women there to ride astride & took long solitary rides. The girls that I used to ride with as a child were both married one lived in Africa one in the Cariboo.[101] I made no others after a year at home during which I returned to normal health. I was offered a position as teacher to The Ladies Art Club in Vancouver.[102] For some time I had considered opening a studio in Vancouver so I went. I hated teaching the Ladies. The club was a purely social affair they met twice a week & had a model they dropped in at class at all hours. One lady always late would re-pose the model after we had already been working an hour. Because I looked young and many of them were middle age society dames they scorned my lessons. "You may look at my work if you wish but I do not care to take your criticism thank you" said one. At the end of the month they dismissed me.

The lady instrumental in getting me the post was an old Victorian. She laughed heartily.

"Millie dear" she said "they all had the same complaint against you."

"That was?"

"That you wanted to make them work seriously & would not recognize they were a group of society ladies killing time."

"Thank you for telling me Mrs Keith[103] the cause of my dismissal I take as a compliment" and was very glad to be rid of them.

Children's Art Classes

THERE WAS ONE young American woman in the Ladies Club who was exceedingly kind. She was a new comer herself so had no standing in the club. She did however want to work she had a little girl of 10. They both came to my studio for lessons. The little girl "Ruth"* told others and soon I had a delightful class of young children. Many of them belonged to Miss Gordon's private school[104] and in self defense Miss Gordon after having turned me down when I applied to teach drawing in her school got me to take special class in her school. I made a success of teaching.**

I lived in one & another of the very miserable boarding houses which were all Vancouver boasted of and had two good rooms on Granville St. for studios.[105] I was very happy in my work and had all the pupils I could manage. I kept away from adults as much as possible, working with children. The studio was a happy place. I had a happy hearted Scotch girl for pupil teacher she helped with the very little ones & kept the materials. The rooms teemed with life & laughter. There was a big old sheep dog Billie & two parrots Jane & Sally a pair of bullfinches and the white rats Peter & Peggie with offspring innumerable. We had wonderful sketching classes along the waterfront the cocatoe & Sheep dog went along. There were competitions & exhibitions, good pupils and bad, even now with me at the age of 67[106] those pupils write to me & come & see me when they come to Victoria.

Cockatoo, Parrot, and Rats

THESE YEARS in Vancouver were of very vital importance to my work, a summing up of what S[an] F[rancisco] & London had taught me and a fresh seeing of the West. I began to sense a glimmering of something beyond objectivity to think of things as doing as well as being. In my teaching I was using this method as well as in my own work, my baby classes started with crude little illustratings of nursery rhymes in which what the people did was just as important as how they looked. It scandalized the old fashioned grown ups but delighted the young. We had exhibitions every three months

* See plate 13.

** See plate 14.

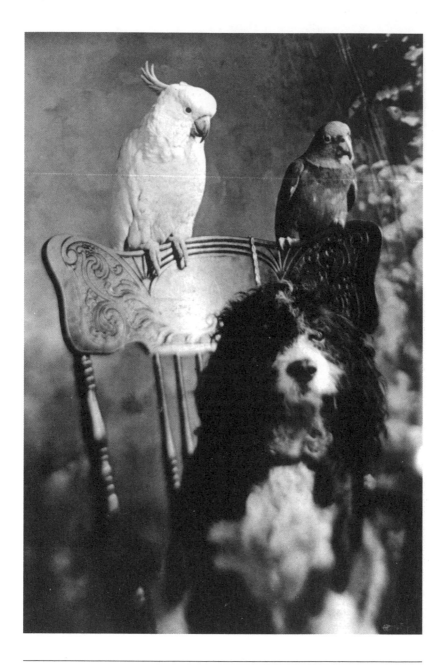

Billie the sheepdog, Sally the cockatoo and Jane the parrot, Vancouver, 1910. The photograph was taken just prior to Carr's trip to France as a memento to take with her. She boarded Billie with a friend in Edmonton and the two parrots with her sister Edith in Victoria. F-07888.

which were thronged with parents & friends. I took my classes out sketching along the water front. Billie the big Sheep dog and Sally the white cocatoe went long everybody was very happy. Men & women who were children in these classes have kept bobbing up all through my life & to see [them brings] happy memories.[107]

Children came and went to [and] from the studio all day. They raced up the long uncarpeted stair. Sally and Jane the two parrots screeched & dithered only once was there trouble from the landlord re the creatures and that was one Easter when I went away for a week & left Sally the cocatoe in the studio where a friend looked in twice a day to tend her but Sally got lonely and sat with her beak wide screeching all day. The landlord said she was the curse of Granville St & must be got rid of but I promised never to leave her again & good fellowship was restored. The rest of the upper storey of our building was occupied by offices—a man we liked & a man we did not and some large rooms down the far end occupied by the mens conservative club. Funny old men went in and out [of] a glass corridor and the stair way shut them off. Stranded old men were always sitting round. They snatched at any entertainment loved me to put the parrots in the sunny hall window so they could hear them talk and did their best to make up to Billie the sheep dog. Gravely polite old Billie refused to be enticed into their rooms. As I could not give Billie the exercise he needed it was my custom to take him wherever I went. I taught in the private schools, a block before my destination I turned & said very firmly "Billie go home." Inevitably the dog turned & made all speed back to the studio whose outer door was always open. He opened the swing doors on the stairway himself and there at the stair head he sat watching for me. He allowed no stranger in the studio during my absence.

Peter & Peggie* the white rats slept most of the day but in the evening when the building was empty & quiet they wandered at will. If they wandered too far I sent Billie in search of them his method was to find them and lay a great paw gently on their backs for a second then he turned & walk[ed] gravely back to the studio the rats always following. One night however Peter got venturesome and one of the Conservative gentlemen brought him home by the scruff with a chuckle. He said "Is this yours? I found it in our waste paper basket."

* See plate 15.

The creatures were as much a part of the studio as the pupils & myself they all had jobs. We drew them played with them loved them. Belle the pupil teacher was devoted to them as also was the old janitor Chinaman.[108] I could never understand how Sally got a black spot below the crest on her snowy head till I came in one night to find old John sitting on the bench beside the cocatoe with his grimy hand rubbing & rubbing. His ugly honest face looked a little embarrassed.

"Take me long time work. Now Sally come."

"Does she scatter her seed too much John?"

He shook his head. "Every night no more people stop."

"He put down head and say scratch scratch. He heap like me."

At first Billie resented John's dusting. One night [when I] ran in unexpectedly I found John cutting up a new loaf of bread which Billie was gulping in chunks.

"I buy for Billie" he explained. "Him kind" pointing to the pointing to the sack of dog biscuits "Willy hard."

We received a warm welcome when we reopened [the] studio after summer vacation. They said they missed a woman around the building that janitor John got slack about the cleaning etc. and that it was "awefull quiet without the birds" & they missed Billie.

I threw myself heart & soul into teaching, the children were delightfully responsive.

One day a delegation from the Ladies Art Club which I had taught for one month called on me.

"We were wondering if you would consider sharing your studio with the art club."

"Or rather," corrected the other lady "if you would give up your studio and halve the expense of ours, which is only used it two days a week."

"And—" said Lady no. 1 "for our social gatherings of course."

"The room is better located than this of yours."

"Thank you" I said "the idea is not workable. My studio is too buisy."

"The social prestige of the Ladies Art Club would be of great value to a new comer."

"Without the prestige I have as much as I can do. That is a class coming upstairs please Excuse me."

"Goodbye" shouted the cocatoe.

"You old fool" croaked Jane and both birds burst into a chorous of laughter.

One day I had a call the fourth in two weeks from a Parson who had a boys school in North Vancouver.[109] Three of his boys wished to take drawing lessons but I could not spare time for the long journey across the ferry for only 3 pupils. There was also a girls private school in North Vancouver and they also wanted me to go over once a week to teach three young ladies.*

"Amalgamate" I suggested

"Impossible!" said the Lady.

"Madam my boys are not permitted to mix with the fair sex in their studies."

"They could sit on different sides of the room" I suggested. I could not make the trip to Vancouver & the light after school hours was too brief for one class to follow the other. The School marm wrote about it every 2nd day the parson called twice a week. I was tired of them both.

"The boys parents are desirous that they shall be instructed in art— Tuesday afternoon perhaps?"

"I have seventy five pupils Sir. Madam Beardsley is anxious for her three girls to have lessons too. Amalgamate & for six pupils I will arrange to come across to the north shore once a week otherwise they must come here."

"Please excuse me sir, but you are sitting on the rats."

"Rats!"

"They sleep under that cushion."

The Parson bounced up & off. To show him I was not fooling I waved Peggie over the bannister as he flew down the stair. I never saw him again.

Victoria Visiting

THERE WAS ONE THING that troubled my otherwise busy happy life. I got so little time for my own work—or did I? Wasn't I constantly rummaging among the accumulation of oddments in art that I had collected in the happy go lucky Mark Hopkins school, the uninspiring Westminster grind, the calm sweet of Bushey and Boxford, the salty tang of St Ives and perhaps not least in its lessons the plowing & lying fallow of three years invalidism.

At Xmas time I packed the parrots in baskets, the bullfinches in one cage, Peggie & her offspring in another with Peter hanging from the top

* See plate 16.

tied up in a stocking. A little gold fish in my bag and Billie chucked below decks I went home.

Enroute the Lady in the next chair to mine had rocked the observation room with a screech when out of an innocent looking wicker bag between our chairs had popped a snow[y] head with full yellow crest and a very sweet voice said into her stocking bag "Hello! Sally's a Sally." I rose in embarrassment & took my bags & blankets out on deck. Presently a man tapped me on the shoulder.

"Does it belong to you?" pointing.

There flopping violently on the deck was the handsomest of my two gold fish. The fool had kicked my bag containing the jar of water. I hurried the fish back into the empty jar & rushed for the washroom. When I returned with my handbag tied on the top of the wide jar Jane was laughing diabolically and people were looking at one another. Everyone thought everyone else could not be quite right & nobody suspected the innocent looking basket under my seat. Finally we got to Victoria & I unchecked the Bullfinches & rats from the Petty Baggage & Billie from below decks & there was my sister waiting with the old horse Renie & the chaise. Lizzie looked extraordinarily down when she saw all the creatures [for] she was our anointed housekeeper. Peter the rat tied up in the stocking so that he would not eat the coconut shell full of babies was the last straw & I hustled everything except the dog who was not allowed in the house and the parrots who were only allowed to sit on the kitchen chair up to my bed room.

I frequently ran down to Victoria for a Sunday & contrived to leave all the creatures except the cocatoe & Dog for one night. Because of the time I left Sally and she had screamed for a week & the landlord had threatened. The return boat sailed at midnight. Alice always came down & saw me on board though she was often very tired & I begged her not [to] and when I was once on the boat it never failed that I looked across the little harbour and began to cry. I don't know what I was crying for but I always had a hard cry on leaving Victoria though I was very happy in my Vancouver work. Perhaps Vancouver was more cityish & there was less freedom. On one of these returns it was a very stormy night. I checked old Billie [in the hold]. At the gang plank I said goodbye to Alice, the porter carried Sally & my bag aboard there was no sleeping accommodation to be had except the top bunk in a 3 berth room. No 2 was getting undressed.

"I'll wait outside till you are in bed," I said. I felt the cry coming on. I put my bags under the sofa. "If that bag squirms do[n't] be alarmed there is a parrot in it."

Even in harbour everything was banging round. I sat in the salon & they brought a woman on board with the keepers. She was mad & going to the asylum. She cursed & swore & cried. They took her into the room next [to] mine with difficulty. Then an old man came along on his wife's arm every few moments they had to stop for him to cough & get his breath. This couple had the room on the other side of me. I had a time climbing into the top berth & carry[ing] Sally's basket up with me. I was afraid to have her on the floor and No 1 berth had not yet come in. I took off my leather belt and strapped Sally's basket to the wooden embroidery along the top of the room to keep the basket from rolling off, finished out my cry & went to sleep for a brief while but the going out whistle and Sally saying in my ear "Sally is a Sally" woke me. The wind was shrieking the crazy woman cursing & the consumptive coughing such a dreadful commotion and Sally got more & more emphatic that "Sally was a Sally" tho I kept touching her basket & whispering "shut up."

Then below I heard an angry "Tech! Tech! As if there was not row enough but that woman in the top must talk in her sleep!" No 1 called up to No 2. Number 3 suddenly realized the cocatoe was cold. I unstrapped the poor old bird's basket & tucked her under the coverlet but the cursing & coughing of our neighbours kept up all night.

Alaska Holiday, 1907

"YOU AND I ARE GOING up to Alaska," I wrote Alice "not the rush round tourist ticket either. We will spend two weeks one at Skagway & one at Sitka."

When the holidays came we went off. It was a grand trip. Alice had not been well & it did her a world of good. We kept a diary called the "funny book" every evening I drew a skit of something that had happened that day & we wrote it up. In Skagway we were introduced to a "Pole" Domlarmus Muchtulous[110] he was customs or emigration or something. He was in Sitka during our visit and took us about, we climbed Mount Verstovia with him and got lost came down hours late totally the wrong side of the mountain, nobody knows how we ever did get down it wrecked us for days.

It was in Sitka I first conceived the idea of painting Indians[111] & totem poles. I made a few slight sketches, an artist by the name of Richardson[112] who was summering in Sitka saw them & praised them highly. He said his were not so good as mine and he sold them in New York. I had always love[d] the Indians. I said to myself:

"I shall come up every summer among the villages of B.C. and I shall do all the totem poles & villages I can before they are a thing of the past."

That was exactly what I did in the years that followed. Every year in the summer holidays I went north. It cost a lot of money but I felt it was worth while & I worked very hard.*

Alert Bay, 1908

I WENT TO ALERT BAY.** I boarded with missionaries and worked very hard my drawings were very authentic. I thought "Now this is history & I must be absolutely truthful & exact" & I worked like a camera. Dr Newcombe[113] who was a great authority on Indian stuff came to see my things. He bought three and said would I mind his comparing them with his photos of the same poles and possibly adding more detail. "The camera can't take artistic license" he added. But when we came to compare there was not a single correction my sketches gave a clearer interpretation than the photographs there was however one bird which lost a wing between the time of his photo & my sketch and this I painted in for him. I think my art owes more to the Indian totem pole than to Westminster School of Art. Drawing poles taught me directness & accuracy, drawing in the Indian villages also taught me to sum my material up quickly and go for what I wanted. Sometimes I had to hire men & canoes to take me to the places. They charged $10.00 a day for hire of boat man food & everything, it was one half what they charged surveyors & sportsmen but I could not afford much of it. The work was exhausting & the travel hard but I worked with a terrific zest loving <u>the</u> people places & material. This all seemed so worth while, completely in harmony with each other too. Little things like discomfort or horrible smells did not gall you like drunken landladies

* See plate 17.

** See plates 18, 19 and 20.

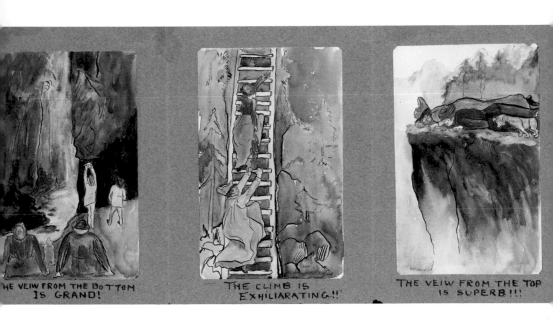

HE VEIW FROM THE BOTTOM IS GRAND!

THE CLIMB IS EXHILIARATING!!

THE VEIW FROM THE TOP IS SUPERB!!!

Plate 17. Triptych with Carr's titles "The veiw from the bottom is grand!" "The climb is exhiliarating!" "The veiw from the top is superb!!!" Carr (in light-brown jacket) possibly with artist friend Theresa Wylde (and a dog). "Miss Wylde, the English artist who has recently come to Victoria, is planning to go on a sketching tour, in which she will be accompanied by Miss Carr, a well-known artist of Vancouver," *Daily Colonist* newspaper, July 14, 1909. Emily Carr, ca. 1909. PDP06083.

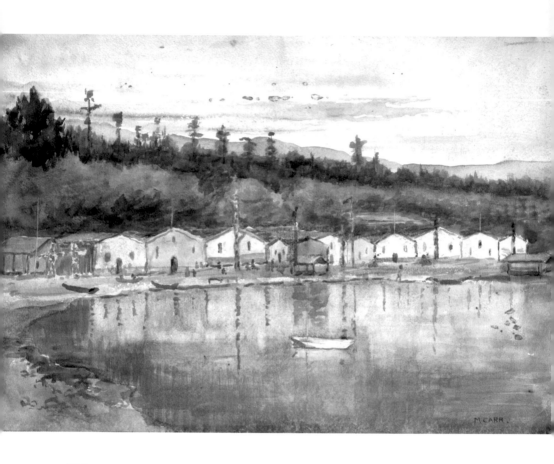

Plate 18. Yalis (Alert Bay). Emily Carr, 1908 or 1909. PDP00618.

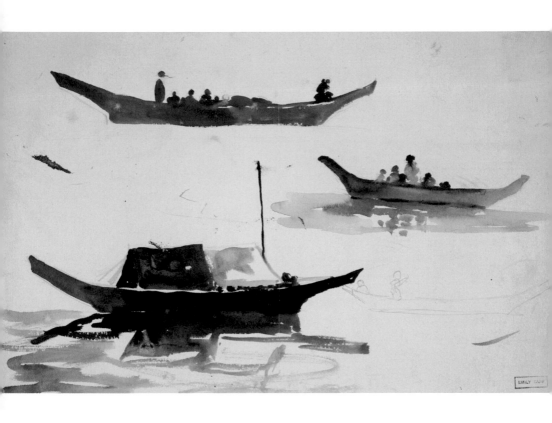

Plate 19. Canoes. Emily Carr, ca. 1908–1910. PDP00923.

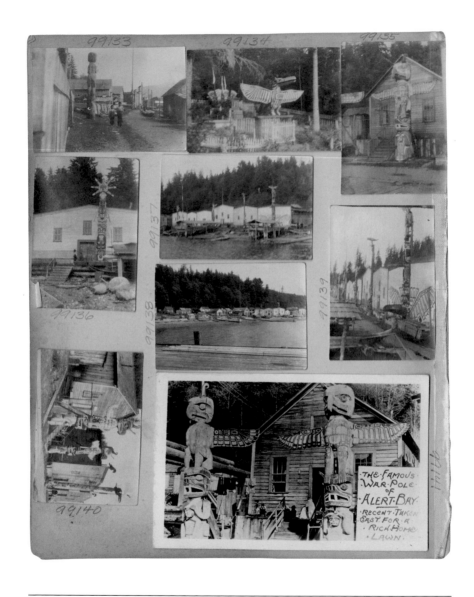

Plate 20. Page from Carr's photo album showing photographs of Yalis (Alert Bay, BC). 198011-002.

Plate 21 (facing). Woodland scene, given by Carr to Hannah Kendall. Emily Carr, ca. 1908–1910. PDP10276.

Plate 22. Street scene, Capilano Reserve on the north shore of Burrard Inlet. Emily Carr, 1905–1908. PDP00656.

Plate 23. View along the beach at Sechelt. Emily Carr, ca. 1906–1909. PDP00648.

EMILY CARR

Plate 24. Kispiox, Skeena River. Emily Carr, 1912. PDP00606.

Plate 25. Eagle rug, hooked wool on burlap. Emily Carr, ca. 1918–1923. PDP01540.

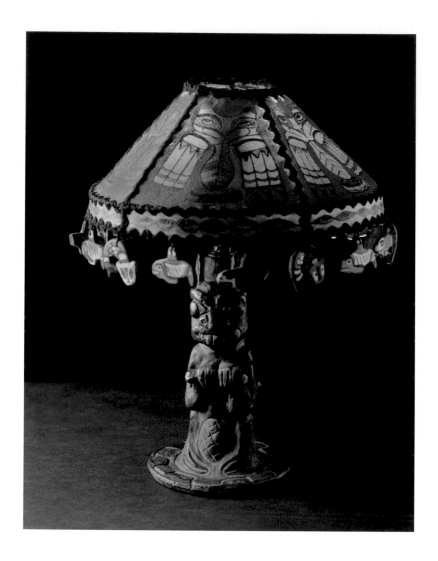

Plate 26. Carr also created hand-formed pottery pieces for sale. Table lamp and shade; hand-formed pottery base, decorated fabric lampshade and pottery ornaments. Emily Carr, ca. 1918–1923. PDP05255.

Plate 27 (facing). Carr's title is "Naas River Pole." Emily Carr, 1928. PDP00935.

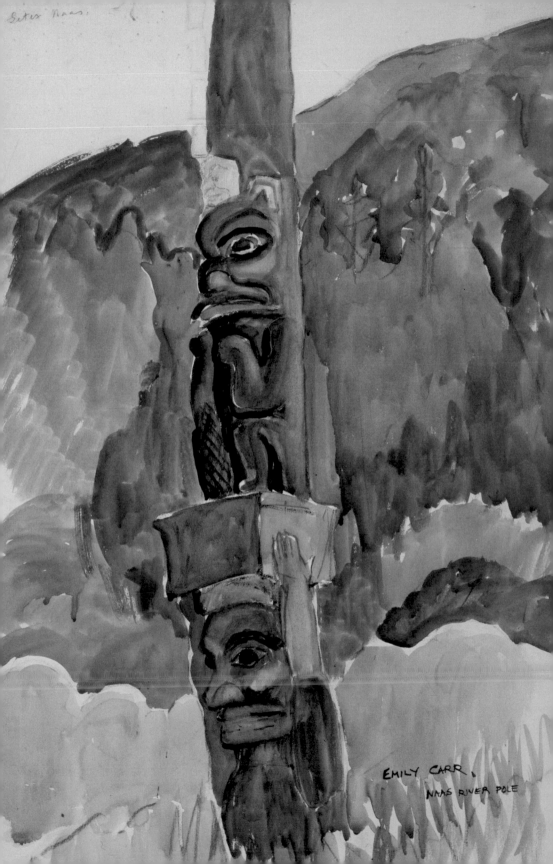

Gitex Naas

EMILY CARR.
NAAS RIVER POLE

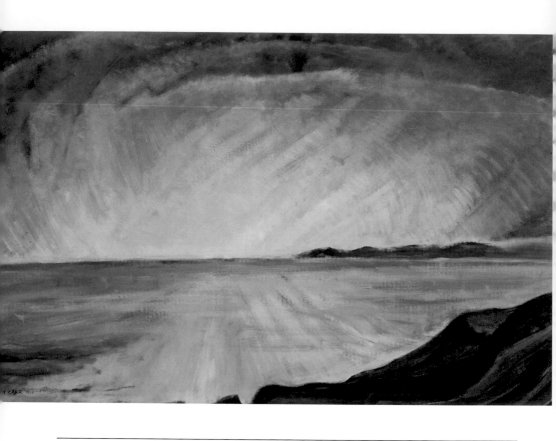

Plate 28. *Sea and Sky*. Strait of Juan de Fuca from Dallas Road, Victoria. Emily Carr, ca. 1933. PDP00545.

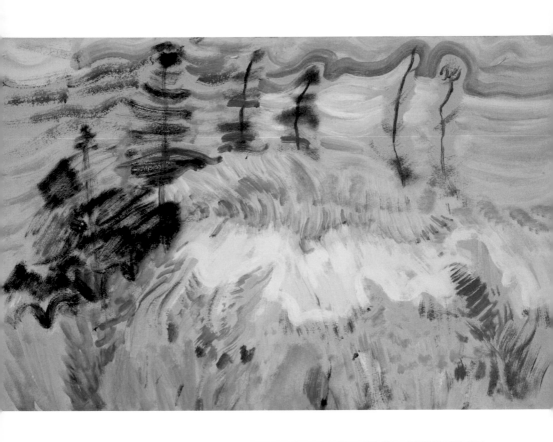

Plate 29. Carr's title is "Pines in May." Reportedly in Armadale woods. Emily Carr, 1938. PDP00543.

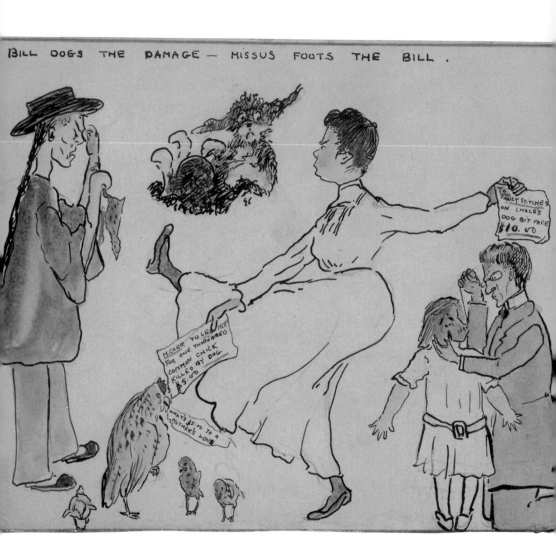

Plate 30. Carr's title is "Billie's Badness." Emily Carr, ca. 1906–1910. PDP09020.

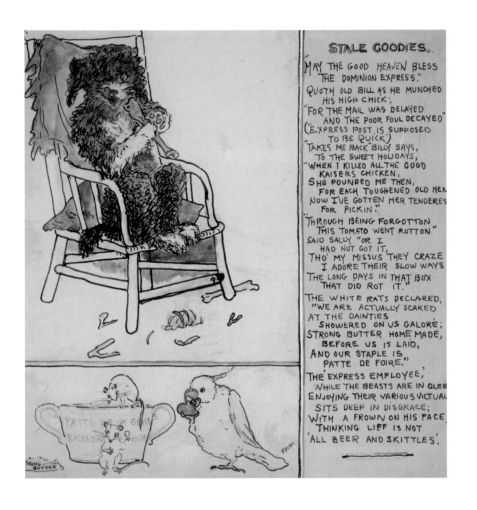

Plate 31. Carr's title is "Stale Goodies." Emily Carr, ca. 1906–1910. PDP09013.

Plate 32 (overleaf). Coastal settlement and wharf. Emily Carr, ca. 1929. PDP08744.

and the repellant hardness and suspicion of great cities. Here it was as if everything hugged you. There everything hurt. I came back to Vancouver after these trips dark skinned & salty & always with some bit of wild life in tow. A baby racoon a vulture that I reared from the nest, a squirrel or a crow. The creatures did not seem to mind coming to live with me.[114]

Stanley Park Sketching

A BIG IDEA was rising in me out of the dawn of nowhere. Whenever I had any spare time and on Sundays I used to go into Stanley Park which was very big very wild & very beautiful.* My friends did not think I should go into the dense jungley parts of the park suicides & queer things happened there at times but it was the places far off from people & houses that appealed to me & I took Billie and went. Billie would not allow any doubtful character to come near me. He had a tremendous growl. There was a horrid smarty man once who poo-pooed Billie's growl. He ordered me to call the dog off but I ignored his demand & left the whole affair to Billie. I was down a lonely trail the dog stood on the great log fallen across the trail & warned Smartie made to defy him & Billie flew at his throat. I never looked up or spoke and the man turned and went away Billie at his heels till he was completely away from me.

There were seven immense Cedar Trees known as the Seven Sisters a trail led to these magnificent trees but all about except immediately below them was dense jungle forest never touched by man this was my favourite spot of all, the appalling solemnity majesty & silence was the Holiest thing I ever felt. I broke slightly into the density to one side an occasional few people would hurry down the path, stop look up at the giants. If they were men they would estimate in terms of lumber. The women said "Come on its spooky" and hurried out of the wood.

I was struggling with a painting missing the density missing the height struggling fiercely resentfully, at how tightly they cooled their secrets from me resentful at my foolish art humble & pleading before the great trees. I had had for my purpose to sit at the side of the open path. An American couple came by.

* See plate 21.

"Wal, wal, big ain't they! Enough fire wood to last a family most their lives. How many cords would you say Father?"

"Cedar don't burn good, reckon they'd be better as lumber," he began to calculate feet.

They saw me. "Wal wow picturing them eh." The woman slumped onto a fallen log. "We'll set a spell Hiram & watch her."

Billie growled a little. Deliberately I picked up my canvas and turned its face to the easel—Rude I know but I was not going to be a pass time for that tree butcher.

"Guess she don't like watching. Come on Pa."

"Thank you," I said.

She looked as astonished as if one of the trees had spoken.

Sophie

SOMETIMES I FERRIED OVER to the north shore and wandered.* Oftenest I went the Indian reserve I had many friends there but the dearest was Sophie.[115]

Sophie came to my studio the first week of its existence. A heavy baby was bound on her back in a shawl a boy beyond behind her a little girl held her skirt. There was a great square basket filled with lesser baskets on her arm they were tied in a cloth. . . .

"Basket you buy Injun basket?"

"Halo chicamen."[116]

"No matter ole clothes good."

We made a deal that was pleasing to us both and which cemented our ever friendship. When I suffered from dilapidation of spirits I went across the Bay to Sophie's little home. There was always a new baby. Often there was a dead baby. Sophie's man drank, her life was walled about by trouble, but through the chinks & knotholes of the walls, shone the serene childlike sunniness of the Indian. The chaff of life surrounding the Indian ignites so readily the tinest, flimsy excuse sent us into bubbles of laughter. When I unfolded my campstool & sat in her house among a tumble of babies with Sophie squatting on the floor at her basket making, sometimes Susan & Sarah Sophie's two

* See plate 22.

friends would come and sit too and old Billie would cock his head gravely or wag his stump furiously when we giggled. Through the open door we saw Vancouver across the Bay, beyond Sophie's cherry trees in the back rose the majestic twin peaks the Lions crouched among the eternal snow.

When the other women were gone home Sophie would take her best skirt off a nail a very full creation in loud plaid with bands of black velvet tie a bright yellow silk handkerchief over her head and folded her hands over the fringe of her big shawl then we visited the cemetery where the tombstones earned by Sophie's basket making and marking the graves of her offspring nestled among wild roses & Brambles. She was so proud of her stones, patting them as lovingly as if the cold stone was a black haired big eyed babe. Then we came to the little Catholic church. I loved the little church with its two little square wooden towers and lazy little bell with the rope dangling just inside the always open door. The steps in front were wide. There was open space around the church the houses stood respectfully back there was a play ground behind. In front was a round band stand and the sea.

Sophie & I crept into the first, first dipping our fingers into a big shell that contained holy water & crossing ourselves. Lizzie would have shuddered but here it seemed right. Then we knelt beside each other in the silent emptiness. It was a tawdry little altar of cheap lace & paper flowers and the soft rich glow of candles which can never be tawdry.

The wind caught under the eaves and the wooden walls creaked, the pews creaked long crackling creaks. You could hear the waves outside & the pidgeons in the belfry but the silence was above everything. It seemed even deeper for the creaks. Coming out my heels sounded insufferable beside the soft naked pad of Sophie's feet. . . .

. . . Sophie always wanted to be "nice." Often if I asked why? She replied "Nice ladies don't."

"Sophie you passed my house yesterday why did you not come in for a cup of tea?"

"I came last week."

"That did not matter."

"Nice ladies don't come to[o] often."

Sophie & I respected each others "being nice," our friendship was based on honesty and trust, we never pretended to each other. Many vails of necessity fell between us vails of race & creed in civilization & language each staid her side sensing the woman on the other. We were the same age. . . .

. . . When I left Vancouver Sophie cried bitterly. She said "I love you like my own sister. I love you more because she forgets [me] sometimes you will never forget." I felt it a tremendous thing to be accepted by an Indian like this. I kissed [h]er goodbye.

"If you want me send word. I'll come."

She did and I went.

After Sophie had buried 20 children she broke & took to drink. Frank her husband had had the habit for years. Coming from Victoria to see her I found her drunk. The shock of having me see her sobered her, her shame and crying were bitter.

Even the disgust of the vile smelling liquor & Sophie dishevelled and wrecked couldn't shake my love for Sophie. It was a comprehensible love. Perhaps to me it needs neither defense or explanation. The people in the village called me "Sophy's Em'ly." She herself called me "My Emily" and so I was. She is dead now and the memory of her folded together with the little handful of things peculiarly mine.[117]

Moodyville Encounter

IF YOU TURNED right when you left the ferry instead of left and followed the shore road you passed a few ships a few scattered houses, went through a wooded road and finally came to Moodyville and an old saw mill.

You got an excellent view of the city of Vancouver which I decided to paint. My first off day I shouldered the canvas bag with my sketch stuff and lunch in it and Billie & I crossed early. As I entered the woody road I met some boys after passing them by a few paces I thought I might have asked if I was on the right road the woods were thick so I had lost the sea. I called as I turned.

"Can you tell me—" but the steps behind me were not those of the boys they had rounded a corner. A man there, close.

"Can you tell me if I'm right for Moodyville?"

Billie looked suspicious but my having addressed the man in an ordinary [voice] concluded all was well & trotted on.

The man said "This road is right. It is quite a bit on before we see the water." He fell into step & began to talk. I did not like having him there.

"Please do not wait for me. I shall find my way." He had walked swiftly while he was behind me.

"I am in no hurry" he said. The wood was rough & shady with dense growth on either side. It was very little used. Billie stayed by me close.

"Fine looking dog you have is he good tempered?" He stretched out a hand towards the dog.

"Not always."

The man said he had been out in that direction & lost his watch he was going back the vague chance of finding it. We came to a tent camp a woman was cleaning fish & the young man stopped & spoke with her. The sea was ahead I hurried on along but was barely seated at my work when the young man followed me. He threw himself down full length close to my easel, and lighted a pipe. I was angry. It was a far off lone some spot. I did not reply to his stream of conversation.

I began to cough. "Please will you go away. I dislike the smell of your pipe you are hampering my work."

He moved sulkily off towards the tent. I could see him talking to the woman and waiting waiting for me. Light was falling. I did not like thinking of that mile of woody road. On the way I had asked him "is there no road nearer the sea than this woody detour" & he said "No this is the only way below is all bog & swamp."

I slipped behind a growth of bush & so on skirting the sea by mud flats. It was terrible going I got mired & had to wade streams but all the time I was glad I had eluded the man and by and bye I came back to the road. He may be sitting there yet waiting to escort me. The next two days I was hardly recognizable for the passing[?] of the mosquitoes in the bog.

Sketching and Animals

I HAD NOW A LOT OF INDIAN PAINTINGS, they were largely water color & oil sketches. It was difficult going from village to village. I had to go by any means I could & stay anywhere I could. Sometimes in Mission houses sometimes in Indian homes sometimes in a tent or a logging camp, cannery or a tool shed, I took a camp bed & a roll of blankets and ate any where they would board me. I tramped & went in canoes & by waggon. Invariably I brought some strange beast home with me, once it was a baby vulture that I reared by hand, an unusual strange creature with a queer wild smell. I had my cocatoe & the sheep dog the trip I got the vulture. I picked him up in an Indian village he

had been stolen from a nest & forsaken. I brought him from the next of kin who argued "It is better I should have 50 cts than the dead bird of my brother."

That was at Sechelt.* I was going up to Buccaneer Bay to visit at a friend's summer camp. The little boat broke down outside in the Bay & my friend rowed out to fetch us we had been frightfully seasick. My friend reached the dog the cocatoe & the sketch sack into the boat but when the squirming sack was [a]board she said "What is it?" most curiously and I replied "A vulture."

She gasped as if [s]he were drowning. I had a little tent on a rock with thick brush all round. The cocatoe sat on the head of the bed. Billie slept under the bed. I was in it and "Uncle Tom" the vulture slept under the floor of the tent. Whenever I went Uncle Tom was at my heels when I went out sketching. The cocatoe sat on my shoulder the sketch sack was slung over the other & the sheep dog & vulture walked one each side. There was no meat to feed the vulture so we went down & dug clams & muscles for him. He grew into a great bird but he would not accept his freedom. I donated him to Stanley Park and when I used to go to see him he ran to me rejoicing.

Some of the men artists in Vancouver were angry because I was making headway and because my work was strong more like a man's than theirs. When the Art society gave exhibitions these men hung my pictures under shelves or on the ceiling.

A woman asked, "Why do you treat Emily Carr's work so?"

"Because it makes the other work look weak," they said.

I [went] right on my own way. I did not bother with the other artists or the societies and they got angrier than ever because I did not care. A plan was forming in my head. It took five & ½ years to earn my ambition. I was saving to go to Paris everyone said Paris was the top of art and I wanted to get the best teaching I knew. I was earning well and able to save as well as to take the Indian trips which I loved so much each summer. Alice was learning French of which I could not speak a word. She was coming too taking a year from her school.

* See plate 23.

France, 1910 to 1911

Departure

CAME HOME with squirrels, racoons, chip monks, crows. My sisters sighed and accepted it as part & parcel of my artist queerness. When it came time for Paris I had a big sorting out of live stock, parting with Billie was bad. I took him up to Edmonton and left him with a friend[118] I knew would be very good to him. My sister undertook Sally & Jane & was soon devoted to them, the lesser creatures were given to one & another. And off we went.

We determined first to see something of our own country, and stayed off at Banff, Lake Louise, Edmonton, Glacier, Sicamous, Medicine Hat, Calgary and Quebec. To Alice's calm nature the ocean trip was a delight to mine it was torture. We passed through Canada in the mid heat of Summer and shipped a trunk ahead with our steamer things. It was stuffed on the boat ahead of the one that we took by mistake which was very uncomfortable for us. And arriving in Liverpool we missed the boat train so that we might search for our mislaid trunk. After great deal of trouble it was located, & then we had several hours to wait for a train.

"Tell you what lets go to Crosses the great distributing house for animals & parrots," I said.

Alice frowned.

"Only just to <u>look</u>."

It ended in boarding our train with a box looking like a monstrous wedge of mild Canadian cheese. In it was an African grey parrot. Alice sighed.

"You left two at home you know," all the time she was fishing half the price out of her own purse.

"But it is so lonesome without one and you know it is the chance of a life time to get an African Grey."

We stayed only two days in London with Mrs Dodd's in Bulstrode St. & hurried on to Paris full of excited hopes for study & for seeing things.

In the grey of early, early morning the train crept through France. Seated in the corner seasickness still heavy on me I watched the villages glide by. Through my miser[able] body my spirit was thrilling wildly. A woman artist[119] had come to Victoria just before we left she brought a letter to me and in time she told me about Paris. She had a friend Harry Gibb she said he was modern. Far out in the West that meant nothing to me. In Paris it did. My sister & I took a small apartment in the Latin quarter in Rue Campagne Premiere off Boulevard Montparnasse. The concierge was terrifying and must be faced every time you went in or out the gate she flew out of her nest like a wasp. All the flats looked into a gardened court, scrupulously kept. The plumbing was primitive no bath, no heat except a difficult-to-manage cook range that cost Alice many a sigh.

Paris Art Classes

I WENT IMMEDIATELY to call on Harry Gibb.[120] He was a dour Englishman with a sweet Scotch wife. He had a beautiful studio overlooking a convent garden. They did everything in the one room and a poke of a kitchen. He had a queer twisted smile a disappointed man crusted over with hardness. When he talked I felt dreadfully embarrassed by all I did not know. And then Mr Gibb shewed me some of his things and even the embarrassment was crushed out of me. I had never imagined such things. His figures were extremely distorted and revolted while they fascinated me. Some flower & still lifes thrilled me with their pure color & interesting forms. I looked & looked & looked. It was practically the first french work I had seen.

"Please can you tell me where to start?" I said.

He advised the Colarossi Studio[121] as a place where the work was serious and the men & women students worked together. In Julian's[122] he said there

were separate classes for male & female students & this he felt was a draw-back for the women because you lost out in not seeing men's work which was stronger. I joined Colarossi's immediately.

Alice went with me to make arrangements because I could not speak French. I felt shy & foolish as I took my place in the classroom and as time went on I felt worse because no more women came into the class. There were a lot of men. I said to Alice I am sure I must be in the wrong place for after a fortnight I was still the only woman, and I made her go & ask at the office but they said I was all right more women would come by & bye. The master was French he waved and babbled but I had no idea at all what it was all about. I just went on working. One day an American man spoke to me. He said he had heard the professor say that English girl's work was good. I was very heartened. Next day I watched the American take a pen knife & cut the pocket out of his coat for a paint rag. I went to him.

"If you will translate my lesson for me I will give you a clean paint rag every day."

"Done," he said.

After several weeks a few women came into the class. They were grey haired kittens mostly who had nearly given up hope of being wives & look-ing for outlets. They did pathetically squiggly little drawings and giggled & goggled at the master in broken French.

I worked in the life rooms and also in the modelling class which I found less stuffy & exhausting. After hours Alice & I roamed about Paris delighting in its queer corners, its Parks & Galleries. She was taking French lessons. Not one word of French would stick in my head. I left all the talking to her. Conserving all my energies for painting. I began to feel myself going, going as I had in London. The close life rooms & the wear of the great city. We went often to the Gibbs. I dreaded going because I felt ignorant & silly but I always picked up some crumb of help & the more I saw of "Modern" work the more it took hold of me. At Mr Gibb's suggestion I left Colarossi's and went to a private studio. Fergusson's.[123] The air was better but Fergusson gave up his studio and I went then to a studio whose name I have forgotten.[124] A young couple ran the studio they were both studying themselves & certain artists came in to criticize. Mr Fergusson among them. I was happy here did good work and liked the students.

Different artists criticized month about. Soon Mr Gibb's turn would come round the students told me he was a very severe critic but he was

considered one of the best in Paris. Before his turn came I was in hospital with Flue aggravated by Bronchitis & Jaundice. I was very very ill. We belonged to a students club[125] where the students met for tea after work. They had a small lending library a small hospital and took conducted parties to see places of interest near Paris which was very much cheaper than going on your own. The Hospital was abominable they had only a couple of private rooms which were always saved for men students the women were put into a five bed ward; and I can scarcely imagine a more disagreeable place. It was run by Americans. With a temperature of 103 and appalling headache I have had to endure the next patient's loudvoiced visitors as many as 6 at any time. The patient able to sit up in fancy jackets & shout with the rest. The visitors sat on the other beds, mine included, to cackle back & forth. Nearly demented with headache I begged Alice to take me back to our flats. The head of the hospital was a horrible Miss Smith.

"Your sister's life is on your own head if you do it" she said. "She is very ill a chill would finish her."

Poor Alice looked so pathetic. I cursed a little with my face turned to the wall—disappointment & jaundice filed my temper to razor sharp. After six weeks in the hospital I crept home weak as a cat. The Doctor ordered all the fresh air possible but Paris was very cold & damp just then. Bundled up I sat by the French windows & watched the people in the court come and go. The girl opposite had two lovers. There was a strange window always tightly shuttered in the flat opposite ours. The Frenchmen came & went. They had pass keys shot swiftly into the door & you heard the lock snap behind them. If one man was out the other was in. The sparrows used to flock to the shuttered window and between the slats of the shutter long pale fingers moved up and down scattering crumbs. The concierge told us the woman in there was mad.

There was an American girl student above us she practised night & day always the same few notes tum-tidddle-de-um-te-dum. Tum tiddle-num-te dum. Over & over & till we nearly went mad. It was law in the court there should be no practise after 10:30. When the 10:30 came & the American girl did not stop the people leant from their windows and clattered on dish pans & screamed "Gar Gar, Gar." While I was in hospital the second time the American pianist above our flat committed suicide. My sister heard bumping going on on the stair and she looked out to see a coffin being carried down stairs. She concluded it might be the poor mad prisoner that

fed the birds but it was the pianist, had turned her gas on deliberately. She had drawn up a lounge chair close and left a note for her people. Nobody knew the reason she was not poor nor as far as anyone knew in love.

Every 6 flats there was a beautifully kept polished stair. Madam Concierge's helper was always polishing one or another of the stairs. Madame's quarters were by the gate there was a short drive way ending in an Arch way that was the entrance to the court garden and here Madame went to stand and shout "Clarisse, Clarisse, Clarisse," in a high screech.

The French people were always having their beds made over, the mattress makers used to bring tressels and do their work under the arch. At midnight every two weeks we were wakened by the most horrific clatter & shouting. The first time we jumped up & seeing men dragging in [a] great hose we thought it was fire & put our heads out to sniff but it was not fire we smelled. It was the sewage carts out in the street and the toilets were all pumped out through the great hose. After that when we heard the row we jumped out & shut the windows.

All the flats faced into the court they backed into a lovely garden but no windows looked over the garden except a small one near the ceiling of the bed room far above anyone's head. We did not know about the garden till one day I climbed on top of the bureau. After that I often put a stool on top of the bureau & sat looking into the garden.

It seems the man who sold the land did so under the promise no one should overlook him. Campagne Premiere was a very narrow little street. One side was all enormous brick wall with no windows just an occasional arched gate leading into these courts of flats. At the far end were small stores of second hand furniture. Students bought the few sticks they wanted for a big price and the promise that they would buy it back when you left but when that time came the dealers gave you only a few sous for it. People brought their own stuff home the students carrying a chair or table. Alice had a lovely home coming present for me in the flat. A fine bath tub she had bought & carried it home herself. When we left, an Austrian student of fine family and a very clever boy she kept from starving in Paris bought our things they piled everything on the bed and wheeled it away with the tub & buckets hanging on the end rattling furiously over the cobble stones.

Campagne Premiere took a twist or two and ended in a cemetery. When I was able to walk that far we used to sit up on a bench in the pale winter sunshine among the grasses. I liked to go there. It was quiet. As soon as I

could I went back to the studio & tried to work but before long the Austrian woman came sneezing furiously.

"I spose now I got some Influenzas," she announced, and sneezed it over the rest of us.

I went back to hospital for 6 weeks more.

It was dreadfully hard on Alice and most depressing for us both. I know I was too hateful for words. It seemed as though I was never to make any headway with my painting. I tried not to think of it or of anything. Moroseness changed into apathy. The Doctor told Alice, "If you don't take her out of Paris your sister will die. She cannot live in cities."

Sweden

WE DECIDED ON SWEDEN. Taking the journey very slowly, stopping in Cologne, in Hamburg & Copenhagen.

Alice was shy of talking French in France and as I could not she had been obliged to be father for us both. Now she said, "You know as much of these languages as I which is nothing it is your turn now" & she sewed her lips up.

If it had not been for the assistance of Mr Cook [Guidebook][126] I don't know how we would have managed, though he failed in Copenhagen. They had named all the hotels we were to stop at for us in Paris except the one in Copenhagen.

"That has slipped my mind but our representative will be on the platform ask Him."

. . . I went up to the familiar official [on the platform] with "Cooks" written in great letters on his cap.

"All day long at Cooks," replied the man.

Over and over I asked using a different arrangement of words each time, and over & over he replied, "All day long at Cooks." I was in despair cross & exhausted when I saw a strange little man beckoning to me behind the station door.

"I wonder," I said to Alice.

"Better see," she replied.

He drew me into the far corner of the station leading me by my scarf like a pup. I wasn't shure of him. But he said "You have troubles of Cooks. I helps you. This Cook fellow he no good. Cook always man go sick. Hotel

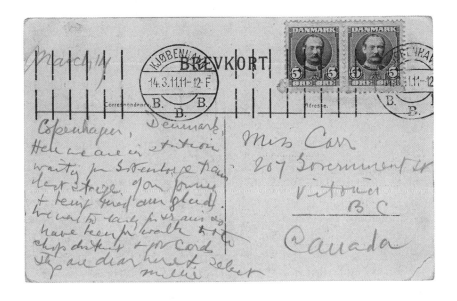

One of Carr's postcards to her sister Edith, mailed en route to Sweden, 1911.
MS-2763 Box 1 File 3.

he wants lots money, I take you good cheap place, before I work Cook now he mad for me." He seized our bags, there seemed nothing to do but follow wondering where we would end. It was quite all right however.

Once in Gottenburg we were quite all right. I had met a young Swedish couple in Vancouver[127] who I had been able to be of service to. They had made me promise if ever the chance came to look them up in Sweden. Mrs Myrin was ill in a Sanatorium but her parents took us in hand. The country was not unlike Canada. After several weeks in Gottenburg we went to Sangadraugh[128] a little sea side resort where I took hot salt baths and got well.

It was hot in the sun patches among the pines. We sat in the open. The Swedish people were fresh & attractive looking more pink & white & wholesome than the French and much more courteous to strangers. We did the wrong thing the first time we went to a restaurant. We sat down at a little table & looked at the card. The names of everything were tremendous rows of consonants that made no sense. The waiter gave us the card & then proceeded to cover the table with food. Cheese, pickles, bread, butter, radishes, sardines, cold ham and many things we did not know the name or taste of. We thought it was grand to display all the food when we could not ask for

it & made a good meal. Then dumb showed our purses were open wanting to pay. Shaking his head the man pressed us back into our chairs. Pointing to the other menu and raising his eyebrows with every point. Seeing there was nothing for it but to take a blind stab at one of the long words we did so & were smilingly brought a steak & accompaniments which on top of the good meal we had already made on snacks made us uncomfortable.

We went into a candy store later where the young woman talked good English. She was delighted to practise on us and we asked her to tell us the names of some ordinary foods. The names were very hard to get our tongues round the only one we remembered was "Skinka" it sounded like that tho I have no idea how it was spelled it meant ham. We lived on ham for the rest of our stay. It seemed that what they had first set before us was the Smora, a small bread a collection of appetizers from which you are supposed to make a dainty selection there being no charge for Smora. We crossed from Gothenburg over to Stockholm through wooded country stopping one night at the Sanatorium[129] where my sick friend was staying.

Crécy-en-Brie

BACK IN PARIS I learned that Harry Gibb was about to open a class in Outdoor Landscape somewhere near Paris. It was expensive but I at once decided to join. Apart from the fact that I got so ill cooped up in city studios and that I love the French country was the fact that the Dour Harry Gibb had something I wanted. Something big and in spite of his use of deformity something I wanted. His color too was lively.

He chose "Crecy-en-Brie" a small quaint town surrounded by a canal.[130] The Gibbs took rooms on the top floor and engaged a room with a tiny kitchen off it for me. It was very quaint, the rooms looked out to the main street which was of cobble stones & very noisy. There was an extra room I could get when Alice came down from Paris to visit for she did not care for the country & preferred to remain in Paris studying with her French mistress. Crecy-en-Brie was two hours from Paris the day we went to look it over there were women on the [railway station] platform who had been down there gathering Lillie of the Valley[131] in the woods, the whole platform was fragrant with them. I wondered what it was till I found & saw the women. They were in bunches as big as dessert plates.

I exclaimed "Oh Alice?"

I asked the woman how much. 8 sous. Four pennies! They were so tightly bunched we made two nosegays when we got home to our little Paris hotel and gloried in them for a whole week.

That session with Harry Gibb down in Crecy-en-Brie awoke me. All the art study gone before was a grinding plod dampened by the dodging of illness.

When I arrived in Crecy Mrs Gibb[132] was settled in their rooms but Mr Gibb had been called back to Paris for a few days. He left instructions that I was to go ahead and sketch so that he could judge where I stood on his return. Crecy delighted me not only the place itself was charming but with short distance in all directions lay tiny quaint villages or little huddles of buildings. The bigger were cow stables square stone buildings very dirty inside and almost windowless. The door looked like a church entrance with its curved top. The manure was piled by the side of the door outside and just beyond the manure pile the little one room cottage stood with a bare earth floor and the barest of necessities for living no matter how poor the hovel. It generally had a flower or two or a little grapevine trained across the front. Sometimes several of these cottages would be semi detached often they were completely forsaken during the day as the peasants were working in the fields sometimes a mother with small children was at home or an old old person. They were very nice to me tho' English students have told me this was not always the case & that they seemed to resent foreigners. And I think my popularity was due partly to my training among our Indians at home who no matter how poor their surroundings . . . I always felt were princely in their own right with the rich glory of Wild for backyard. These Peasants many of them were poorer than the Indians but they too had for background the rich pattern of tilled fields. The dignity of toil was about them. Dumb tongued in their language I at least had the international grin that goes so long a way. And I had something else I had "Josephine" the green parrot[133] I had bought in Paris as company for Rebecca the African Grey we had bought in Liverpool. I had both birds in Crecy. Rebecca was very ill natured & I left her home to sulk but the little Josephine loved to come with me. She rode on the rung of my camp stove and every Peasant stopped to talk with & pet her. The French love a parrot or a chat, to horses & dogs they are cruel.

My first lesson with Harry Gibb was an ordeal. Students told me he was considered the best but the hardest critic in Paris. I had heard of his

scathing crits at McLeans[134] but never experienced one and was sick with apprehension & nerves when the day came.

"I like the way you put your paint on," he said "And your color sense is good." Cold shivers stopped racing up my spine. He sat down in my place and painted an entire sketch. Watching I forgot my own existence entirely. I was puzzled the scene was more than what was before us. It was not a copy of the woods & fields it was a realization of them. The colors were not matched they were mixed with air. You went through space to meet reality. Space was the saliva that made your objects swallowable. Harry Gibb had worked in Spain[135] he had fed on color and atmosphere and had acquired the taste.

He rose abruptly. "Take a clean canvas & tackle it" he said.

I struck out. Harry Gibb said "I like to work with you—you have no fear— are willing to ruin a sketch for the sake of experiment. Yes I like to work with you." Mrs Gibb told me she had never seen Harry so interested in any student's work. His only complaint was "I say 'Mustn't go at it too hard.'"

"But look at the time I have lost after coming so far to get it. I simply must. It is so different to Paris student work." From early to late I worked, worked, worked, singing & quite happy.

Brittany

ALICE WENT BACK TO CANADA. The Gibbs moved to Brittany & I went with them. St Efflam was a seaside place. The Gibbs had an apartment I was at the little hotel. My board was 5 francs per day. It was off season. The new environment set me off on a new tack. I was in the fields at 8 in the morning, worked till twelve noon when a great 8 course meal was served in the hotel. Goodness how those French people ate. There was an elderly couple who came like myself, down before the season opened. Every morning they bolt- ed in[to] the sea. He was very fat & she very lean in their bathing suits they looked appalling. I used to run rather than meet them. They were opposite me at table. They encored every one of the light courses topping each course with pills & pastiles to aid digestion & swilling them down with wine. I found the old couple revolting the man was ferocious. He would look across at my plate & say "as a little bird Mademoiselle eats." I always long[ed] to retort "as a big pig Monsieur eats," but I lacked language. The maid finally saw how I fidgeted in the long long waits . . . [and] said: "Madamoiselle

wishes to get back to work" and brought my 3 or 4 courses & let me go. The evening meal was little different from the noon. Eight courses also. After noon dining I went to my rooms and rested, prepared my materials and went out again at three. I asked the maid to put me up a little supper to eat in the fields & was dismayed when I saw the basket—enough edibles for a family and two bottles one of white & one of red wine.

I did a sketch between 3 and five o'clock lay on the moss and looked up at the tree tops for an hour ate supper and did an evening sketch getting home at dark. Mr Gibb came to the woods or fields & gave me a lesson in the afternoon. He also came to the hotel twice a week and criticized the work I had done between lessons. He took a great interest in my work and was a splendid & inspiring critic. I got little hints from Mrs Gibb too although she was not an artist she was deeply interested in the newer work & followed her husband's work closely, often a little remark of hers gave me some hint that was very helpful. I was very happy at St Efflam my two parrots were with me. The hotel filled overnight when the season opened, Madam P—'s prices soared but Petite Mademoiselle's price (she always called me that), remained the same as before. I went further back into the woods & hills & seldom came in contact with the guests. I loved that country, and those people, the turbid puddles where women knelt in little wooden trays & washed. Spreading the linen on flat stones & beating it with wooden paddles then they trundled it in barrows up a little round hill covered with gorse bushes and spread it on the bushes to bleach the sun always seemed hottest on that particular hill. I have seen the entire hill top covered with men's white shirts. I do not know where they came from, women watched them.

I never ate butter in St Efflam you found fleas in it. The stables were very smelly & dirty & the cowmen slept on a rude bed often squeezed between the cows.

There was a child cow girl who was vastly interested in me. When I laughed she would bend quickly & try to look into my mouth before my lips closed. It puzzled me & I could understand no word of Breton. One day she took hold of one of her own teeth then pointed to me and said "tooth of gold" in French and opened her big eyes wide. I had a broken tooth that was gold crowned. This child wore but one scanty garment of print her bare skin showed through numerous splits & tears. Our Canadian Indians live luxuriously compared to these people. I have been into huts where there was not even a bed only two boards cutting off a corner of the earth floor

and in side a handful of straw a poor sleeping place for a pig and this was the family bed. The mother was boiling a cabbage soup in an iron pot over a few sticks. Outside two little girls were playing dolls the little mothers had stones for babies. I gathered a handful of weeds & stuffed two paint rag heads on which I painted faces. I dressed them up in a newspaper I had with me. No talking walking sleeping dolls could have given more pleasure to child play mothers than those improvised dollies.

One day I came to a little bundle of stone cottages on a hill they were all closed but one in which was a woman and her four children 3 dear little girls and a coarse horrid little boy. The father was a brick layer and was working on a house near the hotel. I worked a week or more round that woman's house—with all the children always squatted round me & often the mother too. She invited me to come inside & see her house of which she was proud. There was only one room the beds were built in the wall behind panels. There was a big open hearth with a huge iron pot hanging over the fire. The floor was of earth hard & swept clean. There were a few stools and a china basin for each member of the family to eat their cabbage soup out of. She fed the children while I was there dipping a ladle of soup with black bread broken into it for each child. They flopped down in whichever spot they stood & supped loudly. Little Marie aged four was my favourite. Our talk was mostly signs. The mother & I had one or two words we could exchange when I asked little Marie if she would come to Canada with me & her Mother had made her understand she jumped up and tucked a grubby little fist into my hand. I loved Marie and made her a grand rag doll with red worsted hair. She clutched it to her and gave it a long long kiss, and then Marie handed it to her mother and ran into the house crying. I wondered, the mother laughed & pointed to the great black smudge where Marie had kissed it. Presently she came back with a clean shining face & claimed her baby.

I had been working under Mr Gibb for five months from interesting work I was getting stale. Very soon now I should have to go back to Canada. When I told Mr Gibb he was very sorry.

He said "If you go on you should be one of the women painters of the world."

I held my breath and looked at him in pure amazement.

I who was going back to the farthest edge of Canada. All help from Art centres & Art critics over. I wrestling in a place such terrific vistas &

diversity it had been pronounced unpaintable time & time again. Here in the old world it had all been tried out the way found the path beaten for others to follow, decently clad in aesthetic traditions. I would go home and drown in the uncharted sea of tremendousness. Wait a minute what about the art of our Indians? A terrific art quite capable of coping with its own problems. I went back to the hotel, pulled some of my Indian sketches from the bottom of my trunk & re-painted them then incorporating the bigger methods I had absorbed over here with the bigger material of the west.

I hated to tell Mr Gibb I was leaving him. I was grateful for what he had taught me. I had worked very hard and was going a bit stale. There was I heard a fine teacher of watercolor summering & teaching at Concarneau. An Australian woman whose name I forget.[136] I had still a short while at my disposal and a little money so decided before I sailed for Canada to go to Concarneau. Change of place teacher & medium would give new impetus to work.

The journey was tedious. The actual distance was not great on the map. I had to make several changes with long waits between the pokey little trains. I had acquired very little French, my tongue did not like it.

The parrots were in their neat little travelling box up on the luggage rack, underneath them sat three priests busily fingering their beads and moving their lips while their eyes roved here & there through the carriage & out over the country. When Rebecca commenced to meow exactly over their heads their eyes bulged so dangerously that I tipped the box forward & showed them the birds after that they chuckled at every meow & forgot their prayers. When we changed trains a gendarme came into the station where Rebecca was meowing furiously.

"Madame" he said "you have a cat in that box."

"I have not a cat Monsieur."

"But Mademoiselle I heard the cat 'meow' cats may not go in the train."

"Monsieur I have no cat."

He turned furiously & raised the cover "Paroquet Paroquet" he roared & chuckled & put the birds on board.

The old Priests took their seats & the train crawled across country, people were coming from Market. An old woman heaved a huge basket into the compartment & puffed in after it. There was a hen in the basket & all manner of vegetables. A gendarme burst in for tickets. He shouted at the woman she shook her head but the man took her basket & emptied it all

over the floor among our feet, the hen's dead head lolled across my shoe, while the noise went on. The conductor then began to examine other people's parcels, the priests were shaking with merriment. "Meow" went Rebecca a priest poked the gendarme & pointed to the parrots. The man investigated & went off laughing all over. It seems you may carry parrots, dead hens or live in a carriage but a cat you are not permitted to carry.

The hotel in Concarneau had no water system everyone went to the fountain in the square with jugs & pails. The meals were tremendous they had some revolting dishes like frogs and the combs of cocks, and rabbits with empty eye sockets staring out of skulls.

I worked with fresh gay vigor sitting in wine shops & sail lofts on the quay or back in fields. I learned a lot & was happy. Then I went back to Paris and packed up and sailed for Canada.

Canada, 1912 to 1939

Return to Canada and Vancouver

THEY HAD NEVER TAKEN MUCH INTEREST in my painting at home but when I unpacked my box there was dead silence among my sisters and my friends. Silent antagonism they neither understood nor wanted to. Nobody painted that way out West.

"You used to paint quite nicely" they said.

They were sorry for me because I had so much sickness to contend with when I should have been studying and because I had made such a botch of things. Friends looked & turned away and talked hard about something else. It was very unbearable. There is nothing that hurts worse than pity at your failure. I was dependant on teaching but nobody wanted to learn what I had brought home.

I went over to Vancouver. A few staunch old pupils came back to me. They experimented doubtfully. My schools said they were settled with teachers.

Barely was I moved in[137] when Wylie Grier[138] an Eastern painter came wanting my studio for 6 weeks. I let him have it and went up North to sketch among the Indians. I found my work with Mr Gibb had vastly widened my view on my Indian work. I was doing bigger freer work.* I attacked my material with a bolder fiercer spirit. Indian art made a much deeper impression on me than it [ever] had before. I also learned directness & a

* See plate 24.

prompt summing up of my material. The Indian charged high for canoe and gas boat hire. I could not afford to waste one moment in indecision. I learnt accuracy of proportion in drawing the totem poles. There were a great many difficulties to be overridden there was a great deal of discomfort usually. In the villages the people edged so close they hampered my movements. In the far places there was weary tramping. The undergrowth was high & dense in the forsaken places. I had to beat my way through growth over my head it was uncanny there down among the roots of things in the greeny dusk, in dank boggy spots. I was always scheming how to get near enough without being buried under close foliage. The mosquitoes were a torment veils & gloves hampered one's movements & helped little. Yet for all this I was thrilled & intense. I love the people & I loved their things.[139] The grand old totems spoke such a fierce strong language. The Eagle, Bear, Raven, Whale, Wolf all the creatures of power spoke through the intense carvings of these people. These carvings & drawings were their only permanent mode of expression. They had no written language. Happenings in their lives tales of greatness could only be perpetuated by word of mouth from Father to son or pictured. Shrouded in the mystery of their comings and goings the animals played a huge part in the Life of the Indian they endowed the creatures with supernatural powers. Each clan had its own totem, people belonging to the same totem might not intermarry the relationship was close as that of blood. In depicting their totem the carvers aim was to give the creature its natural attributes fierce cruel brave cunning in his own life he tried to live up to the qualities of totems of his clan. His heart & soul were therefore intent on expressing in his carving the qualities of the creature—the qualities he strove to emulate, the very qualities that burned in his own ambition. Fiercely he clutched to himself first the feeling of what he was after and with the fire of it tingling to his finger tips and passing through his crude tools, he cut and bored the reality of it into his material. As an Artist he himself did not matter. Often the carvers were slaves.[140] He worked for the ideal in himself that was burning him up worked to boost the great boast of a Chief who was an Eagle Bear Raven Whale.

Working among things of such intensity of feeling with the overwhelming power of the Primeval forest behind them the wrapping of complete aloneness in these far off abandoned villages. Nature's insistent pulling back to itself of that which man did not perpetually wrestle for, these things could not fail to influence my work & myself.

People began to tell me I was wise to paint these Indian places & totem poles because one day they would be valuable when the Indian villages were all gone & the Indians absorbed into the white races. They said I would make money they even began to say that—that modern style suited Indian stuff, made them look bigger & it did but I still hugged the historical side too close. I used color & worked freer but I had not yet quit conventions to the wind. The artist who occupied my studio in my absence took everything of mine off the walls, he said he found them very disturbing indeed.

I gave an exhibition.[141] Which nearly broke my heart. There were horrid write ups in the paper. Deploring that one who had once given promise had thrown sanity to the winds and was outraging nature. My work was consistently laughed at or ignored the hurt of it went very deep, and I had a hard time to eek out a living.

People said "Why not go back to your old type of painting everyone liked that. Why be so pig-headed you must cater to public taste if you want to prosper."

I could never never go back. I had tasted the freedom of bigger spacier seeing. I was not satisfied with bare photographic form. The matching of drab color did not satisfy me. I remembered that light and air altered them. Mr [Talmage] told me to remember there was sunshine in the shadows. John Whiteley had told me [to] remember the coming & going of trees not think of them as solid surfaces. Mr Gibb had waked me to the value of light in color. I came home remembering these things and was ridiculed for being led astray by Modern foolishness. I built a wall high & solid. My friends & relatives, the old way of work were on one side on the other side of the wall was myself, my aspirations my real work. I did not talk about it to anyone.

Move to Victoria and Hill House (House of All Sorts)

THERE HAD BEEN A BOOM in Victoria real estate. My Father had left his property tied up so that it could not be sold. The house belonged to my oldest sister she might will it at her death but not sell, but the property was eating itself up in taxes by the time it could be sold there would be none left to sell. The will was broken but it took time and the boom was over before it was free. The bulk of the property went very cheap, of the five remaining lots each surviving child took one. I decided to build a small apartment house

Carr family residence, 207 Government Street, Victoria; Elizabeth (Lizzie) Carr, left, and Edith Carr, 1909. Photographer: Dorothy Frampton. F-00950.

on mine, one suite with a studio I would live in. I would rent the others & live on the income . . . I moved to Victoria in the spring of 1913.[142]

For two or three months I worked hard in my big studio with the fine north light. The flats were rented what with making a garden & looking after the place there was plenty to do still. I found some time for my painting. All of a sudden war swooped down on us and everything was changed. All the decent men went, the miserable no-goods flocked into town and sneaked into their places. Rents went down & down soldiers wives could not pay above a minimum. The no-good birds flew by night on the eve of rent day or refused to either leave or pay. Sometimes I had to get help from the law. Every property owner had the same trouble, and the rents could not be stretched over taxes mortgage interest & living. I was janitor handyman gardener. Had the mortgager been other than my sister I would have let the house go, anyone else would have foreclosed on me, Alice loathed real estate, she would not have the house.

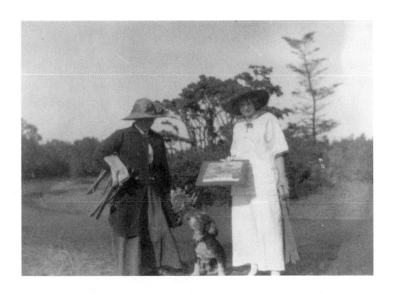

At Beacon Hill with Helen Clay, 1914. G-00410.

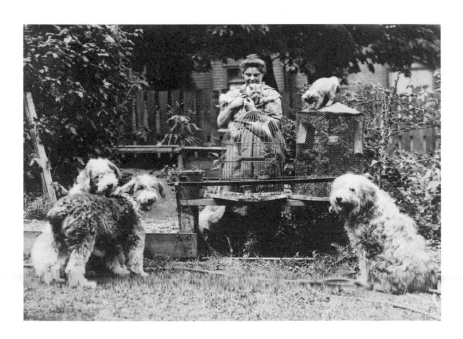

Carr's description reads "Prince Pumkin, Lady Loo, Young Jimmy, Adolphus the cat, Kitten, Chipmonk, and parot & self in garden at 646 Simcoe St., 1918." C-05229.

Painting was out of the question these days. I made rag rugs & sold them using my Indian designs.* I had beautiful fruit in the garden & sold that also I kept a kennel of sheep dogs for which there was fair demand & I raised chickens & rabbits. I sold a bit of property & payed [$]1000 off the mortgage, my sister Lizzie payed another thousand off for me, making things that much easier.

San Francisco Interlude, 1916 to 1917

ONE WINTER I closed the house and went to San Francisco.[143] I painted lanterns & made banners for a firm who were doing a huge decoration for one of the big hotels. The lanterns were made by the Chinese we worked in an empty store in Chinatown and were very pressed for time. The couple I worked for were up in town & had a shop for basketry & fancy things. Another artist and myself were sent to the empty store in Chinatown to paint lanterns, they were huge transparent dressed cloth globes that were to cover the aisle chandeliers in the ball room. We had only 2 days in which to decorate 36. There were no lights in the shop we could only work as long as the day lasted. The woman I was working with got tired. She said "it is getting dark & I am tired. I shall go."

"We must finish" I said.

"I am going. You can't stay down in China town alone in a dark shop."

She was a friend of the Raventos[144] knew them for years.

I said "You cannot leave the people in the lurch like that." But she put on her hat & went.

I opened the door wide to let in what light there was & worked like mad. Chinamen swarmed round the door. It was a strange foreign experience. S[an] F[rancisco] Chinatown was not a savory place. I finished the last lantern just as the dray came for them. In another shop the Chinese were decorating five huge ones. They worked on ladders the lanterns reached the ceiling and were closed up to get through the door. Mr Ravento collected the lanterns and forgot me. I was angry when I realized the last drays were already away and I was left there alone in the dark. I was dazed from exhaustion & working in such poor light and a little frightened as I

* See plates 25 and 26.

walked through China town. When I finally reached Geary St. Square[145] I sat on a bench & cried from anger & exhaustion, then I went into the hotel St Francis and saw the last details of the decoration getting into place it was very beautiful. I tell this because I know now it was all part of what I had to go through, part of my training. It is in these strange corners one learns things.

I lived in a students home in Berkeley. Most of the girls were university students young bubbling things, girls who were going to be lawyers & doctors & teachers. We each had a bed sittingroom & shared a community kitchen. Rows of gas rings where girls stirred & burnt messes. There was an expensive boarding house next door and a hole in the back fence. Those who wished could squeeze through the hole with covered plates and purchase a cut from the elegant boarders roast pudding and each vegetable five cents extra. We stood in the kitchen with our plates while a black mammy served us.[146] Boy students were washing dishes furiously at the sinks, others were running in and out in clean white coats waiting on the affluent boarders. We shared their menu in the country kitchen to the smells of burning concoctions by those whose allowances had run out.

In spring I went home with a new idea in my head. I was going to make my two upper flats into a boarding house for ladies.

Boarding House

MY SISTER LIZZIE'S VOICE always keyed very high when she disapproved. It was almost beyond any keyboard as she said, "Millie you can't do that you don't know a thing about cooking you [will] fail shure thing."

"There's cook books & there's common sense."

"But!" and then her squeak gave out.

I could accommodate ten women. Sometimes people renting the lower flats came up to meals. My great beautiful studio had the dining table one end. The floor was covered with hooked rugs of Indian designs. The walls were hung with Indian pictures. It made a most attractive sitting room. I tried to forget it was my studio, the dreams I had of painting fine pictures there faded. War & the struggle of living drabbed every thing, painting was out of the question. The last time I had tried to buy a tube of paint they were out said they could not promise to have any more for a year. My

Garden room built below Carr's studio at rear of 646 Simcoe Street, Victoria, ca. 1924. F-07886.

Indian pictures were packed away in the basement. I was the keeper of a boarding house for women. I used bright colored dishes on the table & made attractive salads the ladies "supposed it was because I was an artist." I crushed Art out of my life & busied myself with pots and pans. I saw every kind of women, decayed English Gentlewomen, Business women, teachers, students, busybodies, gluttons. A few had innate loveliness a lot were hideous inside & out. They saw that they got their pound of flesh & registered complaints and quarrelled amongst themselves. I drudged on loathing them all, loathing their selfishness & greed, whatever else they complained of I had no complaints about the food even my sister Lizzie pronounced me a good cook, it was one of the three things she ever gave me credit for. The other two were gartering up my stockings well and knowing how to train a dog.

The ladies were greedy, prices of food were very high. I charged a very moderate board. They would beat me down to the last sou and then pile the butter on their bread, cream cheese on top of that and crown it heavily with jam. I was too inexperienced [to] limit luxuries in accordance with my rates. Even after Armistice it took a long time for prices to adjust themselves. Finally I turned the boarding house back into suites & gave up meals, but was obliged to rent my own studio suite to make ends meet. I slept in a

tent in my garden and used a room built on at the back and opening into the garden. I loved my garden & like[d] living so close to the creatures & flowers. Sometimes at night I looked up and saw my beautiful studio alight and shadow people moving back & forth. I had a stab of jealous longing, but as in my long illnesses, a dead lump was in my heart where my work had been. This time I thought I had quit painting for good. After several unsuccessful tenants in the studio, I went back to it myself.

"Early House Days"

FOLLOWING THE BUILDING of my house came bitter years. I stood quite alone. Two sisters live[d] in the old original Carr home a block away. They were very religious absorbed in work[s] of charity and church works. I did not go to church and they strongly disapproved. The rare occasions on which I now painted, it was Sunday which shocked them. They disliked the type of work I did since my return from Paris particularly my sister Lizzie. If any one gave it a good word which happened occasionally because of its Indian interest Lizzie gave an impatient snort. "I prefer that" she would say pointing to some colorless little old childhood sketch of mine. She never missed an occasion to scoff at more modern work. My sister Alice always completely indifferent to my work was too uninterested even to mock at it. At this time she gave up her school and went to live with an English family about 3 miles away for whom she acquired a tremendous infatuation. I missed her terribly we had always been very close other than in matters of Art & I felt very deposed from my place in her life very keenly gave myself up to a bitter engrossing jealousy that warped everything in life. We had always been a devoted if independent family. My smoking, damning and not going to church troubled my family very much. It was frequently thrust upon me that I had always been different from the rest. I loathed being a landlady. From my father I inherited an eye for orderliness about my place. The ways of tenants tried me severely my feelings towards them amount[ed] in most cases to plain hate, during the war when decent men were away & scamps & riff raff sneaked into their places & flooded the furnished apartment houses beating down the prices & leaving even those unpaid when they shipped by moonlight. Every property owner had their problems an unexperienced woman landlady was necessarily hard hit. Inside me was a rage at the injustice and hatefulness of it all. The mortgage on my house was a dragging millstone, painting was the last thing one thought of

materials were thrust away in the attic, if during rummaging for necessities I came upon them a surge of anger swamped me and so for nearly 15 years my work lay dormant. Then one day I receive a telephone call from Eric Brown[147] who was in Victoria.

The East Calls

Eric Brown

OVER THE TELEPHONE a man said "Eric Brown speaking. I hear you have some Indian Pictures I should like to come and see them."[148]

"I don't think that is possible I suppose. I don't paint now & they are packed away in the basement."

The quiet voice persisted that he wished to see my things. "I am the director of the Canadian National Gallery" he said.

I did not know there was one. I'd never heard of Mr Eric Brown & I was not interested. In the end I admitted there were some Indian pictures on the wall which he might come & see if he wished.

He was very courteous. How ignorant I must have seemed. I had never given a thought to Canadian art, if I had I would probably have thought of it as a scuffle and a deadness like it had been to me.

Mr Brown said "We are having an exhibition of the Art & the Art of the West Coast Indians."

"Who told you about my pictures?"

"The Indians themselves told Barbeau.[149] He is up North now you will see him on his return."

Mr Brown was enthusiastic over the work I had done up North. He said he wanted to borrow it for the show.

"The carriage will be enormous," I said.

"The Gallery will take care of that. Why not take a trip East & see the show yourself."

"Could not afford to."

"I could get you a pass if you would like to come."

Again I said "who did you say you were?" I was bewildered.

"Eric Brown Director of the National Gallery," he smiled. "I'll introduce you to the 'Group of Seven.'"

"Who are they?"

"Seven fine men who are the art leaders in Canada. You have not read 'The Group of Seven' just out by Fred Housser?"[150]

"No and I have not painted for nearly 15 years."

"Why?"

"Disgusted. War, no time, no paints."

"Come, make a new start you have fine material out West come & meet the 'Group' they are inspiring."

The next day I had "The Group of Seven" by Housser and new life was springing through the deadness of me. To my astonishment my sisters advised my accepting Mr Brown's offer and undertook to look after things in my absence.

Toronto and Ottawa, 1927

THE PICTURES went East and I followed. I did not care half as much about seeing the exhibition in the National Gallery at Ottawa, as I did about meeting the Group of Seven who were in Toronto.

Varley,[151] one of the Group of Seven was in Vancouver. I met him as I passed through. He wired back to some of the Group. When I went to Toronto the doors of their studios were open to me. First it was A.Y. Jackson then Lismer then J.E.H. MacDonald.[152] And then Lawren Harris. They were splendid showing me their work, treating me as an equal Artist with themselves. I met Mrs Housser at the Womens Art Association[153] & I said "Do you belong to Mr Housser and the book?"

She asked me to tea at their most delightful house where I met Fred Housser. They had beautiful books & Pictures. In A.Y. Jackson's studio there was tea, with things handed round on the top of cake tins. The Studio building on Severn St. was magnificent for work to my thinking it contained 6 or 8 studios, two on a floor. Large solemn work rooms with good lighting. A.Y. Jackson MacDonald & Harris all had studios there at the back was a spartan studio Tom Thomson[154] had used. He was recently dead, they all spoke of him with love like a brother. JE.H. MacDonald & his son[155] had a studio beside A.Y. Jackson a quiet shy man & Boy. The day following we went to Lismer's studio built in his garden and lanky enthusiastic Lismer good as any tonic. There was a pause of one day and then the ladies of the Womens Art Association who had been conducting me to the studios said

we were going to Lawren Harris's studio which was an honor for he did not open his door so easily. Of all the reproductions in Mr Housser's book Lawren Harris's delighted me most particularly "Above Lake Superior," an austere formal picture of great depth and dignity.

He brought out canvas after canvas. I could hardly say a word but sat like a dumbfounded fool. The woman who had taken me did the talking.[156] He must have thought I was fool. I could not help it. I had not any words. Neither in England Paris or anywhere had any work touched me so deeply right to the very core. The whole idea of it was new to me. Not like Mr Gibb's Modern things had been strange & new, this newness was a revelation a getting outside of oneself and finding a new self in a place you did not know existed. Getting a glimpse in those pictures into the soul of Canada, away from the prettiness of England and the Modernness of France, down into the vast lovely soul of Canada, plumbing her depths, climbing her heights, floating in her spaces. I think we were there a long time but I don't know. When we came out I was utterly exhausted. When Lawren Harris took my hand he said "come back again" and I knew, no matter how intrusive or impatient or interrupting it was, I would just have to go back before I went West no matter if he cursed or hated me for breaking in on his work. I must go back. That night I did not sleep a wink. Two things had hold of me with a double clinch Canada and Art. They were tossing me round & tearing me. I had wild bursts of crying. By morning I was limp and spent. I did not want to go to any more studios or see any more pictures of people. I went off to Ottawa.

Everyone was tremendously kind. The Barbeaus insisted I stay with them. I roamed about the National Gallery sketching the Indian things in the museum, revelled in the pictures was taken for drives. Mr & Mrs Brown were lovely to me. I went to their flat & we had long delightful talks about Art & Paris & England & Canada. It was as if I woke up fresh & happy after a long long sleep. For the third time in my life Art had had a long sleep but I believe that unknown to me down in those black places the roots had been growing & growing. Perhaps I was not fit to go further till my roots were better established by experience of life.

Lots of people came to the show of West Coast Indian Art.[157] I met many and they said grand embarrassing things about my Indian Pictures. More of mine were on the walls than any other Artists because I had been up there and worked specially among our Indians. I knew the people and the places

& I loved them more than people who had gone out west and given them a swift look over and who were really much better artists than I but I did not feel satisfied when people gave me credit. I had only copied the Indian's work as faithfully as I could and as historically. The credit should go to the Indian I felt. Their fine poles so wonderfully expressed from the soul and life of the Indian themselves. I could not feel I deserved much credit for the mere copying of it. To the best of my ability by the aid of Harry Gibbs teaching I had been able to feel & see it in a larger way than before I went to Paris, the more Modern way of seeing coloring and feeling that I had applied had undoubtedly increased the strength & value of my work, there was an open air feeling to them.

On my way west I stopped again at Toronto. The first thing I did was to phone Lawren Harris. I said.

"You told me to come again. May I? I just must see those things once more before I go West."

"Shure you can." He set the time. "Wait a minute!" he conferred with his wife. "Come out & have supper with us tonight." He came & got me. His house was full of pictures. He put on a beautiful symphony concert on his gramophone. All evening we did not have to talk so I could sit looking & looking.

"Perhaps," I said at parting "Now I have seen all your home pictures I should not come to the studio & interrupt your work again?"

"Nonsense, come along, you're one of us you know. One of the painters of Canada."

"Me! Way out West me?"

I guess that long talk in Lawren Harris's studio was the pivot on which turned my entire life. Patiently he brought the canvases all out again. I absorbed each greedily. I tasted something I had never found in pictures before. When they were back in their racks again he talked to me about work. He had painted in the Rockies but he did not know my West. When I told him how I felt about my work being to the Indian's credit not mine he said, "Go ahead find your own way, to express your own material."

He gave me the names of some books he thought might be of help but his advice was "read them & then pitch them away & forget them. Their use will be to start you thinking for yourself. By the way do you ever write? That helps too, and let me hear how you get on. You are going to paint again aren't you? Brown says you have not painted for some time."

I had to hurry over to the window. I'd have hated him to see that I was crying.

Like a wood louse that runs without shewing its leg action the train scuttled across Canada. I dipped into my new books but mostly I was connecting space and Lawren Harris's Pictures. They haunted me. When we drew in among the density of British Columbia growth the lush violent upspringing riot of greenery I felt lost & bewildered as to tackling the expressing of it. But I was going to. Then I was glad that the love I had wanted was denied me and that I had been firm against the loves that had pleaded for acceptance. I was free, no ties except lack of money. One day my sister Alice did a noble thing. She handed me papers cancelling the balance of the mortgage. It was like a chain falling away, though I protested vigorously. She had at that time a good school. I shall never be quite happy until every penny of that mortgage is hers again but she is difficult. Any mention of it makes her more angry than anything I know of but I am convinced that sooner or later my turn will come. Perhaps at a time when her teaching is over and she needs it more than she did then. Had I given up when things were so terribly hard & handed the property back for the mortgage, she would have let it revert to the city. She never, never could have coped with the house, she hated property other than her own cottage, like a hen hates water. It was a difficult, difficult place to run expensive and too small for a profit margin.

I was home in time for Christmas. New Year's day I started to paint. Without the awful drag of the mortgage I could manage. Meeting The Group of Seven had given me a bigger vision. Lawren Harris's work had given me inspiration.

1928 and Theosophy

ERIC BROWN GOT ME A PASS on the C.N.R.[158] as far as Jasper Park. That summer I did not go to Jasper itself as accommodation there was high. He gave it to me so that I might continue with my Indian work. I went to Alert Bay, Kitwancool, Kispiox, Kitwangak, Kitseukla, Prince Rupert then I crossed to the Queen Charlotte [Islands].[159] I came home with a lot of sketches and spent the next year putting them on canvas.*

* See plate 27.

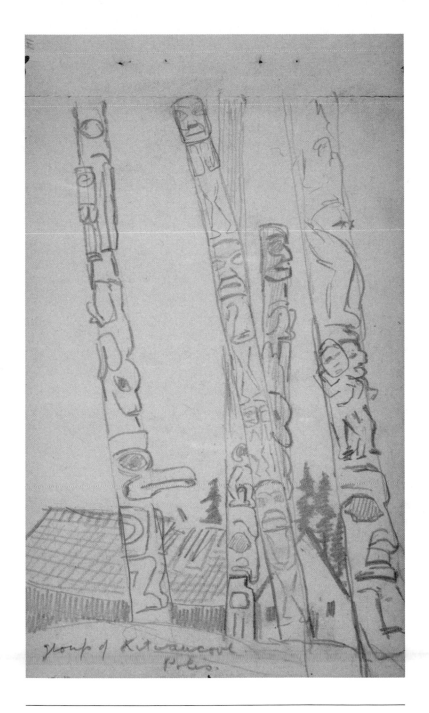

Carr's title is "Group of Kitwancool Poles." Emily Carr, 1928. PDP05801.

In many of these places the Government has set about restoring the poles to preserve them and then all their loveliness in their wild setting all their rich softening & mellowing of age changed. The Indians proud of the new garish paint and of the tourists who came in bunches and gazed with open mouths & no veneration. Turned their poles about. I did not recognize the majestic Eagles and Ravens and Bear whose gaze had been across the river welcoming the visiting canoes. Now they backed the river and in garish new paint faced the rail road & the Tourist, their backs turned towards the peace of the old waterway. When I sent work east that winter they were surprised at the strides I had made. How my work had deepened. Lawren Harris wrote to me frequently his letters were a tremendous help and inspiration in my work and it was a help I had never before experienced to have someone I could discuss my work with freely. I had always felt that my work & my religion were somehow very closely connected and I believed that his were too. I found that he was a theosophist. He wrote me a lot about it for it seemed inseparable from his painting. I was deeply interested. I thought if theosophy made people paint that way I wanted to be a theosophist. I got books & studied.

The Group of Seven asked me to exhibit in their Eastern shows. I sent "Skidigate"[160] and "West Coast Village" and the "Indian Church" & "Nirvana." The Indian Church was enthusiastically received. I was trying to handle the surrounding growth in the villages in the same way as the Indian had handled his material trying to relate the Poles & villages to their surroundings. A.Y. Jackson wrote, "It is unfortunate you are so far away from everything out there. I have seen that country and realize how unpaintable it is with its density of trees & undergrowth."

Pity me would he! Unpaintable! "I'll show those Easterners," I said. "Maybe the Indian material is finished. Civilization has disintegrated it. There is forest left!"

There were three bids for "the Indian Church."[161] Lawren Harris bought it. He wrote most enthusiastically of it. He took a trip to Paris. On his return he wrote, "I saw no picture I would rather possess than 'the Indian Church.'" His every letter was full of its praise he spoke as though I had gone as far as I would ever go nothing that I painted after seemed to please him so much as that church. I got angrier every letter he wrote and then I burst out in an angry letter. "Stop it! Stop praising that Indian Church. Do you think that is the end of me that I am never to get beyond that beastly little church. Is

that picture my limit that you compare unfavorably everything else I do with it!" The Indian Church became taboo between us.

Fred & Bess Housser were ardent theosophists too. They were great friends of Lawren's. I corresponded with them too.

Chicago, 1933

THE YEAR OF THE CHICAGO FAIR[162] all the Eastern Artists wrote me how splendid the Art exhibit was. "Such an opportunity as we have never had on this continent and may never get again," Bess wrote.

I looked at the calendar already it was over.

I opened Lawren's letter "I wish you could have seen the picture exhibit at Chicago wonderful! They are keeping the Fair open another month and fares are very low."

"Girls I'm going to Chicago!" My sisters helped me and off I went.

The railway Co[mpanie]s did everything they could vieing with one [another] who could treat their travellers best especially ladies travelling alone.

They secured me a room in Chicago and sent their representative to me. On the way to the hotel the man said, "Yes the Fair was so successful they are holding it open till the end of November. Art exhibition closed today tho'."

"The Art exhibit closed! But that is all I came for." The disappointment was bitter. Here I had felt was my big chance. The chance of seeing all the great men. Artists had told me it was tremendously inspiring. The cream of the earth in pictures an opportunity not to be missed. Why oh Why had they not told me sooner. I was only 24 hours too late. I rushed off to the Art Gallery first thing in the morning & pleaded at the wicket with a cold woman.

"If only I could just get a peek look in the door."

"Impossible even now the pictures are all down on the floor"

"I could look at them lying on their backs and not disturb a soul."

Too late.

Back in my room a dingy one looking into a brick wall, I sat wondering why, just before I caught up they moved on. England, Paris, halts called by illness, work in the fine studio that I buil[t] to work in halted by war and by being compelled to tackle people—bread & butter problems that I hated, now the chance of seeing all the works of the great ones assembled together dashed away. I came away like a whipped dog & found a wire from Lawren

Harris full of distress. My letter saying I was on the road had reached him after he had heard the Picture exhibition was closing. He wired to Victoria trying to save me the expense of a useless journey but I was already started. He suggested I come on to Toronto and see them all after a day or so at the fair. That thought cheered me. I flung myself into the fair. For a week.

It rained or sleeted and was bitterly cold. The people in their cold little shells of stalls looked frozen. Mostly I sat watching the people scurrying from one building to another to get into the warmth. Sunday I spent in the Park Zoo. The live monkeys were delightful if they had not looked so dreadfully bored but there was no mistake they enjoyed showing off & admiration. On the other hand the halls & halls of dead Monkeys in the Field Museum were amazing tho it seems awful we have to make them into corpses to admire them. The sliding dome affair for viewing the Heavens[163] appalled & made me giddy. Sitting in the dark with a sepulchral man intoning the wonders of the Heavens from a desk with a shaded lamp was about all one could bear but when the universe slipped it was the last straw you clutched your chair & groaned with shut eyes & when you dared to open them again were astounded to find yourself as you were.

An interesting lecture on "Mormonism" in the hall of Religion, a talk & demonstration of Television. And best of all the process of life demonstrated by unborn babies floating in alcohol are my lasting memories of the Chicago Fair appart from scurrying people with umbrellas blown inside out & drabbled stockings.

I wrote to Bess Housser "am Fed up with Chicago, meet me by the evening train." And there they were even to their dog "Boots."

The Houssers have one of the most delightful houses you could imagine to live in. Over the living room fireplace was a calm lovely picture [by] Lawren Harris—sea & mountains—that seemed to set the pace of the room. Each member of The Group was represented by a picture and there were books. Art books & religion books and worth while new books of all kinds. The Houssers were Theosophists, so was Lawren Harris. He came the next morning & took me to his studio. There was something very calm and restful about Lawren's studio the walls were a quiet mellow grey and there were no pictures on the walls except the one on his easel. The Studio Building stood in Rosedale in a quiet corner away from traffic. I loved to go to that studio to talk to Lawren about work. He threw so many many side lights on work. I wanted to get hold of something in his work that mine lacked,

a bigness lying behind it. I did not want to paint like him. I never could because in ourselves our natures were so different. He was calm where I was all turbulence and eruption. He had scratched the surface of things & got below. I began to question Lawren & Fred Housser about Theosophy perhaps the secret lay there. I had long been convinced that Art and religion were very closely related. I was shy of talking to these two men at first and then I found them easier than Bess[164] they were very patient explaining their views when over in the East before. I had through these men become an ardent admirer & student of the writings of Walt Whitman & had found tremendous inspiration and illucidation from him. I had long talks with Lawren & Fred but I never got their viewpoint. They gave me books & I studied them honestly because I <u>wanted</u> to get Theosophy but it troubled me. It seemed so cold & vague and helpless an everlasting going on and on. They robbed mankind of a Saviour, took the Divinity from Christ. I could not accept their way of ignoring so much of the Bible and upholding the teachings of M[me]. Blavatsky.[165] I heard them say things about the church & the Bible & prayer that shocked me.

"Don't you ever pray?" I asked Lawren.

"I try not to. In the sense of making petitions to an Almighty. All true living all inspiration is prayer."

Now as regards going to church kneeling on a footstool and repeating words with a wandering mind, I don't know if I felt much upliftment myself but I did believe in prayer. I believed that God was everywhere and I prayed or rather endeavoured to commune & come as close to God as I could to feel the power of his presence in everything about me as I worked. The woods seemed so full of God full with a sweetness of devotion, seemed to me shut away from this breathing life the sneezes and coughs of the people, the set artificiality of the parsons. The prayers that had soured & gone stale before they quite reached God or were pulled down the earth side of the roof by someone in the pew in front fighting. All these prayers chained in the church by earthly incidents couldn't escape & go up like woodsey prayers. Here I could feel those words.

I God surround thee like an atmosphere.
Thou to thyself were never yet more near.
Seek not to [shun] me whither woudst thou fly?
Nor go not out to seek me. I am here.[166]

Lawren & Fred were very patient explaining to me their Philosophy. Bess also was an ardent Theosophist. I came home however quite unconvinced that it was what I wanted but I came home with much food for thought.

Oil on Paper

FOR SOME TIME PAST I had been feeling the necessity of doing large sketches as to get the sweep and freedom of these great tree forms. [It] was impossible unless you could get space for the free swing of your arm. When I sent some of my sketches on paper east the Eastern Artists—Arthur Lismer in particular—criticized me wondered why I was straddling over large sheets. Thought smaller sketches were more satisfactory but I was after something and I went on my own way. He came West a couple of years afterwards.

"Lets see what you've been doing."

"You don't like my paper sketches?" I said "you criticized them as unnecessarily big thought I'd do better to work smaller."

"Who told you? I did not mean that to be repeated."

"It was but I did not heed it" I said. He was broad enough to be very enthusiastic saying "I am glad you did not take my advice."

"Some one took me out into your woods. I was—I was bewildered. I meant to sketch but I was bewildered at the density & tangle. I only looked."

That "defying" the advice of Arthur Lismer indicated a new mile stone in my work. Up to that time I had looked up [to] the Group of Seven as Canadian top notcher Artists and I had not questioned their superiority over my own knowledge. I was willing to see through their seeing but it was Eastern seeing and now I realized I was Western and stood quite alone. As far as finding a way to express the dense wooded West I must pioneer, A.Y. Jackson had once to me pronounced it as unpaintable. Lawren Harris had painted in the Rockies & the Arctic, the calm stillness of high west places was in his pictures. Not the tumultuous tangled rushing of growth of the West. I was unreasonably annoyed when Lawren Harris still wrote about the little Indian Church.

"You will I feel never do a better canvas."

At last I wrote back angrily. "Stop praising that beastly Indian Church picture as if you thought it was my finish."

"The Indian stuff maybe almost a thing of the past but I'm not."

He was always kind and help full. I do not know what I'd have done in those hard days of lonely plunging into new depths but for Lawren's helpful letters but I could not accept his Theosophy. It seemed to me so cold, so distant. I did not think of God as a cold enormous bearded Man God as he seemed to think most church people did, but I thought of Christ as God too. God made man and the Saviour of the world. As near as I could understand Theosophists thought themselves as much Gods as Christ. They thought they had to work out their own salvation through endless torturing paths they talked about future states and what met them when they passed on, deplored the teaching of the church & picked only those portions of the scriptures they liked and seemed to me to give as much place to Buddha as Jesus Christ.

A young Hindoo preacher came to Victoria.[167] When I saw that he was giving a lecture on Mahatma Gandhi I went. I did not at the time know that Raja Singham was connected with Missions. He was an ardent Christian and an eloquent speaker. I was very very much impressed by his speaking. He came twice to my house. I talked earnestly to him and knew then that I was no Theosophist nor ever could be. I wanted to be what I was brought up to be, a Christian. I wrote to Lawren Harris.

"I have gone back to the Religion I was brought up in. Theosophy does not satisfy me at all. I have burnt Madam Blavatsky's book. It would only be hypocriting to let you think I was still interested in Theosophy."

I wrote also to Bess & Fred Housser with whom I had had such long discussions. From that time although we discussed work freely we did not discuss religion. I think all artists are religious. Art & religion are so close perhaps they do not know they are religious but if they are real artists it is the God in everything that they respond to tho' they may not call it Religion.

About this time I saw a trailer offered for sale cheap. Trailers had not come into fashion yet. This was a crude affair that a man had built to bring his family from Ontario in. For many years I had searched the country each spring for suitable shacks where I could go with whatever family of animals I happened to have at the time. A big truck came for us, Woo the monkey, 4 or 5 dogs, Susie the white rat, the Blankets, food, sketching material. Off we started towing the old van behind us. We halted at some definite spot I had previously selected. It was never very far from

Victoria no more than 10 or 12 miles off the highway. Requisites were isolation yet within walking distance of some means of transportation, running water, safety & freedom for the creatures and woods & sky for my work. I think these were the very happiest days of my life. The quiet & freedom the opportunity of concentrating on my work, the living in the very heart of what I loved. I left the flats with all their cares behind. I forgot the tenants entirely they washed clear out of my mind. I did not encourage visitors. My sisters visited me very rarely. Both of them disliked camping intensely. They required that I keep them informed by mail of my well being. How I busied myself or how my work progressed was a matter of complete indifference to them. The monkey and each dog had its special corner, there was a row of boxes down one side. The creatures were as completely happy as myself.

Caravan, 1933

EVERY SUNDAY the three Sisters that were left dined together at the school. My school sister's kindergarten had boarders as well as day pupils. There was a long table and brown heads or yellow straight or curley bobbed over their plates. It seemed all the most ill behaved youngsters in the land were thrust upon my sister. When children became so utterly spoiled their parents could not manage them they dumped them in the school and went away for a holiday or they retired into the hospital to produce another hoping to have better luck with its manners than the last. Alice took them in and in her patient way drilled decency into their young persons. The palms of my hands used to itch to smack their young hides for the first three weeks but she had them mostly tamed by the fourth they said please & thank you and ate like humans. But if I found it hard Lizzie found it ten times harder.

Alice would brook no interference whatsoever and Lizzie loved to interfere. Alice carved with a high chair child at each elbow and other youngsters were mounted on pillows and the big dictionary to bring their mouths above table level. The children who came to Alice's school were at the teeth shedding age so that we seemed to have perpetual mince and pappy puddings.

At dinner on Sunday I said I saw something I'd very much like to possess.

"What for instance?"

"A caravan." I told them of the ugly thing sitting by the roadside for sale cheap. To my surprise both sisters advised that if I could manage it at all I should purchase the van so a dream came true not the kind of caravan I had pictured with a horse etc. but a movable head quarters to be out sketching in.

In the Van, August to September 1933

IT WAS PUT IN THE VACANT LOT next [to] my house. Several times that night I got out of bed to look at it. I should have to hire something to drag it. For the first trip I was towed to Goldstream flats a wooded wild Park through which ran a river. In my house at the time was a girl I thought a lot of and her young brother a victim of sleeping sickness his mental growth had been arrested at the age of 9 years.[168] It left him a complete mental wreck. He was now 19 years of age. When the sister came home from business she had her flat to keep & meals to prepare the girl looked very tired. Danny was in a perpetual contortion if he was not twisting one part of him he was flipping another or rolling his eyes or flipping his fingers or nodding his head or hopping on one leg at [a] time, he could scarcely speak for stuttering, at times he was sweet & amiable at times he was ill tempered & aggravating. There was little of interest in his life he used to send my household distracted by his hopping on one foot above the heads of the other tenants. I invited Danny to spend a fortnight out in the woods with me for his sister's sake as well as his own. He had a tent beside the van and could hop all he wanted to.

Goldstream Flats lay between hills. The sun came in late & passed out early. The flats were lush with green, a river ran twisting through broadening out through marsh land as it approached the Saanich Inlet a rough little river rattling noisily over boulders bursting over and under fallen logs humming over broad pebblely places having as many moods as turns. A long winding path up the valley was peopled by Magnificent trees Maple Cottonwood Firs and Spruce all of great age and heavily mossed. But the outstanding magnificence of The Flats was the Cedar trees with their heavy sweeping bows drooping with a fern like gesture layer upon layer of bluey green. You would stand in the caverns of their hollow reddish trunks but it was terrifying to do so. Like Jonah must have felt inside the whale. The van

was jacked up under one of those monster cedars. The layers of bows were like a shingled roof even when the rain poured down it was dry under the cedar. I placed the monkey's sleeping box inside the hollow trunk. In the thirteen years of her life it was the only place I discovered that she could not wreck, she crawled up and down catching bugs & spiders her box had a perch in it and a bundle of woolies hanging from the top which she drew about her and sat peeping from the cavern of the cedar in perfect content. Danny was a harder proposition to settle. I was exhausted by preparation delays etc. the ha[u]ler had not brought right equipment for packing us up & things were slow & tedious, by the time the man left it was dark in the valley. Dan's excitement had worn off he was tired & morose. School had reopened and all campers had left the Park. Down a piece further was a tiny stall where a woman lived with her three boys & sold Ginger Pop & tea & sandwiches to picnickers. She was cut off from us by the blackness of the night. Up on the high road far above the park dashed the lights of passing motors otherwise all was quiet blackness even the sky was shut out by the cedars the sound of the complaining stream made the silence seem greater. Our camp fire glowed & I lit a lamp in the van but it was hopeless to search for anything but food & bedding.

"We'll turn in. Tired Danny?"

Too tired to speak Dan started to hop. I got his bed ready & tried to coax him into it. "Come Dan lie down you're tired."

Round & round the cedar round & round the campfire Dan hopped & hopped. In his pyjamas waving a tooth brush his head rolled as far back on his neck as it would go & his eyes showing nothing but white. So far were they rolled up. I coaxed & scolded but untill he had hopped one solid hour & had exhausted himself he refused to get into bed. I nearly wept for weariness myself. When he finally sat on the edge of his bed he refused to put his feet up but sat there rummaging in his bag.

"What is it you want?"

"Fffffflaaash lll."

"Flash light. Here it is right on top of the bag."

I picked his feet up & twisted them into bed & covered him up. The monkey & dogs were asleep long ago. It was September the nights got chilly. I climbed over assorted camp gear & got into my bunk to find my hot [water] bottle had burst. Out in his tent I heard Dan tossing & muttering.

When light broke through the cedars it was like a key unlocking delight. Under the hang over of weariness from the day before & the poor night was the irrepressible joy of the world uncluttered by man and convention, the crispness of the air intoxication of the Cedar scent—the camp fire. Dan went to the River with a pail but slopped most of the water by hopping, his nerves were a little calmer. I rushed through camp settling, tingling to attack my "work" meaning "painting" for all throughout life, other things have been necessary details of existence to me. I was about 4 weeks in camp that first trip & did some work of deep feeling. I began as never before to burrow under the surface to sit still and let the woods push me rather than dicker with them—try to squeeze and bound them with thin arbitrary lines. I melted out into them through the black nights—let them absorb me in the sunny days & take me where they would. The first two weeks Dan was with me. When light left the valley & the damp drew in early, we had our supper by the camp fire, it was spread on a fallen log. Danny spent his days playing with the Pop lady's small boys but at night after tea his great pleasure was to be read to. The lamp perched on a stump the campfire low. Often the Pop lady would creep over to hear adventures not near so entertaining or thrilling as the one we ourselves were on. The little lamp lit the only book and our faces. Beyond the little light and the books lurid thrill, was enormous palpitating growth. Life throbbing to the tops of the cedars and above into the live air. Every year one lived it became more wonderful. Man had only begun to ruin the edges of Goldstream flats then. Now it's a man's pleasure park—meaning natures luxuriance has been trimmed tidy. Monarchs have been felled and pert tea houses built. Picnicker's litter blows hither & thither. Great patches of gold eyed daisies have silver foil from chocolate bars to stare at. There is a railed-in place for amusement & little colonies of privies.

All the week a magnificent peace spread over the Park in Gold Stream flats. Only occasionally a car turned off the highway & came in. Saturday more came, but Sunday!! Early in the morning they came. Smart automobiles and workmen's trucks, whizzing Lizzie's and boys on bicycles. They whooped & yelled & picnicked everywhere. Because of the difficulty of the big truck which towed my van I had to be near the gate at the side of one of the main roads of the park. I dare not leave the van. People took possession of my camp fire and dishes used my table meddled inside the fallen logs

which should have been barrier enough to suggest the privacy of the small enclosed space under my cedar. They brought their children & their dogs.

To paint in the Park between the hours of 8:30 A.M. and 7 P.M. was out of the question, one side of my camp was bordered by the river. I put up a clothes line & hung my blankets on it making a sort of studio. They seemed to think my ugly box van as a sort of Gipsey encampment & snooped over & under my barricades. The Monkey "Woo" was very clever, she had a little bump of earth which overhung the river as her own. There was scrub willow & moss on it. I was afraid boys would see her & mob us but "Woo" acted up she lay along the greeny grey willow bole or climbed under her shelf of land, hunting insects in the river bank and was so much the color of her surroundings no one noticed her at all. The dogs kept to their boxes. As much as possible we slept through Sunday or read, stretched to nervous tension that threatened to snap like the silence and sweet quiet had snapped. They had shut themselves up and gave little response. One Sunday when it was over the blaring horns & strident voices gone I put the Monkey to bed in her hollow cedar tree & took a walk with the dogs. Mrs Pop Lady was counting the sales of her day.

"Good business today," she purred.

"Fortunate that the bedlam was to some purpose."

"Shan't keep h'open much longer. Even Sundays 'ul fall off soon and there ain't nottink 'ere but gloom once folks 'as quit."

She fell to counting pennies & nickels & I walked on. When I came back Woo was not in bed. She was crying OOO, OOO, OOO, her little grey face looked pinched and suffering but I did not know what ailed her. She refused dainties that I offered & went on trying to tell me, but what? I covered her warmly & hung the heavy blanket over the front of her cage in the tree. Early in the morning I found her no better, she drank a large quantity of water and she vomited the contents of a whole tube of green paint. I went to the tent & found the torn empty tube. She had crept under the tent & robbed my reserve paints. Mrs Pop Lady & her three boys, a kind soul from up Finlayson Mountain in the Park who often came to see me & the creatures, also a little woman from town who came out often & slept a night or two up the mountain in a cabin came they stood round watching the limp little body with closed eyes lying in my lap.

"O'nst our cow licked new paint off our green boat an' she died!" said Pop Lady in condolence.

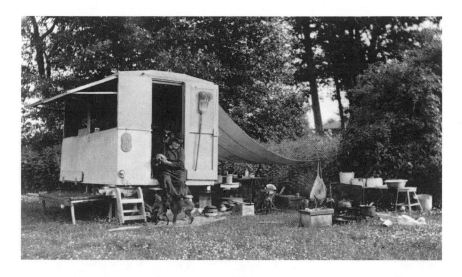

Carr and caravan at Esquimalt Lagoon, May 1934. F-7885.

The little lady up the mountain had heard Woo was dying from her boys who came down to play with the boys at the Pop Shop & came hurrying down dragging most of her 6 children and a quart of new milk for Woo. Woo was very very ill for two days but she did not die. For many a year though she ate red, blue & yellow as well as the green and was violently ill after each. She had an incredible reach, what was beyond her long long hind leg when she lay flat with her her neck at the end of her chain she contrived to reach by slapping towards to her foot with her tail. Woo craved paint like a drunkard.

In the Van, May to June and September 1934

NEXT SPRING I moved the van to Esquimalt Lagoon. A clear stream in a little wood, wide daisey patches, Sweet Briar rose bushes, sheep nibbling, the sound of the sea & a great stretch of sandy beach—perfect setting. As the spring advanced my spot got wetter and wetter till finally the van stood in a bog. It was an alternative of bare foot or gum boots. It seemed the river had changed its course. After a fortnight I decided to move, climbing half a mile up onto the Metchosin high road searching for a likely place. I came upon John Strathdee[169] working his field. He was not old but some while

Woo warming herself by the fire, Metchosin, 1934. G-0413.

had past since he was young. I asked him about the adjoining property which was wild & open.

"Well now," said John. "I could na advise it being unfenced & hoodlums round about. Move her to the corner of my place if ye've a mind."

There was a little corner with pine trees & mossy, John's rail fence would certainly be a protection. The moving van came. I piled the animals & furniture food & blankets in but when it came to the van she refused to budge from her bog.

"I will have to go to town for different gear" said the man. "Will take you & the stuff up to new place & go back for 'th'ole lady.'" Meaning the van. We sat in John's field from 11 to 3 waiting in which were my food stores & work material.

I was aware that a shadowy little person was skirting the front & then the side of John's fence, that her eyes leveled the top rail & pierced under scrutinizing me. I saw her finally go into John's house gate. She came towards me a fancy little person in a scarlet hat & high heels.

"Have ye seen a lad abouts anywheres?"

"No" said I, not connecting John with youth.

"Its me brother John this is his place." She regarded me sternly. "Are ye havin' a wee bit picnic in brother John's field?"

"Not exactly a picnic," I replied regarding the bricks & top that would form the stove, the bed, two chairs, a table, 3 dogs, the monkey & Susie the rat. "I am waiting for my caravan. Mr Strathdee has given me permission to camp here."

"OO aye" she said as dubious as if I'd been 16 instead of 60 and the "lad" a young sport. John did [lose] his heart not to me but to the monkey. Every night he came to her stump to play with her. Elsie came from town once a week to rid up "th' lad's hoose" then she came to the van & had tea with me loving all the creatures and always with some dainty for Woo. There was a wild happy peace in John's field, and behind was great stretches of second growth land, fuzzy young firs with brilliant new yellow green tips & every bow all upward curves & circles, an occasional old veteran grim and stark throwing its arms against the sky with a battered droop to it. Spindly poles of trees with little tufts on top but no lower bows. Trees that had been too blemished or insignificant for the loggers to bother with swaying in the wind as if they wanted to tickle the sky, long vistas of scraggy leavings and fallen trees which missing their fellows had crashed. Now myriads of red ants & black were boring, chewing nesting in them, reducing them to red powder that green growth soon pushed through. Mountains here & mountains there, close ones fir covered & green far ones cloud topped and blue as the Heaven that met them. What a lot those quiet stretches of logged off left to itself land had to say. I never met a soul only silly faced sheep who scampered off bleating because of the Griffons[170] whose haughty noses and rolling eyes ignored them.

There was a gale one night small bows broke off the old pines above me & cracked on the taut canvas top of the van like drums, any minute I knew a big bow might come down and crash [onto] the van. I dare not light my lamp, fire would be worse than all. So lying in the dark with the creatures I waited, reashuring them when Woo gave little fearfull "Woo Woos" & the dogs whined. It is amazing the strength & comfort one gets from the calm of animals. Great bows did not smash the van that night but I welcomed daylight with the wind down.

Opposite Mr Strathdee's gate was a wood, very dark & sombre. The trees were high & thick with reddish earth seamed with roots & little

undergrowth. Ghost flowers[171] grew here, sometime called Indian Pipe they pushed through the flakey leaf mould seeming to like bursting up under a litter of fallen things. The hook of their necks showed first like little colonies of white grubs. They looped higher & higher till necks pulled their heads out of the soil and you saw the cups of their dead white faces with white caps over them. Everything about the ghost plant was white. If you touched it or if it was exposed to strong light it turned black as though it felt you more than most flowers & said "Keep away can't bear you" but if you sat and watched its strangeness without touching, it was one of the most melancholy mysterious flowers I know. These solemn woods sloped from the highway & down & down & down towards the sea. I got some fine big tree work there, immense boles rearing into dimness of far above tops. Lying directly under Heaven itself you knew the blue sky pressed down upon the green black top branches that those powerful boles upheld. The solid masonary of these heavy cathedral-like woods with their sensitive [ghost] plants mysteriously pushing through the pine needle mould was entirely different to the stretches of vivid second growth on the further side of the highway with its singing exuberant upspringing.

In the Van, May to June and September 1935

NEXT SPRING I moved the van 3 miles on to a sheep grazing field which was shared by a flock of turkeys from a farm across the gully. The turkeys came hunting grasshoppers early in the morning uttering their dismal peep peep. The hens minced across the field with their small headed poor-fool chicks running behind & sinking in a gawking squat when they saw the griffons who kept a circle clear of sheep & turkeys round the van. Over us the skies were high. From the Point you saw across the sea the Cascade Mountains.[172] I spent part of May & the month of June out in the Van and did a lot of open sky sketches here. The three nearest houses to me were all empty. At night when the turkeys & the sheep had gone home to their farm and the dell below me lay black & silently except for the secrets whispered between the sea & the trees, I would sit among the sleeping creatures in the van my feet on a biscuit tin that contained a hot brick the little lamp above me and write. When I lay in my bunk waiting for sleep to catch me up the whole ceiling of the field

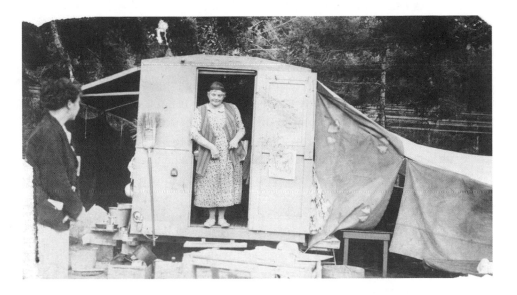

Emily Carr standing in the door of her caravan "Elephant" with Ruth Hembroff-Herrington at the left, in Metchosin, July 1936. Photographer: Helen Hembroff Ruch. D-03842.

was peppered with stars. In the autumn when I returned, the skies were high & aloof & then I busied myself with the sea & rocks and interesting trees in the little dell.

In the Van, June 1936

I MOVED THE VAN to the Gravel Pits, lying about 3 miles north of Albert Head.

The high bank was hollowed out in the immense Pits. At first the vast mystery in the emptiness of these yellow grey centres appalled and sickened me. Far far down at the bottom near the sea lay the cluster of work buildings and a long tres[tle] running out into the sea down which the cars ran & dumped the gravel & sand into scows. A whistle blew at 12 and at five & there was a far off palpitating chug chug but there were no voices work men looked like flies. My van was on the Bank. I looked over the harbor lights of Victoria which twinkled across the sea as the stars twinkled across the sky, on the land no lights were in sight. Groups of fir stood about me and very many huge ant hills. Down the road a way was

a dense junglely wood where I did much study. It was so big and thick you could easily [lose] your bearings eventually you would come out on one of three roads but it might be a very long way from the van. One day when I got lost from being intent on searching for my subject & forgetting to note my direction I landed in a bog & had to fight my way through dense thicket. I was ravenous by the time I made camp and found Woo had stolen the enormous Brown egg I was going to have for lunch & had drunken up the milk. I found a new stump for Woo after that. Her cosy log was nailed on top of the stump so that she was quite protected if wind or rain came up while I was away, rolled up in her woollies the little grey face peeped out the door with a screech of welcome as soon as she heard me coming. She heard quicker than the dogs two or three dogs were always in camp and one out with me. I worked much better when a dog was with me he sat at my feet very protective. Some of my best work was done in my caravan days & I was furiously happy from the moment I woke & ran with my pails barefoot through the soft wet sheep grass, dogs & Monkey racing & squabbling behind, and I used to sing "Oh ye works of the Lord Bless ye the Lord. Praise him and magnify him for ever." Like the chant they had sung in the San Francisco church the Easter so long ago when by my bringing up I was shocked by the violins & paid choir and then swept off my feet by the beauty of it but now I addressed everything I met, earth, stones, little fir trees, grass, old stumps & sheep and sang "Oh Ye sheep & lambs Bless ye the Lord etc." Life seemed so responsive and awefully good. I did up camp cooking over an open camp fire & shouldered my big sketch sack & went off to the woods. In the evenings there were good skies over the sea and pits and when the light was gone & the campfire out the Old Van with the lamp & the hot brick for my feet and my typewriter clicking out the tune of my stories. I wrote "Mrs Crane"[173] at the Gravel pits. At the end of a month or six weeks I had to come back & shoulder that bad old burden "the house." And found the weeds in the garden grown enormously & the house looking absolutely "rented." No matter how nice I left it, the flats looked like the half fledged brood a hen has forsaken and gone back on the roosts. A blind broken a huddle of leaves blown into a corner gates open the milk bottle left where some one broke it, a shoe on the lawn, some one's hurl at an operatic cat.

In the Van, September 1936

I REMEMBER WELL THE LAST TRIP. Getting things in shape to leave was always so big a job that I used to say it is worth while. I had to find some responsible person I could leave in charge of the place. There was baking and buying so that my time would be as little broken by food bothers as possible. There was the preparing of my work materials, the assembly of the miscellany of disreputable oddments one takes to camp. It was a horrible array of wreckage out on the street pavement when the truck came. The monkey was beside herself rattling her cage & shrieking with joy, she usually contrived to undo something or get into some mischief before we started. The dogs would not let me out of their sight, camp to them was complete bliss living so close to me. Only Susie the rat was calm, Susie's world was bounded by the smell of my things, she never went beyond it. I could leave her loose in the van with doors & flaps wide open but Susie never thought of leaving it. One time she did chew the tail out of my town coat to make a nest, I'll admit otherwise Susie was a perfect lady.

Well that last trip[174] I remember how tremendously tired I was on starting. The weather had been variable but the morning of my start was grand. I made camp building a stove out of bricks & a sheet of iron fixing a tent fly over an old trestle for the food tent, putting up a clothesline, bestowing the dog boxes along the side of the van making the cosy bed that I could lie in and look out my window at the stars, taking the pails of water & setting them on the bench & then the rain came down. I returned to bed with a hot [water] bottle. Every creature in the van slept. The rain continued for one week and for that week I slept waking only to read a little or put the kettle on the oil stove & make tea or run out when there was a lull to loosen up the dogs legs. My spirit was occasionally fret full at the work I was missing but my body was resting in preparation for a mad onslaught. Why we can't take these stallings to our good and benefit to the full by them instead of fussing & worrying I don't know. When you look back you can see it. At the time your inward fret at inaction warps the calm of waiting.

People were beginning to notice my big woodsey sketches.* I backed some with cloth mounted them like maps & sent them East. They were exhibited in Toronto with most favourable comments.

* See plates 28 and 29.

Overgrown garden and Carr residence, 207 Government Street, Victoria, 1935, just prior to the death of Elizabeth (Lizzie) Carr, then sole occupant. Photographer: C. C. Pemberton. A-06516.

Mr Charles Band[175] wrote from the East he asked me to send him some canvases to see, offering to pay their expenses. He sent back twice for more and a number were sold. The Art Gallery of Toronto bought and several private collections as well as individuals.

That Autumn my sister Lizzie died.[176] I had only a short session in the caravan and most of the time it rained which meant more writing than Painting but I found writing helped painting as painting helped writing. It seemed to make things clearer in my own mind, trying to express them one way or another. It taught me to look deeper with a searching earnestness. I visualized my words and worded my "seeings" and seemed to get a fuller understanding a deeper inlook. At first it was very difficult to find words & form sentences they seemed to have a preference for going hind[?] before. I found there was a great deal of cutting down leaving out and selecting just as there was in painting. I went over and over and over disheartened

at the crudity & illiteracy of my writing and then when I remembered all the miserably poor sketches I'd made I did not feel quite so bad. I began by writing animal stories. I did not want to sentimentalize over the creatures nor give them human attributes or make them think human and above all not to speak. I wanted them to belong to their own kingdom but come half way to meet me as I would go half way to meet them that was what I wanted a half way meeting place that was "no man's land" but above all don't let it be a place of mawkishness & sentimentality, that lowers the beautiful beasty dignity, the integrity of their own kingdom instead of sinking the unwilling creatures to the level of 10th rate humans giving them sentimental ideals instead of the honest instincts of their being.

1936 to 1937

MY APARTMENT HOUSE WAS 22 YEARS OLD. It was out of date & out of repair but I had no money to level it up to date. It was sliding into second rate & the rentals falling. I put it up for sale there were no offers. As the rentals sank taxes rose. After a year of steady search I found an exchange in a small rentable house in tolerable repair. Giving up the Studio and the garden hurt. I gave my tenants polite notice with singing in my heart.

The exchange was in a good district the other side of town[177] not the part I'd been born & raised in & there was no possible room I could use as a studio. With the going of my house my income went so I rented my little new house and moved to a cottage[178] in a cheaper district too tired after the turmoil of moving to care what happened to me. It was a working man's district but there were open spaces. A great sports field, a children's playground and a bit of wild unused land the sea close and a good yard with fruit trees where the dogs could run, and a not too bad light for a studio.

For some time the long stairs had been trying my heart. Shortly after I gave up the big house I went to see the Dr. He said my heart was bad, it got worse and I went to the hospital. With the uselessness of my body my brain seemed to become very alert. One day I said, "Doctor if something is teasing you in your head isn't it better to write it down and be rid of it?"

"Yes. What sort of things."

"Stories I want to write."

"Write a little but don't overdo."

So I began to write Indian stories. Little incidents of person[al] experience among the Indians during my sketching trips. Descriptions of their villages & totem poles and of the Coast of British Columbia. I lay there travelling and re-living. It came to me very clearly. I could close my eyes and be there taste & smell the country and the big woods as well as see & feel and hear it, was back among the people and the places. It was the salvation of the long weary hospital days and the year of days when unable to paint I tried to express in words.

One day in hospital there was an abrupt knock & in burst a telegraph boy & thrust a telegram at me. It was a bitter day the road gilded in ice, undoubtedly crazy thoughts flew to me. Without rhyme or reason my sister fallen & broken her leg etc tho why a telegram from [the] same town. Fearfully I read "Can you see Eric Newton Art Critic of Manchester Guardian.[179] In town few hours sent by National Gallery of Canada to see pictures."

"What can I do?" I said to the boy.

"Dunoo" said he.

"Tell him I can't."

We were muddling out my no's when a friend came in & helped to straighten things out.

Miss Humphrey met Mr Newton, Mr Newcombe had my house warmed & exhibited the pictures. Mr Eric Newton came to the hospital upset by the wire the nurses refused to let me see him but by lunch the Doctor was there & being a common sense Dr knew it was better I should see him than worry. Eric Newton was a quiet gentle man he had only seen a little of my work when he saw me. He had been up island.

"I have driven all day through the stuff you paint. It has touched me deeply."

"Get better" he said, laying his hand on mine. "Those hands are too clever to lie idle."

Then he went back to my cottage and stayed till the midnight boat. They told me he revelled in my woods, was most enthusiastic. He made a selection of 15 pictures to be sent to the National Gallery from which they were selecting for purchase.

They told me Mr Eric Newton was extremely enthusiastic. He said "I have not half time enough I wish I had another day to spend with these pictures." Willie Newcombe arranged all the shipping, some of them had to be brought to the hospital to sign and off they went. The National Gallery selected three

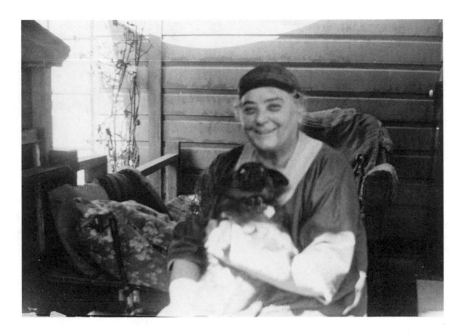

Emily Carr on the veranda of Alice Carr's home, St. Andrews Street, Victoria, 1941.
Photographer: Nan Cheney. UBC 1849-46.

pictures "Blunden Harbor" "Heina" large Indian pictures and "Sky" one of my recent sketches. Mr Band had in the meantime purchased "The Indian Church" from Lawren Harris and "Nirvana" from among those he had had sent over. Lawren Harris had also purchased two. Mr Band collected those pictures from Ottawa and gave me a one man show in The Grange Gallery in Toronto. Very few of those pictures came home again, and I think the easing out of the hospital & Doctors bills by the sales of those pictures had very much to do with my ultimate recovery. These years of success are harder to record than the struggle. My work was built up of knocks they were the hard good bricks morticed together by the loneliness of a solitary struggle. I never thought I'd be so happy at the closing, the struggle still goes on and will to the end. I have set 70 as the working limit I want to stop when I dodder & get weak. So often visitors say "the amazing part is your work gets more & more powerful more uplifting." That's a very glorious thing to hear and heartening to the little Old Black sheep that after Mother's death grew up crude & unchurchy in a family of godley women.

Facing: "The Merry Widdow" (detail). Emily Carr, ca. 1908–1910. PDP06150.

Emily Carr's Stories

"Black Sunshine"180

THERE WAS A COMMON BLACK CROW whose name was Crocker, "Crock" for short. I owned him.

One after another I climbed seven tall pine trees, a crow's nest in the top of each, to steal Crock from his mother before he was rightly fledged. He was in the last, the seventh tree. When I descended from the sixth climb I was very tired. The seventh tree stood a little apart and the mob of angry crows that had swooped and screamed over my head had pretended steadfastly to ignore the old, dirty, dilapidated nest in the top of the seventh tree, leading me from one to other of the first six.

I began to get into my petticoats which I had left on the ground while I climbed, but ... I had set my heart on a baby crow. Throwing my petticoats again aside, I began to climb the seventh tree. It's under bows were dead and brittle, snapping under my weight, piercing and ripping my flesh on their sharp jags. Higher up the bows were supple and green, they swished and whipped me briskly as I passed, hiding unpetticoated me from the earth and the sky. The crows had quieted while I was down below; now with mad clamour they massed over the seventh tree, a flapping mob of black fury, fathers, mothers, aunts and cousins of the tribe. Their rasping caws were deafening. The seventh tree was the tallest and the hardest to climb. When I got to the top, the birds swooped, their wings fanned my hair, I ducked my face into a crooked arm to save my eyes from their beaks, firmed my feet into two stout crotches of the tree, so as to leave

Emily Carr with crow Crocker on her arm, seated with family and friends, Gonzales Beach, Victoria, BC, ca. 1887. Photographers: Hall and Lowe. I-60890.

my hands free; crept one hand over the nest's rim. The nest was full of hot, naked flesh, burning heat which develops young birds with such amazing rapidity.

Slipping my fingers round the body of a baby I lifted it from the nest and put it into the little basket I had tied round my neck in case I had luck. I buttoned the basket under the front of my blouse to keep it from upsetting or being torn from me in descent. Kindly boughs closed over my head shutting me away from the fury above. I was panting when I came to earth, as much with delight as with exertion.

He was a hideous, unclothed little creature but I was very happy in possessing him.

The advent of the crow into my life brought lots of trouble—I now had his battles to fight as well as my own. Never was a bird so mischievous as Crock, never was I more rebellious. Crock and I were punished each for sins of our own and for joint naughtiness. Affliction drew us close, we comforted one another.

The crow was very intelligent, more so than any parrot I ever owned and I have owned twelve. Crock was never confined; he flew and hopped wherever he would. He wanted to be wherever I was—close. I had but to call, "Crock" to be answered immediately by a hoarse, "Caw" and have him swoop from some hiding. He was a thief and a plunderer. He brought me tears and giggles. Now I remember more the giggles than the tears. I feel again the burn of his glossy black when he had been sitting in the sunshine, and I went close and laid my cheek against his sun-soaked feathers.

Dogs[182]

"Billie"

PERHAPS THE MOST COMPLETE animal friendship I ever enjoyed was with my old Sheepdog Billie. He came into my possession at the age of three with a reputation of Vicious. He was offered to me and I refused him because of the vow I had made not to have a dog till I owned my own home. I refused Billie but Billie accepted me. From the moment his great brown eyes rested on mine every bit of Billie was laid at my feet to do what I would with.

Because Billie was reputed as vicious he was kept closely chained and only loosed at night. They had had him some time when I returned from London. What a life tied to a kennel day in day out.

I took him out sketching with me and thrashed him well en route for killing a chicken.* The powers that be were scandalized they had been warned never to whip him he was so vicious and bit. "He has killed a chicken," I retorted and finished the job well. Billie was subdued and remorseful and I had gone way up in his regard because I was not afraid of him. Next I bathed him and was told that I'd get badly bitten if I took these liberties with such a wicked animal. Now the dog was clean and self respecting and knew just where we were with each other. Still I dared not love him too much for I

* See plate 30.

did not own him. The powers were afraid of him and at any time he might share the fate of that other dog of mine.

When I went to live in Vancouver and first had a home of my own I claimed Billie. Even in the few months of our acquaintance we had become deeply attached and he was becoming gentler and sweeter all the time. In three months he could be trusted with any baby. Year by year during the sixteen years of his life he got sweeter and sweeter tempered. I have never seen a dog win such respect and affection from every soul he came in contact with. He was a character a distinct personality. Intelligent trust worthy and magnificently obedient. Always jumping between me and any danger guarding me or anything I loved from a baby to a white rat with the utmost devotion.

Billie had the keenest sense of humor. He joined in all the jokes. The markings of his face made him look as if he was always on the broad grin. When we first went to Vancouver to live and Billie was a free dog he had a notion that when I went in to a store and got a parcel that he ought to come out with something too. One time it was a pound of butter another it was a cake or a piece of meat often he would wait behind the counter and dash out with his trophy as I left the store.[*]

One day I was getting some cream I saw Billie disappear behind the counter, he returned with a mouth full of chocolate creams. The man was angry. I paid for the sweets and then whacked Billie. A week later I went to the shop again. I left Billie outside but some one left the door open and I saw his bobtail disappear behind the counter. I whistled and instantly he came and sat by me. I was some little time. As soon as we were outside the door Billie looked into my face with one of his irresistible grins and produced a huge stick of pink candy out of his cheek. He could see no sin in them and the spankings were only to appease the shopmen to his way of thinking. One day I went to a cake shop.

"Those cakes you gave me yesterday were stale." I complained.

The woman was cheeky. "Well," she said, "I have to work the stale ones off on some one."

Before I could answer Billie walked straight to the window selected a cake and walked out of the shop. It was so apt that even the woman laughed and did not charge for the theft.

[*] See plate 31.

What care Billie took of the Studio and all in it. I could visit other people in the apartment block knowing that if any one came to the door he would let me know. One night I was visiting some neighbours and Billie gave my visitors bark so I went home to find no one there.

"Billie dog," I said, "you fooled me."

Billie walked over and sat under the telephone. I took the receiver down it was some one trying to get me on the phone. After that I knew that if he barked for me and there was no one at my door, there was on the telephone. All my pupils loved Billie. Periodically I gave big exhibitions of my students work it was wonderful how Billie entered into the whole spirit of it. He always had a preliminary bath and then a ribbon tied on his wooley head and another on the tuft that represented his bob tail. And he was the busiest person at the party. He went to the head of the stairs and welcomed every visitor brought them in to me after shaking hands with them and then went out to meet the next. Billie was three quarters of the party. When I took sketching classes of children out Billie was in his glory rounded the youngsters up like sheep [and] entered into all their jokes.

I was up sketching once in Yale B.C. It was winter and very cold snow and Ice. One night I went up the mountain trail at dusk. The trees stood black and solemn pointing skywards and deep shaddows lurked beneath. Presently Billie sprang in front of me every hair bristling and deep growls rumbling in his throat. He stretched himself in front of my feet and begged me to go back. First I did not heed and told him to get up but tho he rose he would not let me go on and I could see that he was very upset he trembled violently. "I guess you know best old dog," I decided as we turned. He was over joyed and urged me on as quick as he would. I told people in the hotel how he had acted and they asked where I was.

"Ah" they said. "There has been panther coming down that trail every evening after sheep and chickens." If it had not been for Billie I might have walked in to this beast.

That same trip I finished work one night and started home soon I missed Billie. I whistled but tho he cocked his ears he did not leave the spot where I had been sitting. I went back to see what ailed him and found I had left my brush case on the ground with a lot of valuable sable brushes in it that I could not have replaced and would have finished that sketching trip.

That was the way of it. He took care of me and mine and I got to rely on the dog's sense very completely.

When Billie was ten years old I went to Paris and the only bad spot about that trip that I had saved up for [for] so long was the leaving old Billie. He had lots of friends and several offers of homes during my absence. But I took him all the way up to Edmonton to leave him with a special friend. This girl had stayed with me in Vancouver and Billie liked her.

"Understand" I told her "that if in any way Billie should get into trouble or suffer he is to be put to sleep don't wait to hear from me my wish would always be that he should not suffer."

I stayed with her a week or two and settled him in. When the time came I put Billie into the basement and I went down to him. I gave him one of my coats to lie on and I said to him very clearly, "Billie I am going away and you cannot come." A piteous look came into the brown eyes but he lay down on the coat for he never disputed any command of mine.

I kissed the wooley head and wondered if I'd ever see him again. He meant so much in life to me.

They were very good to him and made it as easy as possible but Winnie wrote to me it made her ache to see the far off patient look in his eyes, always waiting. His one comfort was Winnie's baby. He appointed himself nurse maid. She put the baby to sleep on the porch and Billie lay beside the buggy. If the child cried he got up at once put his great paws on the edge of the buggy and jiggled it and stuck his great kind face under the hood. She would watch him through the window. When the child was in the pram he appointed himself her special guardian. Indeed Winnie wrote that I shurely would have to get a pram when I returned as Billie enjoyed his walks so much better beside one.

I was away for eighteen months. It was arranged Billie should be shipped to Calgary and I would pick him up as I came through. We had twenty minutes. I ran into the shed and asked the man if they had a dog for the train. He produced a little yellow mongrel then I gave Billie's whistle. Oh the Yowl of Joy that came from that pile of barrels in the shed. And when he saw me well it was just a stir up of extasy warmth sweetness all misted up with tears.

The express man said "That dog seems pretty glad to see you miss."

"We've been parted eighteen months" I replied. Then every one on the platform got nosey thought the dog was going to eat me up or something and I bundled him on the train and ended the exhibition.

Winnie had written "I am afraid old Billie will hardly hang on till you come he has aged dreadfully." He was old and fat and grey round the muzzle. But the years dropped from him miraculously. He lived six more years and when Winnie came to Victoria three years later she was amazed.

Towards the end of his life he could not bear to be away from me if I had to leave him for a night or so he aged up and got so feeble he could barely crawl but the moment I came back to him he got strong and brave again. It was as if the dog's very life was bound up in me and I was necessary to keep him alive.

When he was sixteen he became blind deaf and very rhumatic. All of a sudden and I knew that the time had come for me to fulfill my oath for I had sworn that Billie should never live beyond his happiness.

I loved him too much for that. No matter how hard it was for me the greater love thinks of the object above the self.

I got him a great dish of Ice cream which he loved. I could trust the man who was to take him and he knowing me came an hour ahead so that I need not suffer so long.

Billie knew as I put the leash to his collar he licked my hands. The old dim eyes looked into mine. The old stump tail wagged contentedly he trotted from the room, a fine brave old gentleman to the end.

Studio Billie

A MAN WHO BRED very fine dogs in Vancouver used to twit me about Billie for Billie was not quite pure bred he had some retriever in him but the sheep dog characteristics were all there. I believe deep down in his heart he had a tremendous admiration for Billie's wisdom and nobility of character the depth of his affection for me and his magnificent obedience. Enclosed is a little rhyme I wrote at the time it still hangs with a portrait of Billie in the Studio.

Billie
Billie ain't no special Breed
Billie can't be jest styled handsome
But his only vice is greed
I ain't got no pa nor ma
I ain't got no brothers

Ne'er an uncle or a Aunt
I ain't got no lovers
Kith wat wants me lives away
Kin wots here don't like me
Life ain't jest a comfie place
Often seems to strike me
When I'm sittin thinkin
Darn it ain't it drear
Billie up and whimpers
Licks away the tear.
Billie savveys heartache
Wheedles it away
Enters in with joyous zest
When the world is gay,
Billie shares the labours
Holds his end up fine
Does his duty fair and square
Good as I do mine.
Billie's just a bundle
Love an fleas an smell
Think I'd change my Billie
For the thorough breddest swell?
I don't say it's again a dog
Bo[a]stin' miles of pedigree,
I only say my ole cur Bill
'S good enough for me.

Old Billie

OLD BILLIE HAD very few whippings in his 16 years. When he got one it was for some unpardonable sin. What hurt far worse than the whipping was the glassy eye with which I regarded him after it. I could not keep this ignoring up too long for it made the dog sick. At first a whipping did not mean much but as the dog got more sensitive to love and close companionship to be whipped by his God and then left out of her daily life for even an hour or so was torture to the beast.

One day when we were in a far off Indian village sketching the breeze brought a whiff over the land that was more than unpleasant. I was talking to a companion and did not miss Billie for a bit I whistle for some minutes before he came over the hill with a hang dog air that at once gave me the clew. It was a dead sheep all gone to goo. Billie had rolled and rolled in it and the situation was beyond description.

He was sleeping in my room at the hotel as there was a monstrous colley who fought and killed every strange dog who came to the village so I would not dare leave Billie in the shed.

I got a stick and did it thoroughly. Billie took his hiding without a whimper and even tho the offense to my nose made the whipping easy I wished he would squeal as it is horrid to whip a dum[b] creature.

I took him first by the front legs and then the back and drew him across the sand but the awefulness was sticky his long coat was full of it. Fortunately I had a bit of soap in my sketch sack and tied my water cup on to a long pole then I waded into the sea and my friend ladled water on to Billie's back while I scraped and soaped with a swab made of my paint rags.

We had a bottle of lavender water and poured it on lavishly and for the rest of the day I would neither speak to or look at Billie. My sister was going driving with the pony and cart and to run behind the trap was the only thing Billie would do away from me and enjoy but he never went unless I told him he could.

"Shall I take him?" she asked.

And I said to the dog "Go, Go."

He gave me a pleading look as I went in the other direction with my paint sack but I took no notice and I saw him droop out of camp behind the pony.

By and bye I felt rather than saw that Billie was behind me. When I sat down on the campstool to work he did not come as always and sit beside me but stayed behind his head sunk on his paws. Engrossed in my work I forgot him till I heard a young foal in a field screaming and racing. The thought flashed suppose Billie was chasing it. "Billie" [I] shouted in my usual voice.

He was just behind my stool, at my cry he was upon me forgetful of pallet[te] and paints and all the artistic etiquette he was so well trained in.

Forgiven.

It had been a beastly lonesome day for me too.

He did look funny half his face green and half red and yellow and blue on his great paws. But I Turpentined him and didn't care. I had seen the

bare soul of the dog that day. That aweful smell was wild beast intoxicant irresistible. Too strong for the sense of right and wrong that he had to a remarkable degree, for the moment even swallowing his adoration for me. The patient heroism with which he stood up to his punishment.

The abyss of agony in which he sank when my love and notice was withdrawn from him, and the faithful sneaking behind to take care of me in the woods. These all swallowed up in the wild ecstasy of forgiveness. How the great brown eyes glowed behind his shaggy mob that night. Billie you were nice and what a magnificent spring you did make at that undesirable in Stanley Park. Humbling angry growls first and warning him to leave your missus alone and then the leap at his throat so that he beat a hasty retreat with you at his heels clean out of the woods. And how I worked straight on knowing well I was quite safe in any lonesome spot with you by. Yes Billie was fine. I owe lots of my Indian pictures to that old dog for I straight couldn't have gone to some of the places alone. There was the night at Guyasdoms not one soul within miles. Ghostly old houses buried in undergrowth. Just Billie and a little Indian girl and I. We had no light and the fire wouldn't burn in the broken stove half full of water. Rats swarmed boldly we were invading their domain and as our blankets were on the floor. It was impossible. The little Indian girl alternately cried because she was afraid and snored because she slept. I sat the night through on a box while Billie snuggled close and watched. The moon came up very late and shewed a coffin in the pine outside the window broken and its g[h]astly contents hanging half out. The branch the coffin was tied to tapped the window all night. The one bit of human comfort was Billie his warmth and his courage and his devotion made it possible.

Just one time do I remember the old dog losing patience with his Mom. The first time he saw me in the water learning to swim and squeaking a goodish pet I guess. Billie was on the boathouse. He hated the water. With one great plunge he sprang in to save me, when he swam out and I refused to be saved and called him an old hen for his pains, he was indignant. Back to shore he swam and going up to my room got under the bed and sulked when ever he saw me in my bathing suit after that he hid under the bed refusing to go on the beach and behold anything so against all his principals.

When Billie was in danger or trouble many people remarked the fact that he just kept his eyes on my face. Once when the bank caved in where

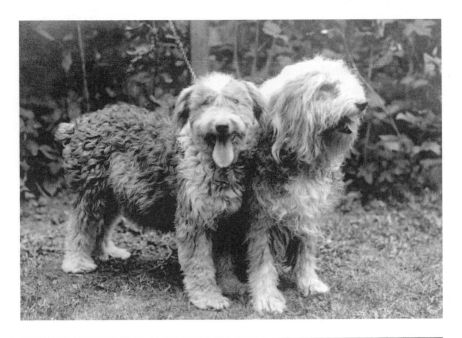

Two of Emily Carr's bobtail sheepdogs, 1918–1924. G-05040.

he was drinking and he was swept down a roaring torrent[,] his trusting eyes were on my face all the way. When a great dog three times his size sprang on him and pinned him down on his back he never gave his enemy a glance he had no chance but his eyes were on my face. Three people were there, all remarked [on] it. Ah Billie you were nice.

When Billie died I said to myself, "I don't want another." Folks feel like that, then I said "Look here old girl. You gave that old chap the best life you could he lived longer than most and you were darn lucky to have had him so long. There'll never be another Billie, and you don't have to give his spot to another. But there's lots of dogs full of love. And it's a small mean heart that can only hold one in a life."

So I tried pups. I got three pups in turn without a speck of sense between them, so I passed them on to someone else and finally located some Bobtail sheepdogs like the best part of Billie was. I started a Bobtail kennel. Times were hard and it was a case of Boarder or Dogs. I did well with the sheep dogs raised 350 pups shipped north south east and west my dogs were noted for their wisdom. They were dandy workers with sheep and cattle not a few

I sold to mind Babies for a Bobby wants work and responsibility. Then he is in his glory. I could fill a whole book with their quaint ways and funninesses. The pups were adorable roly poly wooley bundles of comicality each one with an individual character.

I called them after the patriarchs Adam Eve Solomon Rhoda David Job Moses Noah. My Garden was a lively bible. I dragged them through distemper. Helped the mothers out with a baby bottle when their familys got too big, sat up all night with mothers who wouldn't let me out of their sight till their families were all safe and sound in the cosy nest and I had admired each pup in turn. They had enormous families one lady had 14 at one go. I let a mother keep about six and either bottle[-fed] the balance or bucketed them according to how the market for pups was going.

It seemed such an aweful waste of energy and strength to have perfectly good pups and drown them. That's something in life I don't understand why a mother should produce more than she can handle.

Adam

BEFORE I FINISH with the sheep dogs there is Adam. For a change of stock I bought Adam in Calgary as a tiny pup. One of my pups David two months older than Adam was as keen on Adam as I was. It was comical to see David wait on Adam. He would hand him over his own food. Once when it rained Adam was chained as he was a terrible jumper a six foot fence was nothing for him. David went into the basement and carried rugs out and put [them] down for Adam to lie on.

When Adam was 18 months old I went up into the Okanagan and took him for company. I had gone for two weeks but owing to an illness was there for two months. People were very good to Adam and he was allowed to lie beside my bed every evening for a bit it was thawing and his great shaggy feet were wet so it was very nice of them to let me see him.

Finally almost too weak to crawl I started for home. We took the boat from Kaleden to Penticton had to spend the night there and got the train next day for Victoria. I took a cab to the place I was spending the night and left Adam at the baggage room for the night going down early the next day to give him a run before train time.

One of Emily Carr's bobtail sheepdogs, possibly Adam. G-02843.

When the train came the earth trembled. I was on the platform and the dog was running round near me.

When the earth shook Adam bolted in fright like a runaway horse before I knew what had happened his great long legs [had] taken him way up on the benches, beyond my call, in terror he was streaking higher and higher up the slopes.

Here I was too weak to chase him or even yell loud. The train going, they renewed my ticket but only for that date. I had so far overstayed my time that my money would only just take me home.

"Don't worry" said the station master and suggested that the jitney man be sent right after Adam and take him a couple of miles on where our train waited for some time for water etc. If he did not make the train they would send him on next day. There was nothing else to do so I did that.

But Adam did not make that train not the next or next and in a fever I waited. Then wired and wrote, I sent an ad to the Penticton paper offering a reward. I got in touch with the police. Finally I was told that Adam was running wild that he kept coming down to the wharf but would let

no one get hold of his collar, if spoken to he bolted. I did not believe it at first for Adam was the gentlest of dogs and accustomed to travel and strangers. However several people I knew went up there and all told me the same story. No one knew where his headquarters where he was just seen running here and there with frequent trips to the boat to hunt for me. I was very unhappy. Finally for six months I got no further news he seemed to have disappeared and I concluded he must be dead or taken out of the country. After Adam had been lost for 19 months I got a letter from a lady in Penticton, she told me she had moved into a new house. It had been empty for a considerable time. Adam she found was sheltering under it. She knew the dog's story and being a sweet and wise woman her heart went out to the poor lost creature she called his name. He stopped running at that sound, but when she advanced he tore away. She put out food each night going into her house and shutting the door that gave him confidence. Some few days later she was working in her garden and felt something by her side Adam was there with his paw held up to shake hands with her. Her tact won him.

She wired me at once asking me to come up and get him. I was crazy joyful. Before I had time to start came a wire. Shipping Adam today.

"I couldn't bear to keep him away from you a day longer" she said "and I was getting so fond of him that I would not have wanted to give him up" she wrote me.

I hurried to the wharf he was in the baggage room and did not see me till I spoke.

Slowly the great head lifted to my shoe, smelled me quickly to the chin then the great shaggy paws were on my shoulders and I had the biggest licking since I was a kid.

I wondered would he be wild and unruly after 19 months of wild life but he might not have been away 24 hours he took his place in my home just as usual except that he couldn't bear me to go out of his sight.

A few months later I had to undergo a severe operation. From the time the Dr had given his verdict Adam became terribly restless. He broke collars chains chewed down the side of his bed, jumped the yard fence I could do nothing with him. It was very wet weather and I was cleaning house before going off and he had to be out. The moment he was loose he would come to me lie at my feet and cry. At last it dawned on me Adam knew I was in danger, he was wretched.

When I went to the hospital he was inconsolable, he gave long piteous howls they could not keep him quiet except by letting him come in and lie at my bedroom door. As soon as I was out of danger he settled down again. His doggy sense an extra that we poor humans lack had told him.

Ginger Pop

"So Big so Little so Shy so Brave"[182]

FORT RUPERT had the reputation of being a wild fierce place at one time. A sea captain that we knew who lost his ship had been banished to Fort Rupert with his family as a punishment. He probably held some small post in this wild outlying place I [do] not know but they described it as fierce and wild. Now Fort Rupert was the very calmest of places everything complemented everything else. The Indians were all away when I visited the village all except two women and a baby with whom I lodged. Both women were half breeds.[183] A big a[nd] much respected family had a big store at Port Hardy in the summer—the man (who was a German) married to an Indian wife and gone Indian. The wife and four daughters who were rapidly whitening went to help him run the store in summer. One daughter stayed back in Fort Rupert to mind the little store which they ran in winter for the Indians. There was one son who had gone over the line and brought back an Indian wife from the American side. It was she and her baby who were summering with her brothers wife in Rupert. I was sketching all day and we all made rag mats in the even[ing].

We went to Fort Rupert to sketch, Ginger Pop and I. There was great peace in Fort Rupert. Over it Eagles circled and far back in the forest they nested. The male and the female have different notes "qua" cried the one, flat and guttural. "Ping" answered the other sharp as a twanged string. Ravens strutted the Beach.

The Indians were all away all except two young women, and a wee mere baby alone in the village. There was a little Indian store of sorts that their Father ran in winter in the summer he took his family save these two to Port Hardy where they ran a bigger store. There was nothing to guard in Fort Rupert nobody came that way, no mail boat no gas boats not travellers. Everybody appeared to have forgotten Fort Rupert but the sunshine

Top portion of the Hunt Pole, Fort Rupert. Emily Carr, 1928 or 1930.
PDP00928.

and the Ravens and the eagles. The Eagles earnestly watched circling high on their tireless wings but occasionally they left the sky and flew into the forest. They flew with a great soft secrecy and high flight. Even so, you felt they knew that speck on earth was you.

The shore of Fort Rupert was rough, storms struck it but its beach was gentle. The waves struck the faces of the rocky cliffs boom bang! But then came the rippling answer of withdrawing waves singing over the pebbly beach as the sea sucked them back.

The ravens black as polished Parlor stoves stalked up and down the beach talking to each other gutturally discussing the tiresomeness of summer when the Indians were away and there were no cook pot refuse to be picked up along the sands. They flapped heavily over roof tops and went back into the deep woods, from here they called. The male raven in a deep guttural voice "Qua!" the female answering "Ping!" sharp and musical as the twanged string of a musician's instrument. "Qua—Ping!" "Qua—Ping"! They kept it up for hours on end. Were "Qua" and "Ping" love words in Raven talk? Or were the birds just automatically keeping each other aware of their near-ness? It was certainly more musical than if both male and female had said "Qua"! or both had said "Ping!" The cries complemented each other. That was the way with everything in Fort Rupert, things completed one another.

I did not know there were any cattle within miles of Fort Rupert. Indi-ans do not milk their cows they beef their cattle. Turned into the woods to rummage for themselves they grow [into] wild and ferocious beasts.

I had been down on the far point at work the day was very hot. On the bluffs beyond our end of the beach was a high ridge and beneath its shade a bed of soft moss. I flung myself down to rest and slept. Ginger Pop jumped up on my body stuck his nose under my chin and was soon snoring.

I was awakened by his fierce growls so out of proportion to his size and his sharp claws scraping the neck of my blouse. Fortunately I did not start up in alarm that might have started horror. I turned my head. On all sides I was surrounded by wild cattle a circle of 16 beasts with bloodshot morose eyes. A wild mystery of snorting breath a forest of horns lowered to a fringe of danger between me and the sky.

Wicked horns. They regarded intently but not one of them made a move. They hardly seemed to see me their attention was on the dog at whom they stamped and wagged their heads. One great cloven hoof could have killed him or a toss from those wicked horns. The conclusion I came to was that

the beasts had never seen a human being flat on the ground before, lying in front of their hooves, dogs they always saw from that angle, and then out in the bay a gas boat whistle blew shrilly. I felt the tenseness of the situation change [al]most imperceptibly the beasts started to back into a strip of densely bushed semi cleared rough land between the village and the forest, only a patch of red was showing here and there among the bushes. The dog laid down and was quiet.

A gas boat to the cattle meant man. Man herded them and shot the fattest skinned it then and there in the bush carried away the meat and left the hide to dry on the bushes. The earth and bushes smelled of blood.

It was supper time. I rose and went to the Indian house one woman was at the store selling to the visiting Indians.

"My wasnt you scart to death?" said the other.

"No. Should I have been?"

"You bet you should of bin. When I seen you down among them beasts feet I sez 'When the big bull gives the signal the herd will stampede and you will be stomped into the soil no knowin which is you or dirt or Ginger.' When we seen 'em back away into the bush we was glad."

"Maybe that dog Ginger" looking earnestly at the tiny dog, "Maybe Ginger Pop small but maybe Ginger he big too!"

Fifty four sharp hooves tearing at us one hundred and eight horns goring was not merry imagining. The woman looked contemplatively at Ginger. "He small but his heart welly strong" she commented.

"Ginger Pop"[184]

AT PRINCE RUPERT the hotel refused to take me in because "I had a dog."

"But, look at the size of him!" I said.

"My hotel he say NO DOG. No big dog no little dog some small dog very bad."

I opened Ginger Pop's travelling-box they had taken it for a hat-box and brought it up along with the other luggage. Ginger's comic face was out through the wire opening. Ginger Pop was a very small Belgian Griffon dog with great, almost human eyes and a snub nose and the most glorious aggressive beard any grown man might have envied. His coat was fiery red so was his spirit. I opened the lid of his box. The man looked in and laughed, "Heap funny little dog!"

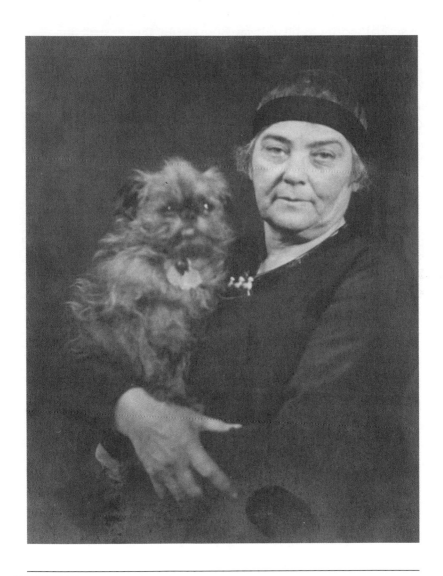

Emily Carr and Ginger Pop, 1930. F-01220.

The Prince Rupert Hotel was run by a Chinaman. I was told he had been special servant to the railway Boss during the construction of the C.N.R. railway. The Official thought very much of this man and when the offices were disbanded and the railway finished; he set the Chinaman up in business. The Office staff were Occidental but the host and manager was Chinese and a very courteous gentleman he was.

Ginger evidently took the man's fancy. "Me, I go think" he said and disposed of the rest of the passengers luggage to underlings who took it away.

"Sign" he said and so I went to the desk, hopeful while he sent my luggage (all but Ginger) up to my room.

"Come, I show," He said.

"Ginger Pop." The name tickled him as much as the dog. Just beside the Hotel entrance was a door leading from a small landing, a stair went down to sample rooms below where commercial travellers displayed their goods.

"Ginger Pop good here? Upstairs bedroom no can. All right?" The arrangement was fine. The dog would be no trouble, he would be out with me all day and I would pad lock him into his box at night.

During my week in the Hotel I seldom went down to get the dog but once the Chinaman had some visitor and the two of them were down on their knees peering through the wire at Ginger. I would hear "our dog, name Ginger Pop very good little dog heap smart."

The week I stayed in Prince Rupert Ginger got very well known he was always at my heels.

My boat North was to sail at 3 A.M. They gave me a call at two. A dreary hour everyone half asleep in the lounge. I was put into a cab. "Ginger Pop?"

"His crate go luggage van."

I will confess I was anxious untill the van arrived at the wharf and the big doors rolled back. I was seeing to my ticket when the agent attending to me gave an amused laugh . . .

"Knows his job," said the man. The Chinaman was there. He was the only privileged person whom I allowed to open Ginger's crate. He had done so to bid the small dog goodbye. Ginger jumped out, heard my voice knew I was all right then rushed off to his special job. He walked around the pile of bags and bundles on the floor sniffing till he found my sketch sack. With a happy jump he had mounted it knowing as well as I that the sack and I were inseparable, where it went I followed, where I went Ginger followed.

Cadboro Bay, 1938

I N MAY A FRIEND TOOK ME to Cadboro Bay. I said "I have such a hanker to get into the woods some where easy from town." Cadboro Bay has long ceased to be woodsey. Its magnificent sweep of sandy beach is a favourite beach for children. It is safe and somewhat warmer than most of our beaches. The Bay is now circled by a fringe of summer shacks and cottages where once it was farms and woods and water cress beds. The Uplands end has produced a smart Yacht Club and where Goodacre the Butcher's wild fields ran down to the cattle wharves, where, mad with fear, steers were launched from upper country ranches and about to fatten & calm down amid bush grasses & lovely fields of wild lillies before the wild jaded from their eyes and the rich food gluttoned fat under their hides. This part now lay in beautiful gardens belonging to wealthy homes. The beach was a screech from morning till night with children & holiday makers.

"No, not here." We went a little further Telegraph Bay.

There it was, that to-let little Workmans cottage near a great cow barn. When they said "Already taken" at the farm, I was bitterly disappointed.[185]

The thick stretch of wood round the base of a vast twinkle of rocks amounting to mountains. Darkness of fir woods about the rim with bursts of joyous light where some mossy mound of rocky space opened up. And below the wood, the rocky coast and wide sea dotted with islands. Grand red trunked Arbutus very old & gnarled tying themselves into an agony

of knots & nobs. With the shiny smoothness of their satiny young leaves bunchily springing in fanlike arches absorbing a glut and sparkle of sun & sky with themselves holding it in the polished surface of each leaf dandling the reflected blue, as the leaves swayed back and forth till the trees were as much blue as green and the red of the bark was redder for having burst and showing the delicate green yellow new skin underneath. The Arbutus were so upspringing and gay standing among the rocks or in the open exulting spreading their branches to the sky [indecipherable] & reflecting the sky. The pines stood behind them sombre, intense, spreading their lower bows wide brooding over the earth hiding it, pointing each one into the sky a single slender tip. Its mystery hidden close to earth where the red brown shaddows lurked in the loose pine needle loam smelling earth-sweet. Sometimes it was the arbutus and high skies & sea that called to you but oftenest it was the mystery of the brooding pines.

Sometimes the cows sat with me. The slow rhythmetic chewing movement of their jaws soothed. Red cows, dun cows, white and black, pretending that I did not exist and all the while keenly conscious of my every movement flopping their tails & flipping their ears, getting up & down on their knees so clumsily.

Their square hind quarters lumbering along morosely heads pushed forward & nodding, eyes & jaws everlastingly rolling. Something so completely common sense & sterling about cows and they have their pinch of sentimentality too. How their ears turn towards music. There was a swing of slow musical movement to themselves when the long line of them came lumbering their unhurried way towards the barn at milking time.

The dairy was run by a large happy family. At six in the morning & six at night they swarmed into the barn. Young men & women small boys and girls. There was clatter and singing, and milk pouring into pails & the tossing of hay and a calm chew chew, warm cow smell. The cow farm was peaceful I did good work and was happy there.

"Canadian Coast"

THERE WAS THAT cold remote silence all about. Space was sopped with it. It sogged ones person. The deck and deck houses trickled with the cold sweat of dawn.

The warm of your breath was trimmed with visible vapor travelling out into space till the warmth of your lip was chilled out of it. Your knees shook a little and your teeth chattered nothing was still. The shriek of our whistle cut the air bluntly and was thrown back to us from treed shores. Two men were pulling towards us across the water, now they shipped oars and held on to our side. Unshaven men in rough clothes, mist clung to the hairy wool of their sweaters.

"Where's the money?" asked the purser holding the parcel above the boat.

The men looked at one another and I saw futile fingers in their empty pockets "next time." The purser shook his head, pretended he was withholding the package. He jumped inside his very sternest mask. The corners of the men's mouths sagged, and shot up again when the little package thudded into their boat, they rowed briskly away through the haze.*

The canneries bay cold and silent there was nobody about. A few trails of smoke drifted up from the row of Indian cabins the smoke reflection from the chimney pipes, hovered down through still water of the cove. Rope steadied us along the wharfside till the few bales were wheeled on to

* See plate 32.

Nootka wharves and cannery. Emily Carr, 1929. PDP05693.

the wharf. The mate gave terse orders the Captain looked silently out of the wheelhouse & a steward peered from a port hole. The cold slap of the rope tossed back on the water. Snuffle of engine—we were off again ploughing through waves passing and passive. The fir dressed rocky trimmings of the Western Canadian coast miles uncounted of forested shore in a variant of mountainous shapes pointed, flattened, squared rimmed with rocky edges.

Millions & Billions of firs running back & back densely packed fathomless stretches darkly green recede through space till distanced blue as heaven itself. In some countries it takes only a field or two to blue a distance. In Canada where limitless space is bounded only by the horizon the very monotony carries you on & on & on. Our Father and Mother settled ten bodies in Canada and were satisfied. They would have been cramped & discontented had they gone from Canada back to England to live. The transplanting was agreeable to them in the new soil. They thrived but they were of English seed.

Their two oldest children too had been born in England. A tinge of homesickness colored their lives a little, each child born to them was slightly more Canadian than the previous one. The England each in turn knew from their parents was a little more idealized. When they took trips to this Ideal

England they realized how truly Canadian they were when English eyes stared at them they felt maybe unpolished & crude. These polite English traditions lacked for them the sterner realities of their Canadian birthright. The stilted ideals of their English parents became to the children vaporish.

England first view of country. How quaint, charming pretty it all was! How well ordered & tidy. How ripe it all seemed—finished—made—polite and complete. How different the growth was from the lush pushing exuberance of the Western soil. The grand old trees there were hoary with veneration. Years of pruning and discipline they were nunnish in their deportment, not like the wild hurley burley chase to look over the top like our forest fellows interfering pressing taking crude twists to absorb all the light going, they had to fight for the survival of the fittest nobody saw fit that weaklings were encouraged, robust ones squeezed & starved their old ones, crushed down & smashed them. What was their faint swish against the roar moan of the great ones swift rush—The thunder of their crash through the silent forest. The great ones scattered the seed for their prolific offspring lavishly. The youngsters sprang up & choked the space about them sucked the nutrient from the earth absorbed the light. The crude bursting vitality of the new country was different from the mellow self satisfied old, sorting refining replenishing full & mellow, meek, satiated.

"Onlookers"

1.

I have always detested someone at my shoulder when I painted be it even a master. It was as if someone was peering inside my brain watching my thoughts go through the folded about tubes of it. My thoughts stuck like mice paralyzed with fear in the corners or else they scampered clean off & never came back. To watch another think seems such an impertinence for that reason working from a model always upset me, looking, looking searching for the life spark in him so decently hidden so much his very own, such impertinence to go root for it. Hunting for that same cellular spark in nature other than human beings is different does not embarrass. Sometimes I have been very rude to "rubbernoses."

2.

Once was sketching on Beacon Hill hidden in the broom. Always when locating I seek for protection from behind. Suddenly a la-de-da in plus fours & eyeglass parted the bushes.

"Is it possible? Is it Possible!" he exclaimed "Here in the far West—An Artist! Modern too by George!"

"People do paint otherwhere besides England," I snapped.

"Aw! . . . rewally . . . !"

The sheepdog at my feet was growling.

"Please go away I want to work."

"W e a rly now!" he adjusted his monocle.

"Get out—" I said and the dog & I rose simultaneously—He went.

3.

Once in a Northern Indian Village I was busy working by the roadside. A sharp nosed little white woman came mincing towards me. She halted in front of my easel.

"You are obstructing my view"

"I have a message for you."

"Indeed?" Messages from home came in devious ways to out of the way places.

"The message," I asked looking up at her.

"It is about your soul" she replied "I dare not neglect it."

She sat down on the grass beside me. For the moment apparently more interested in my painting than my soul. Her foot overturned my water jar.

"Now see what you've done!"

"Oh, but my message!" she exclaimed.

"Look here," I said splashing more water into my cup. "One of us has got to go is it you or me?"

She sprang up like a jack in a box and left my soul in the dirt by the roadside.

4.

There was a couple in Stanley Park who rolled up a log and prepared to sit and watch me work for a spell. I had tramped miles to get away from humans. These well dressed people were obviously American I presume they were human. They began making conversation about the scenery.

I turned my canvas face to the easel folded my arms & became a deaf mute.

"Rec[k]on she don't like audience" whispered the old [man] still puffing from having rolled the log. "Come on."

When they were well under way I said, "Thank You."

Having been shure I was a deaf mute they exchanged surprised looks.

The one exception to my horror of watching eyes was the dull brown Indian eye.[186] Indian children could press close could sniff & whisper each soft guttural appraising was whispered by every child in turn by the time the brief comment went the round it became fact.

Except for the click click of gum chewing the adults watched patiently silent. Their wondering was even slower than their chewing. The bare feet padded slowly down the dirt road. A wonder to a foot fall three chews to a wonder.

Jubilee Hospital, 1943 to 1944[187]

"The Crooked Approaches of War time"

THE HOSPITAL[188] stands on the summit of a slight hill. Immediately surrounding the building is a smooth flattened area of considerable dimensions and on a great oak tree to one side of this space is a large sign: "For Doctor's cars only."

The Doctor stratum was flanked by a build-up of great boulders in and out among the boulders flowers grew and at their base was a flower bed always gay.

The doctors cars surrounded the old original main entrance, a squatty unpretentious old brick building that had erupted wings in all directions. Wings crammed to the roof with sick wings, more up to date, more sanitary, more pretentious. The ugliest part of the structure, the part of the hospital that made patients shudder almost as hard as knife and pain was the billing office where was recorded its great inexorable accumulation of obligations to be paid or everlastingly stab its record of humbling charity in a public ward, all patients were recorded with their disease or their hurt. In the offices close beside the original main entrance of the Hospital some were carried out another way a back entrance to a quiet place to wait the undertaker's rig.

This was war time and now the Doctors who climbed bag in hand up the Hospital's steep steps were mostly elderly sobered men and bent under the heavy grind of large practises, abandoned by the younger men for war,

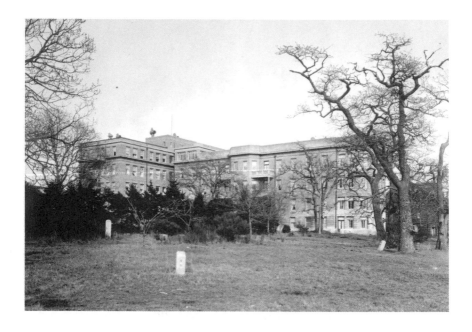

View of the east wing at the Royal Jubilee Hospital and Garry oak trees, 1925. D-05177.

young men were doctoring soldiers. Civilians were not supposed to be sick during war time with war to be attended [to].

A hand-rail divided the comings and goings up and down the hospital's steps nobody's hand ever touched the rail but it kept those who came from colliding with those who went.

Below the Doctors cars and below the flower beds visitors cars might park and there were paths, none straight, meandering ways between shrubs and bushes, then came a broad paved way for ambulances and a certain number of parking spaces at the side for officials and "staff" cars. Ambulances both civil and military came and went continuously. The military ones stopped at the out-patients door. They seemed to deal more with sheafs of red-tape papers than with sick soldiers. A smart chap in uniform with all arms and legs intact jumped down from beside the driver, rushed in and delivered or received papers and was off again. It seemed an awful lot of gasp to waste just on a few papers. The Civilian ambulances were white and slithered in between two wings of the building where there was a big door yawning to receive stretchers. If one was alive enough to notice at all, they were glad

that the wing hid their ambulance and listless bored half healed eyes could not look down and say "Here's another. What is this trouble I wonder?" and watch the two old stretcher-bearers unload you. On the far side of the Ambulance Drives stood a great Oak tree. This was the end of hospital parking space round the bole of this tree cars stood thick as a petticoat, cars of every description, mostly poor mean things home painted or not painted at all. There were numbers painted on the pavement under the tree the cars were each supposed to sit on a number, but they did not always but straddled a dividing line then officials came & looked fierce.

Dead people did not use the Hospital's front approach. Attendants wheeled them out by a back way to a place in the Laundry building sniffing scorch & soapends with their poor stiff noses till the Undertaker's carrier picked them up. The carriers took them down the back lane, I met them when I was out for airings in a wheel-chair. There was always a hesitation between my wheeler and the hearse driver as to which took precedence Wheel-chair or coffin. I always insisted "Let them have right of way certainly." It seemed to me it was the only tribute I could pay to death. My "Wheeler" thought death should stand aside and let life pass and was angry when I made her wheel me behind a great rain barrel till the dead had passed.

Look when I would out of my hospital window the approach was dotted with white caps and aprons. The Nurses home was at the far end of the long curved main drive as there were hundreds of nurses and they came on and off every four hours it stood to reason some of them were always on the way. From my distant wing I could not see their faces. They all had one face which was not a face at all but an impression. Probationers did not count they were neuter till they got caps (if they proved themselves worthy of them at the end of three months). I loathed probationers messing round me. I hated being a nursing lesson. I had always thought probationers learnt in the wards and that private patients paid enormously. I thought the big price included privacy but it seemed not. Every Monday a new batch of probationers was let loose on the floors. "One year olds" and "two years old" were treats and when by luck you got a graduate you were almost in heaven. War had grabbed all the graduates with the exception of just a few left as teachers. It amounted to this and could not be helped it was war. If you pressed your bell till your thumb ached and there was not any one to come, it was not any one's fault. It was the fault of war, filthy war!

The first night in hospital was always hideous. Those detestable beds that were made for men's length not for woman's and bent you in the wrong place when, according to Doctor's orders nurses screw[ed] you up so that you slept perpendicular. You did breathe better I'll admit, but you slept worse. As soon as you had got used to the night-nurse she was off and you had a day one who didn't know your head from your heels only pretended she did and perhaps you were whisked off to hospital in such a hurry you have only half your things, she fixes you up with makeshifts till somebody came to see you, then, another twenty four hours wait till they can bring what you need meantime the wretched probationers have lost all the original make-shifts!

They were forced to take in terrible junk as probationers during that three months I spent in that hospital because there was nothing but the remnants of womenkind left. Oh dear! They did not know your arm from your leg and anything below the neck was stomach and above your neck eyebrows. It was astonishing how some of the hopeless did make good (the ones who <u>wanted</u> to). As soon as they once got their caps they took on the hospital strut, before they had their caps they only mimicked nurses walk in a sort of important waddle with no purpose. When the hospital decided they were worthy of a cap they settled and strutted, strutted up and down, up and down the crooked paths of the Hospital approach. Every day and all day long the nurses came and went. They were all the same in shape, little pancake women flat front and back, they wore little navy blue capes over their uniforms, stupid capes that came only a little below their waists, the wind got underneath so they dragged the capes taut across their back and clamped them down with their arms folded across their waist line in front filling in the curve with their folded arms. At my distance they looked as if they were cut out of Hat cardboard. It drizzled most of the three months of my stay, their caps and aprons limped. Why did they not carry umbrellas? It was not done. Nurses do just what the nurses before them did and they the ones before that for ever and forever.

"Night Supervisor"

TWO STRIDES from the corridor and she was through the open door, standing there erect and crackling with starch her Nurse-clothed body her thin brittle heart and pointed nose. She stood in <u>exactly</u> the same spot every night at

Eight O'clock when she made rounds, so she would stand as long as her Supervisorship lasted no matter who came to or went from that bed, she would say indifferently "how are you?" Her job was not to nurse but to supervise, to supervise Nurses and to supervise death beds. She had the key to the merciful drugs that still pain in a mock death. Up and down the long corridors she went noiseless as death itself listening at the rooms and the wards where some slept in the blessed forgetfulness of natural sleep. Some slept the narcotic half stupor and others lay and stared into the dark open eyed.

Night Supervisor was not ill-looking. She was nearing middle-age, a pink-faced woman with nose rooted in the centre of her face protruding in a sharp point very like a red Eversharp pencil. She had a "Mrs Noah waist." The Mrs Noah of our "Childhood Arks" who was moulded in wood. The Night Supervisor was moulded in starch and the figures of both were corset modelled.

"How are you tonight?" She did not expect an answer. You lied of course "fine." She knew you were lying and you knew you were lying in the approved way of hospitals.

She was more solicitous over the window and the door than about you, they were always too open or too shut to suit her.

One thing puzzles my memory when it strays back to describe Night Supervisor. That is her hands. They were always hidden. Her arms hung straight at her sides. I feel the weight of hands at the end of arms, it is as though the hands were plunged deep into two immense pockets one each side of her apron, and as if they were groping, groping at the bottom of the pocket to find something she could never find.

I said to myself "Oh, if I must die in Hospital, may it be in the day time when Night Supervisor is tucked in her bed. If it is necessary by Hospital rules that there be a Supervisor to take over my empty corpse from the hospital then let me be shown out by dear Day Supervisor.

"The Healthy Oak Tree"[189]

WHEN I KNEW HER she centered a lawn in between two wings of the hospital. Hundreds of successive bed patients looked out on her, scores of wheel chairs rolled under her shelter. She scattered her acorns on heads of them and made them jump sometimes she threw them a leaf for comfort. She was very gracious and comely backgrounded by the dull red brick of the two

hospital wings. Ambulances full of pain passed beside the Oak Tree on their way to deposit stretchers in the great doors that received stretcher cases. The hospital was always sprouting new wings they were fussy and noisy in construction. The Oak's tree growth was silent and reminiscent, powerful and imperceptible. The people in the hospital beds were always changing, babies coming old folks going, for generations their tired sick eyes gazed out some did not even see Oak Tree, to others she gave strength and joy.

The great bole bursting from the earth at right angles to the green lawn, that was the first and the last of Oak's angles. Then her sap poured into that immense column under the rough crinkled bark and dispersed to the tip top enough for every acorn, every leaf.

The Oak exampled Robust Health in the middle of sick weakness.

Every part of the oak's form was firmly roundly moulded no angular elbows no sharp turns each sturdy limb started staunchly from the main trunk proceeded a short way then rounded back on itself. No weak undecided turn, but a pushing back of stubborn strength as if Oak backed to gather more strength, more force, from the parent stem yet withall she managed to maintain perfect ballance. She marked her slow growth by centuries not years. Her leaf form was rounded too they gave the impression of being thicker than they were because of their rounded bulges like leaves moulded in leather work in form they were not flat nor smooth in texture they were both. The edges of the leaves were scalloped in the round and each bunch of leaves blobbed roundly up in the sky. The acorn cups were round and each held an acorn oblong but round at the ends when the acorns were ripe the cups tipped and spilt their acorn out each acorn as it struck earth made a round little O sound.

After Doctors Nurses patients have all finished with life, yes and the bricks of the Hospital that the Oak grows beside, have been picked separate and cleaned and sold as seconds, Old Oak tree will go right on living her fully matured sturdy self she has tremendous grip on life.

"Tears"

HUNDREDS AND THOUSANDS of tears or more tears than bricks went into the building of the great hospital. Frightened tears, hopeless tears, angry tears, goodbye tears, tears for tearing pain. Tears of gladness when relief at last came.

How can Doctors and Nurses stand it, tears, tears, tears, tears. How they can bear the sight of hurting flesh? How combat invalid fretfulness? I do not know. I have not been a nurse I have only been a patient many times and I have contributed to the great agony. I have cried, sometimes not knowing the reason, dumb misery I could not name. Sometimes I knew well enough what the merciful hypo was for. Nurses did not see me cry often. Sometimes after a joking "Goodnight nurse" the nurse would suspect, she would double back round the screen and find me an island, in a lake of tears.

Spring sunshine brought a whirr of slow wheels out onto the lawns. The hospital Nurses trundled Wheel-beds and wheel-chairs holding patients. The patients looked up at the trees and the skies and then they could not cry. Because I discovered that if you roll your eyes over your head tears won't come. I've proved it by trying. Patients cried in their rooms outside they looked up & saw trees and bushes.

"Wheel me into a quiet corner, Nurse let some bush hide me, I do not want to see other people's disease. I do not want people to see mine."

Nobody cried outdoors. Tears were dammed behind patients interest in sky over head, grass underfoot, trees, flowers. In these things are no tears it is the joy of the world.

"The Char and the Cyclamen"[190]

THE HOSPITAL CHAR-WOMAN came round the end of my screen noiselessly [with] her mops and brushes. I liked this woman. Her uniform was a sunny pink with white apron and short sleeves with a turn[ed] back cuff of white up her near the shoulder. Her face was quiet and happy. Sometimes she brought me a finished with newspaper from another patients room. Some times I was asleep then she was very quiet. If I did not smell her floor polish I would not have known after I woke that she had been. Sometimes half awake I lay and watched her, and sometimes wide awake I talked to her a little. We talked about religion mostly. Neither of us told all we knew or felt. The woman kept steadily on with her work as she talked. I knew she had more stored behind her talk than her quiet face told.

This particular morning I did not hear her come, I woke and she was there but not doing her work, she was standing beside my bed-table wrapped in worship. She said "Oh! Miss" when she saw my eyes on her and folding her

hands over the top of the mop handle stared. I lay watching her face. I had said just the same sort of "Oh!" yesterday when the pure white cyclamen had come. It seemed as if that was all one could say. It was such a pot of holiness. I moved a little and the woman started, her hand stole to the earth in the pot feeling, feeling, to see if my beautiful plant needed water. Seeing me really reminded the woman of dust and mops but first she went to the tap & got water for the plant.

It was a superb specimen. Pure white with delicate grey shaddowings in each round hole of a mouth where her heart lived. She had thirty blooms of opaque purest white. Her leaves were of so unobtrusive a green as to be almost neutral. There was a faint reddish glow in the stems where she made direct connection with her bulb and the earth. I had twin delights in being remembered by my friend and owning the plant. In the quiet of the night I had turned my light many times to regard my Cyclamen's serene presence.

The Char gave a sigh, not covetous not a longing to possess my flower for her own. When she left the room she was smiling yet not smiling, rather her face was lit she was beyond, a way beyond, as the Cyclamen's beauty was beyond ordinary flowers & blooms.

The char woman took my Cyclamen under her special care. Her first thought on entering my room each morning was, Cyclamen, do you want water? She stood a moment, looking. Then her fingers stole to Cyclamen's roots. She drew water from the tap and gave just so much and stood silently looking. Then she did her work and went quickly from the room as if afraid she would neglect her duty towards the floors if she stayed by my flower too long.

Tragedy! After I had cyclamen one week a careless probationer setting my tray on the bedtable pushed the plant too near the edge. With a crash it fell heavily to the floor bottom up. The girl grunted and rushed from the room scared. I could not lean from the high hospital bed to right her myself. It was useless to ring this was the nurses dinner time. I longed, how I longed for Char. She would not be in my room till tomorrow. The Hospital was very shorthanded. Cyclamen lay there her blossoms in the dirt for three hours. One or another nurse or wretched little half nurse came into my room for something each trampled the dirt into the char's new polished floor. Each said, "I will come right back and pick up the plant" but they never did. She lay there till my regular nurse came on duty. "I will take it to the gardener" she said, "get him to repot it." But the gardener was away for the week end.

The nurse did the best she could, blowing off the dirt and securing a great jam tin to hold Cyclamen till Monday came.

The Gardener repotted her, trimming a broken leaf or two and a mutilated flower, they brought her to me surprisingly little damaged. I was put into a basket bed and wheeled into the garden. In the corridor I met Char. She stepped back to hold the swing door for my bed to go through.

"Cyclamen is repotted and almost as good as ever," I said.

"I am glad." Such a ring was in her voice such light in her face. "I'm glad!" it was all she had to say she turned away. Something in that plant is more than I can word. She and I were as inarticulate as cyclamen.

Emily Carr Chronology

1871
- December 13: Emily Carr is born in the family home on Government Street in Victoria, the last of five girls, after Edith, Clara, Elizabeth and Alice.

1875
- Brother Richard is born.

About 1880
- Begins drawing lessons with Emily Woods.

1886
- Mother, Emily Saunders Carr, ill for several years, dies at home of tuberculosis.

1888
- June: Promoted to high school.
- Father Richard Carr retires from business, but dies later in the year.

1890
- December 30: Sails on the steamer *Walla Walla* for San Francisco to attend the California School of Design.

1891
- April: Edith and Lizzie, two of Carr's sisters, move to San Francisco for an extended stay, into 1892.

1893

- Family finances necessitate Carr returning home to Victoria.

1894 to 1899

- Teaches children's art classes in the barn behind the family home.
- Exhibits pen-and-ink sketches in Victoria fairs.

1899

- Travels to Hitaču (Ucluelet), on the west coast of Vancouver Island, to join her sister Lizzie at a Presbyterian mission.
- Carr leaves Hitaču (Ucluelet), where the Aht community called her the "Laughing One." Klee Wyck is an anglicized spelling of that term. Meets "Mayo" Paddon while on board the steamship *Willapa*. Paddon would follow her to England and propose marriage, which Carr declined.
- August: Leaves for England, registers at the Westminster School of Art in London.
- September: Brother Richard dies of tuberculosis in a California sanatorium.

1901

- Early spring: Takes art classes under John W. Whiteley and paints outdoors at Bushey, Hertfordshire, a few miles from London.
- April (Easter): Travels to Paris for twelve days and visits the Louvre and other galleries; absorbs the artistic scene.
- June: Alice arrives in England; the sisters travel to Devon and Cornwall. Enrols at art school in St. Ives, Cornwall. Stays over the winter and studies under Julius Olsson and Algernon Talmage.

1902

- Leaves St. Ives in March.
- Returns to Bushey and studies further with John Whiteley.
- Visits friends in Scotland.
- Becomes ill and is assisted by her English friends until Lizzie arrives.

1903

- Admitted to the East Anglian Sanatorium in Suffolk, after suffering a breakdown.

1904

- April: Discharged from the sanatorium, returns to sketching in Bushey.
- June: Returns to Canada. Spends several months in the Cariboo with childhood friend Edna (Green) Carew-Gibson.
- October: Arrives in Victoria.

1905

- Teaches art classes and draws political cartoons for the *Week*, a Victoria newspaper.

1906

- Moves to Vancouver to teach at the Vancouver Ladies' Art Club. Begins exhibiting her paintings and teaching children in her studio.

1907

- Visits Alaska with Alice and is inspired by an artist who painted the monumental art of the Tlingit.

1908 to 1910

- Makes several trips to First Nations communities to record art and village settings, including Yalis (Alert Bay), Campbell River, Sechelt and North Vancouver.

1910

- July: Travels with Alice by rail across Canada, then overseas to France.
- Meets and is inspired by artist Henry William Phelan Gibb.
- Enrols at the Académie Colarossi in Paris, then studies under John Duncan Fergusson.
- Becomes ill.

1911

- Travels to Sweden with Alice to regain her health.
- Returns to Paris, and then moves to Crécy-en-Brie to be taught by Gibb and then St. Efflam, Brittany.
- Studies in Concarneau with Frances Hodgkins.
- Two paintings selected and hung at the 1911 Salon d'Automne exhibition in Paris.
- November: Returns to Canada.

1912

- Moves to Vancouver.
- Stays as a guest at the home of artist Statira Frame in West End Vancouver for two or three weeks while awaiting occupancy of her new studio.
- February: Moves into studio on West Broadway.
- March: Exhibits seventy of her French watercolours and oils created in the Fauve style.
- July: Sublets her studio to artist Wyly Grier. Travels by steamer to visit Kwakwaka'wakw villages along the east coast of Vancouver Island, including Yalis (Alert Bay), and then to Prince Rupert and up the Skeena River to Tsimshian, Gitxsan, and Wet'suwet'en villages, then to Haida Gwaii, where she is taken by Haida guides Clara and William Russ to remote and abandoned Haida village sites. Paints poles and houses in their natural settings.

1913

- Rents Drummond Hall in Vancouver and mounts a large exhibition of about 200 works dealing principally with First Nations and painted in her new French style.
- Writes and presents a public talk titled "Lecture on Totem Poles."
- Returns to Victoria and begins to build an apartment house on the property behind her birthplace. Begins life as a landlord, a period lasting over a decade in which her art production dwindles.

1916 to 1917

- Works in San Francisco painting decorations for special events.

1917

- Begins to raise purebred English sheepdogs and then Brussels griffons.

1917 to 1919

- Employed as a cartoonist for the *Western Women's Weekly*.

1919

- Sisters Clara (Nicholles) and Edith die.

1923

- Buys Woo from a Victoria pet shop for $35 cash and a trade of one of the Brussels griffon dogs from her breeding kennel.

1926

- Enrols in a course on short-story writing.
- Marius Barbeau of the National Museum of Canada visits and views her work.

1927

- On his third visit to her studio, Eric Brown finally convinces Carr of his interest in her work. He selects many of Carr's works for an exhibition about Canadian West Coast art that displays Northwest Coast First Nations art alongside Canada's modernist painters.
- Carr travels to Ottawa for the opening and meets members of the Group of Seven. Connects intellectually and spiritually with their work, especially that of Lawren Harris, who would become a mentor and friend.

1928

- Travels north again to visit and paint Haida Gwaii and Gitxsan, Wet'suwet'en and Nisga'a villages on the Skeena and Nass rivers.
- Meets Seattle artist Mark Tobey, who conducts a master class in her studio.

1930

- Has solo shows in Ottawa, Victoria and Seattle.
- Exhibits with the Group of Seven.
- Travels to Ottawa, Toronto and New York.
- Meets American artist Georgia O'Keeffe.

1931 to 1936

- Makes local sketching trips.

1933

- Purchases a caravan to enable longer, self-contained sketching trips; calls it "the Elephant."
- Travels to Chicago then Toronto.

1934

- Enrols in a short-story-writing course in summer; her first story is about the "Cow Yard" of her childhood.

1936

- Sells her apartment house and moves to 316 Beckley Street, Victoria.
- Sister Lizzie dies.

1937

- Has her first heart attack. While recuperating, begins writing stories about her experiences travelling to Indigenous villages and interacting with the people she met there.

1937 to 1938

- Has solo shows in Toronto and Vancouver.

1939 to 1940

- Has another heart attack, which forces her to move in with Alice. A stroke follows. Her stories, assembled under the title *Klee Wyck*, are championed by friends and read on CBC Radio.

1941

- Publishes *Klee Wyck* and wins the Governor General's Award for Literary Merit in non-fiction.

1942

- Publishes *The Book of Small.*
- Makes her last sketching trip.
- Establishes the Emily Carr Trust.

1944

- Publishes *The House of All Sorts.*

1945

- March 2: Emily Carr dies.

Bibliography

Printed

Works by Emily Carr

The Book of Small. Vancouver: Douglas & McIntyre, 2004.
Fresh Seeing: Two Addresses. Toronto: Clarke, Irwin and Company, 1972.
Growing Pains: The Autobiography of Emily Carr. Vancouver:
 Douglas & McIntyre, 2005.
The Heart of a Peacock. Vancouver: Douglas & McIntyre, 2005.
The House of All Sorts. Vancouver: Douglas & McIntyre, 2004.
Hundreds and Thousands: The Journals of Emily Carr. Vancouver:
 Douglas & McIntyre, 2006.
Klee Wyck. Vancouver: Douglas & McIntyre, 2003.
Pause: A Sketchbook. Vancouver: Douglas & McIntyre, 2007.

Other Sources

Barman, Jean. "Growing up British in British Columbia: Boys in Private School,
 1900–1950." Doctoral thesis, University of British Columbia, Vancouver, 1982.
Batts, John, ed. *The Diary of English Art Critic Eric Newton on a North American
 Lecture Tour in 1937.* New York: Edwin Mellen Press, 1997.
Bear, Shirley, and Susan Crean. "The Presentation of Self in Emily Carr's Writings."
 In *Emily Carr: New Perspectives on a Canadian Icon*, edited by Charles C. Hill,
 Johanne Lamoureux, and Ian M. Thom. Vancouver: Douglas & Mcintyre, 2006.

Berdjis-Kamranpour, Hedye. "Understanding Emily Carr: A Look at the Fashioning of an Autonomous Self." Unpublished thesis, McGill University, 2018.

Bridge, Kathryn. *Emily Carr in England*. Victoria: Royal BC Museum, 2014.

Bridge, Kathryn. "Everyone Said Paris Was the Top of Art." In *Emily Carr: Fresh Seeing—French Modernism and the West Coast*. Vancouver: Figure 1, 2019.

Bridge, Kathryn, ed. *Sister and I from Victoria to London*. Victoria: Royal BC Museum, 2011.

Bridge, Kathryn, ed. *Wild Flowers*. Victoria: Royal BC Museum, 2006.

Burns, Flora Hamilton. "Emily Carr." In *Clear Spirit—Twenty Canadian Women and Their Times*, M. Q. Innis, ed. Toronto: University of Toronto Press, 1966.

Coburn, Kathleen. "Emily Carr: In Memoriam," *Canadian Forum* 25 (April 1945).

Crean, Susan, ed. *Opposite Contraries: The Unknown Journals of Emily Carr and Other Writings*. Vancouver: Douglas & McIntyre, 2003.

Dawn, Leslie. "The Enigma of Emily Carr: A Review Essay," *BC Studies* 152 (Winter 2006/07).

Dennison, Mariea Caudill. "The American Girls' Club in Paris: The Propriety and Imprudence of Art Students, 1890–1914," *Woman's Art Journal* 26, no. 1 (Spring-Summer 2005).

Donald, Leland. *Aboriginal Slavery on the Northwest Coast of North America*. Berkeley: University of California Press, 1997.

Hembroff-Schleicher, Edythe. *Emily Carr: The Untold Story*. Saanichton: Hancock House, 1978.

Humphrey, Helen Ruth. "Emily Carr: An Appreciation." *Queen's Quarterly* 65 (Summer 1958): 270–276.

Humphrey, Helen Ruth. "Letters from Emily Carr." *University of Toronto Quarterly* XLI, no. 2 (Winter 1972) 93–150.

Moray, Gerta. *Unsettling Encounters: First Nations Imagery in the Art of Emily Carr*. Vancouver: UBC Press, 2006.

Morra, Linda, ed. *Corresponding Influence: Selected Letters of Emily Carr and Ira Dilworth*. Toronto: University of Toronto Press, 2006.

Perry, Adele. *Colonial Relations: The Douglas-Connolly Family and the Nineteenth-Century Imperial World*. New York: Cambridge University Press, 2015.

Polay, Michael. "1911 Exhibition at the Paris Salon." In *Emily Carr: Fresh Seeing—French Modernism and the West Coast*. Vancouver: Figure 1, 2019.

Roy, Patricia E. *The Collectors: A History of the Royal British Columbia Museum and Archives*. Victoria: Royal BC Museum, 2017.

Silcox, David P., ed. *Sister and I in Alaska*. Vancouver: Figure 1, 2014.

Stewart, Jay, and Peter Macnair. "Reconstructing Emily Carr in Alaska." In *Emily Carr: New Perspectives on a Canadian Icon*, edited by Charles C. Hill, Johanne

Lamoureux, and Ian M. Thom. Vancouver: Douglas & McIntyre, 2006.

Switzer, Ann-Lee, ed. *This and That: The Lost Stories of Emily Carr*. Victoria: Touchwood Editions, 2007.

Tippett, Maria. *Emily Carr: A Biography*. Toronto: Oxford University Press, 1979.

Van Kirk, Sylvia. "Tracing the Fortunes of Five Founding Families of Victoria," *BC Studies* 115/116 (Autumn/Winter 1997/1998): 149–179.

Tovey, David. *Pioneers of St. Ives Art at Home and Abroad (1899–1914)*. UK: Philip Wilson Publishers, 2008.

Walker, Doreen, ed. *Dear Nan: Letters of Emily Carr, Nan Cheney, and Humphrey Toms*. Vancouver: UBC Press, 1990.

Watanabe, Kiriko. "A Fresh Look for the West Coast." In *Emily Carr: Fresh Seeing—French Modernism and the West Coast*. Vancouver: Figure 1, 2019.

Primary Sources

Newspapers

Vancouver *Daily World*
The *Week*
Western Women's Weekly

Archival Records: BC Archives

Carol Pearson collection PR-2359
Edythe Hembroff-Schleicher fonds PR-0881
Emily Carr fonds PR-1263 (includes MS-2181, MS-2763)
Emily Carr art collection PR-2378
Emily Carr MS-2064
Flora Alfreda Hamilton Burns fonds PR-1148
Humphrey Toms fonds PR-0163
Kate and Dick Mather fonds PR-2225
Maude Elghmey McVicker fonds PR-aaju
Myfanwy Pavelic fonds PR-2283
Newcombe Family fonds PR-0356 (includes MS-1077)

Archival Records: Other

City of Victoria Archives
 Cridge-Laundy Family fonds, PR-0076 26e5 7
University of British Columbia Rare Books and Special Collections
 Nan Cheney fonds RBSC ARC-1121

Notes

1 Emily Carr to Kate Mather, April 17, 1937. BC Archives Kate Mather fonds, 94-9184-1 Folder 2.

2 Manitoba-born Ira Dilworth (1894–1962) moved to British Columbia as a child, growing up in the James Bay district of Victoria, a connection with Carr that, despite the age discrepancy, enabled shared understandings of neighbourhood and families. He taught English at Victoria High School and at the University of British Columbia. He was an advocate for music in schools and lectured widely. In 1938 he became an administrator with the CBC, moving into different national positions during his career. His friendship with Carr was key to her literary success and was an important emotional lifeline. Hundreds of their letters to each other survive. As one of Carr's executors and her literary heir, his guiding hand was felt after her death in several of Carr's posthumous publications. See https://www.thecanadianencyclopedia.ca/en/article/ira-dilworth-emc and Linda Morra, ed., *Corresponding Influence: Selected Letters of Emily Carr and Ira Dilworth* (Toronto: University of Toronto Press, 2006).

3 Rosemary Neering, introduction to Emily Carr, *The Heart of a Peacock* (Vancouver: Douglas & McIntyre, 2005), 6.

4 Sewiṅḵelwut (Sophie Frank) a Skwxwú7mesh (Squamish) weaver, lived at Exlhá7an (the Mission Reserve) and travelled into Vancouver to sell her woven baskets. Carr met her in January 1905, and the two remained friends until Frank's death in 1939. The extant letters received by Carr from Sophie Frank are in MS-2763 and MS-2792. A letter from Jimmy Frank is in MS-2763. The 2018 Vancouver Art Gallery exhibition *Lineages and Land Bases* focused

on their relationship. See https://vagallery.s3.us-west-2.amazonaws.com /wp-content/uploads/2020/01/07212409/VAG-lineages-Final-Didactics-2020. pdf, and Shirley Bear and Susan Crean, "The Presentation of Self in Emily Carr's Writings," in *Emily Carr: New Perspectives on a Canadian Icon*, edited by Charles C. Hill, Johanne Lamoureux and Ian M. Thom (Vancouver: Douglas & McIntyre, 2006).

5 The portrait of Gamlakyeltxw (Miriam Douse, 1873?–1949; PDP00629), and those of Clara Russ (1882–1960; PDP00630) and William Russ (1881–1954; PDP00595), whom Carr fictionalized as Louisa and Jimmie in her book *Klee Wyck*, were painted in 1928. The life dates given are from the BC Archives genealogical indexes. These and other references with the prefix PDP (Paintings, Drawings and Prints) are artworks in the BC Archives. References to photographs are to photographs in the BC Archives unless otherwise cited.

6 For details on why this was removed, see Kathryn Bridge, "Introduction: The Lost *Klee Wyck*," in *Klee Wyck*, by Emily Carr (Vancouver: Douglas & McIntyre, 2003).

7 Attempts to trace Lee Nam have been unsuccessful. We know from Carr's journals that he was in Victoria (ca. 1933–1935), working by day as a bookkeeper for a business in Chinatown. No examples of his work are confirmed, although one dry-brush ink drawing (PDP09010) in the Carr archive might be an example: https://emagazine.aggv.ca/lee-nam-project-karen-tam-instagram.

8 Leslie Dawn, "The Enigma of Emily Carr: A Review Essay," *BC Studies* 152 (Winter 2006/07): 103.

9 *Merriam-Webster*, s.v. "unvarnished," accessed December 1, 2020, https:// www.merriam-webster.com/dictionary/unvarnished.

10 Journal entry for Sunday, November 23, 1930. In Emily Carr, *Hundreds and Thousands: The Journals of Emily Carr* (Vancouver: Douglas & McIntyre, 2006), 43. This phrase and longer quote from Carr was included in the publisher's foreword to the first edition and in the introduction by Gerta Moray to the 2006 edition.

11 Hedye Berdjis-Kamranpour, "Understanding Emily Carr: A Look at the Fashioning of an Autonomous Self" (unpublished thesis, McGill University, 2018), 45.

12 Maria Tippett, in her foundational biography of Carr, used some of the content to provide connectivity in her narrative, but the citations to it were too general to be easily traced. Maria Tippett, *Emily Carr: A Biography* (Toronto: Oxford University Press, 1979).

13 Emily Carr to Ira Dilworth dated "Tuesday" (probably December 9, 1941). BC Archives, MS-2181 Box 1 File 1.

14 Emily Carr to Ira Dilworth February 15, 1942. Quoted in Morra, *Corresponding Influence*, 111.

15 Kathleen Coburn, "Emily Carr: In Memoriam," *Canadian Forum*, April 25, 1945, 24.

16 This is Carr's own descriptor for her verses, mentioned in Emily Carr, *Growing Pains* (Vancouver: Douglas & McIntyre, 2005), 236.

17 See David P. Silcox, ed., *Sister and I in Alaska* (Vancouver: Figure 1, 2014), Kathryn Bridge, *Sister and I from Victoria to London* (Victoria: Royal BC Museum, 2011), Kathryn Bridge, *Emily Carr in England* (Victoria: Royal BC Museum, 2014), Emily Carr, *Pause: A Sketchbook* (Vancouver: Douglas & McIntyre, 2007).

18 Journal entry for July 11, 1934, Carr, *Hundreds and Thousands*, 196.

19 Carr's copy of the textbook is in the BC Archives, MS-2064.

20 A copy of her submitted manuscript is in the BC Archives, MS-1077 Box 17 File 5.

21 English-born but Victoria-raised, Flora Hamilton Burns (1891–1983) was the eldest daughter of Flora Alexandrina MacDonald Burns (1857–1924), a friend of Emily Carr whose family home, "Armadale," was not far from the Carr home in James Bay. Following her mother's death in 1924, Flora Hamilton Burns established her own friendship with Carr and became one of her "listening ladies." Burns was a freelance writer. In 1961 she published "Emily Carr" in *The Clear Spirit—Twenty Canadian Women and Their Times*, ed. M. Q. Innis (Toronto: University of Toronto Press, 1966). The Flora Hamilton Burns fonds includes research notes and drafts, photographs, correspondence and art. An audio recording from 1962 is in the BC Archives, T1286.

22 Posthumously published in Carr, *Heart of a Peacock*.

23 Journal entry for October 19, 1935, Carr, *Hundreds and Thousands*, 274. The typescript "Talk on Art" is in BC Archives, MS-1077 Box 17 File 3. It was eventually published in Emily Carr, *Fresh Seeing: Two Addresses* (Toronto, Clarke, Irwin and Company, 1972).

24 Journal entry for July 9, 1934, Carr, *Hundreds and Thousands*, 195.

25 Journal entry for October 1, 1934, Carr, *Hundreds and Thousands*, 211.

26 Journal entry for April 12, 1934, Carr, *Hundreds and Thousands*, 159.

27 See Carr's text for June 1933 in this book on page 124

28 Journal entry for April 24, 1934, Carr, *Hundreds and Thousands*, 166.

29 On several dates in late 1934, Carr notes in her journal the rejection and return of manuscripts from *Maclean's*, the *Atlantic Monthly*, *Saturday Evening Post* and the *Countryman*. Tippett, *Emily Carr: A Biography*, 220.

30 Journal entry in small notebook "68," February 21, 1941. BC Archives, MS-2181 Box 3 File 10.

31 New Brunswick–born Helen Ruth Humphrey (1898–1984) taught English at Victoria College and later at the University of British Columbia. She met Carr in 1936 and was an early advocate for her work. She brought Carr's writing to the attention first of Garnett Sedgewick and then Ira Dilworth (Morra, *Corresponding Influence*, 22). In 1958 she wrote an article about Carr and in 1972 published the 44 letters she had received from Carr. Margaret Jean Clay (1891–1982) was chief librarian in charge of the Victoria Public Library from 1924 to 1952 and member of the Public Library Commission of BC from 1958 to 1960, a vocal supporter of libraries in the schools.

32 Journal entry for February 5, 1934, Carr, *Hundreds and Thousands*.

33 Journal entry for February 5, 1934, Carr, *Hundreds and Thousands*.

34 Helen Ruth Humphrey, "Emily Carr: An Appreciation," *Queen's Quarterly* 65, no. 2 (Summer 1958): 274.

35 Humphrey, "Emily Carr," 274.

36 Other posthumous titles include Bridge, Kathryn, ed., *Wild Flowers* (Victoria: Royal BC Museum, 2006) and Ann-Lee Switzer, ed., *This and That: The Lost Stories of Emily Carr* (Victoria: Touchwood Editions, 2007).

37 *Canadian West Coast Art, Indian and Modern* opened at the National Gallery of Canada in Ottawa, December 2, 1927 then travelled to the Art Gallery of Toronto and the Art Association of Montreal. For further details and analysis, see Charles C. Hill, "Backgrounds in Canadian Art: The 1927 Exhibition of Canadian West Coast Art: Native and Modern," in *Emily Carr: New Perspectives on a Canadian Icon*, edited by Charles C. Hill, Johanne Lamoureux, and Ian M. Thom (Vancouver: Douglas & McIntyre, 2006).

38 Lawren Harris to Emily Carr, n.d. (1931), BC Archives, MS-2181 Box 2 File 4.

39 Lawren Harris to Emily Carr, n.d (1933), BC Archives, MS-2181 Box 2 File 6.

40 Emily Carr to Nan Cheney, March 13, 1941. Transcribed in Doreen Walker, ed., *Dear Nan: Letters of Emily Carr, Nan Cheney, and Humphrey Toms* (Vancouver: UBC Press, 1990), 307. Eric Brown died April 6, 1939.

41 Emily Carr to Nan Cheney, March 13, 1941. Transcribed in Walker, *Dear Nan*, 307.

42 Emily Carr to Nan Cheney, March 24, 1941. Transcribed in Walker, *Dear Nan*, 312.

43 Emily Carr to Ira Dilworth, September 27, 1943. BC Archives, MS-2181 Box 1 File 5.

44 Ira Dilworth to Emily Carr, postmarked October 2, 1943. BC Archives, MS-2763 Box 3 File 1.

45 Berdjis-Kamranpour, "Understanding Emily Carr," 10.

46 For information on the Emily Carr Trust, see Edythe Hembroff-Schleicher, *Emily Carr: The Untold Story* (Saanichton: Hancock House, 1978).

47 Carr attended the Westminster School of Art on Tufton Street, London, beginning in September 1899 with breaks to early 1901 and again briefly in spring 1902.

48 Susannah Simpson, aged 70 and a widow, is listed in the 1901 England Census as proprietor of a grocery and tea house on Tufton Street.

49 In this account Carr has used the true names of her friends. In the published *Growing Pains*, she employs the pseudonym Mrs. Radcliffe for Marion Redden (b. 1937; née Sproat), who was Canadian, although she lived several decades in London, where she died in 1917. Carr had a letter of introduction from a Victoria friend to "Aunt Marion," and she proved to be an important contact. Carr kept in touch with Mrs. Redden and her son Frederick over the years following her time in England. The young men are Frederick Redden (1866–1936), then an articling solicitor, and his friends, journalist Edward Mortimer (1865–1919) and barrister Samuel Blake (1868–1923). All further citations about Carr's adventures and her English friends and acquaintances in this book are from Bridge, *Emily Carr in England*.

50 The South African War (Boer War), was fought from October 11, 1899, to May 31, 1902, between Great Britain and the two Boer (Afrikaner) republics but had wide ramifications. It began within a month of Carr's arrival in England. Canada sent three contingents of volunteer soldiers to South Africa.

51 Samuel Blake's Canadian-born father Edward Blake was then a British Member of Parliament.

52 In addition to attracting the interest of Edward Mortimer, Carr was courted by three other men in England: a ship's doctor, whom she met on her Atlantic voyage (and who probably ministered to her, as she was particularly prone to seasickness); the English son of one of her sister's friends; and a young man, William Francis Locke "Mayo" Paddon (1876–1972). Born in Ireland to a large family, Mayo came to British Columbia as a child. He grew up in Victoria and was the purser on the small ship that took Carr up the west coast of Vancouver Island just months before her departure for England. Lovesick Mayo wrote to say he was coming to England. She tried her best to dis courage his interest, but he remained for three months, proposing marriage each day. Carr declined every time. She fictionalized his name as Martyn in *Growing Pains*. An earlier account in the scrawled-over pages, MS-2181 Box 3 Folder 7, is not included here.

53 Carr fictionalized Sophia Mortimer (1829–1914) by naming her Mrs. Denny in *Growing Pains*. A widow, Mrs. Mortimer was a British subject who had been born in France and married in London, and then lived many years in Canada, where she raised a family before moving back to London. She died in Canada, having returned ca. 1910. Mrs. Mortimer hoped her son Edward and Carr would become an item, but to no avail.

54 This is not Emily's sister Alice, but Alice Watts (1875–1949), a clergyman's daughter from Wisbech, Cambridgeshire, named Alice Watkin in *Growing Pains*, a fellow student at the Westminster School of Art. She and Carr shared rooms, changing residence three times in a year. Watts, who married Donald Piper in 1909, became a lifelong friend, corresponding into their old age. See MS-02763 Box 4 File 36.

55 Carr was given two nicknames by friends in England. Alice Watts called her "Carrlight," and Mildred Crompton-Roberts called her "Motor." These friends continued to use the nicknames in their letters to her decades later.

56 Marie Hall (1884–1956), whose early life was impoverished, was born in Newcastle upon Tyne. She attended the Birmingham School of Music directly before moving to London, where she studied violin under Johann Kruse. In 1905, as a violin prodigy, she toured Canada and America.

57 Carr is referencing a boarding house for women run by Mary Dodd and her husband, Albert, at 4 Bulstrode Street, London. Carr boarded here from May 1900 to spring 1901, returning in March 1902 after her sojourn in Cornwall, and again briefly in 1910 en route to Paris. Carr immortalized boarding house living in a "funny book" of poems and sketches she titled "A London Student Sojourn," reproduced in full in Bridge, *Emily Carr in England*, 34–81. The UK 1901 census lists the occupants of this address, but Carr is absent, enumerated while on an overnight visit with Victoria friends resident elsewhere in London.

58 Called "Kindle" in *Growing Pains*, and "Kendal" in Carr's manuscript, (Beatrice) Hannah Kendall (1883–1969) was working in London as a typist, and she typed the text for another of Carr's funny books, *A London Student Sojourn*. She and Carr retained a friendship, and Carr gave her a copy of the funny book (pages reproduced here) and a watercolour landscape painting (also reproduced here) which remained in the family for decades.

59 Sir Hubert von Herkomer (1849–1914) established an art school in Bushey in 1883, and it became renowed for its progressive teachings. By 1904, when it closed, several former students had already opened their own studios. See https://busheymuseum.org/herkomer-room.

60 Yorkshireman John W. Whiteley (1859–1936) was a former Herkomer student who lived in the town with his wife and two young children. He favoured

outdoor classes for both figure studies and landscapes, which would have suited Carr. He proved to have a lasting influence on Carr, reminding her to look carefully in the forest for the light amid the shadows. Meadows Studio, the long, unpainted, shed-like building where he taught, was only 100 metres from the Herkomer School. Known for portraiture and landscapes, Whiteley exhibited at the Royal Academy between 1882 and 1900.

61 Carr appears to have made up a word here describing one who is not a genius.

62 In geography, the antipode of any spot on Earth is the point on Earth's surface diametrically opposite to it. Antipodal points are as far away from each other as possible. See https://en.wikipedia.org/wiki/Antipodes.

63 This is a reference to a carriage pulled by two horses.

64 Only one pencil and watercolour sketch has survived, shown here. It is in Carr's sketchbook along with a draft of the entire poem.

65 Harold Milford Norsworthy (1886–1917) was raised in Cornwall. His health was apparently not good, necessitating his leaving boarding school, at which time his mother arranged art classes in St. Ives. He was just 15 years old when his mother registered him at Bushey. Norsworthy was killed in action in France. See http://www.stanwardine.com/cgi-bin/malvernww1.pl?id=305.

66 Martha and Elizabeth Mead lived at 6 Herkomer Road, Bushey, and were unused to lodgers. Carr moved into the bedroom previously occupied by their blacksmith father who had died just a few months previously.

67 Carr may have forgotten the correct surname and certainly changed the wife's given name. The 1901 UK census enables us to determine their identities. The Martins were actually John West and his wife Lisette (née Martin), living at Ivy Cottage on Merry Hill Road. Both aged 22, they had married earlier in 1901.

68 Another example of Carr's use of descriptors that were in common parlance then but are now recognized as insensitive.

69 Carr consistently misspells the name of renowned marine painter Julius Olsson (1864–1942) as "Olsen" in her manuscripts, sketches and in *Growing Pains*. For greater clarity, I have taken the liberty of correcting her and replaced "Olsen" with "Olsson."

70 Landscape painter Algernon Talmage (1871–1934) proved to be one of three drawing masters, along with John W. Whiteley and Harry Gibb, who Carr credits as having been significant to her artistic development. Talmage was a previous Herkomer student. It is likely that Whiteley recommended him and the Cornish School of Landscape and Sea Painting to Carr. Talmage would have received her then as a student taught previously by a colleague. David Tovey, *Pioneers of St. Ives Art at Home and Abroad (1899–1914)* (UK: Philip

Wilson Publishers, 2008), 133. Carr wrote to Talmage in 1910 asking advice about leaving her studio business as she contemplated Paris. MS-02763 Box 4 File 56.

71 Carr visited St. Ives's photographer John Douglas (1860–1938) in December 1901 so she could send images of herself to friends and family. At least two poses are known to have been taken.

72 This title is given by Carr in a letter to Ira Dilworth January 14–16, 1942 (Morra, *Corresponding Influence*, 100). Carr created a poem and two watercolour drawings of this adventure (BC Archives, PDP10254, reproduced in Bridge, *Emily Carr in England*, 116–117).

73 A differently worded version of this story is in *Growing Pains*. Sydney Noel Simmons (1880–1916) was from Addlestone, Surrey. He and his mother in Weybridge hosted Carr for a few days in the summer of 1902 and befriended Carr later that year when she became ill. Simmons exhibited with the New English Art Club, but his life was cut short. He fought and died in the Battle of the Somme in the First World War.

74 Hilda Fearon (1878–1917), Carr's closest friend in St. Ives, was English, born in Banstead, Surrey, despite Carr describing her in *Growing Pains* as Irish. She studied first at the Slade School of Fine Art in London and later in Dresden, before moving to Cornwall for further studies. Carr created a series of pencil drawings and verse showing Fearon working amid villages in St. Ives, reproduced in Bridge, *Emily Carr in England*. In 1908, after the breakup of his marriage, Talmage and Fearon left St. Ives for London, where she exhibited her impressionistic works—landscapes and contemporary life—at the Royal Academy. She died at the age of 39.

75 Arthur Burgess (1879–1959) was an Australian artist. He described Carr in a letter to his fiancée as being "neither young, handsome nor thin." He also admitted he would miss Carr when she left, and visited her in London when she returned briefly to the Westminster School of Art. Quoted in Bridge, *Emily Carr in England*, 118.

76 British-born John William Ashton (1881–1963) was raised in Australia. He arrived in St. Ives in 1899 to work under Olsson and from 1901 to 1902 studied in Paris at the Académie Julian. He was a prolific painter of landscapes and became prominent in Australian cultural affairs, serving as director of the National Art Gallery of New South Wales from 1937 to 1945 and following that other positions in Australia. He was appointed OBE in 1941 and knighted in 1960. See https://adb.anu.edu.au/biography/ashton-sir-john-william-will-5071.

77 Bedfordshire-born Marion Frances Horne (1876–1958) lived with her mother and sister in St. Ives until her marriage in 1909.

78 The Digey is an iconic winding cobblestone street in St. Ives, Cornwall. See https://www.cornwalls.co.uk/photos/digey-st-ives-1890s-3923.htm.

79 This story is in the scrawled-over notebook, BC Archives, MS-2181 Box 3 File 7.

80 Carr is on a tight budget and being thrifty by patching her slipper. When she arrived in London in 1899, she came with an injured toe that had been badly set. While in London she had the toe amputated. Wearing a soft shoe was necessary for some time afterward. This is the reason she had a stool with her at Queen Victoria's funeral procession and one of the reasons she found it difficult to stand at an easel for long periods.

81 This story is in the scrawled-over notebook, BC Archives, MS-2181 Box 3 File 7.

82 These last two episodes are from a scrawled-over notebook page not from the "Growing-pains" scribblers. BC Archives, MS-2181 Box 3 File 7.

83 St. Erth and Mousehole are the places she visited.

84 The paragraph above is from a scrawled-over page, not from the "Growing-pains" scribbler. BC Archives, MS-2181 Box 3 File 7.

85 Carr returned from Bushey to London in the spring of 1902. The coronation originally planned for June 26, 1902, and about which she writes, was delayed as the king was ill until Aug 9, 1902.

86 Hampstead-born Mildred Theodora Crompton-Roberts (1871–1947) was known to Carr as "Crummie," while she in turn called Emily "Motor." Crompton-Roberts lived in the family's home in upper-class Belgrave Square, London. Carr was invited first for a short stay, and then, when her illness progressed, remained until other arrangements were made. The two remained friends and correspondents for life. MS-02763 Box 2 File 18.

87 Miss Letitia Cole (1859–1929) was former governess and family friend of Crompton-Roberts. She is listed in the 1901 UK census at this address.

88 Widower and former journalist Francis Ford (1831–1907) was the curator at the Architectural Museum, within which the Westminster School of Art operated, and so must have struck up a friendship with Carr then. His duties seem to have included registration of students and management of classes in the absence of the art instructor. He is featured in Carr's cartoon illustrated in this book (plate 9; BC Archives, PDP00152).

89 It was not for the coronation (which took place on August 9) that Emily bought a ticket for Lizzie, but for a later event recorded in Lizzie's diary. "October 25. Went to see the Royal Procession. Millie gave me a present of a ticket for a seat at the Canadian stand." Lizzie Carr diary, 1902. BC Archives, MS-2763 Box 1 File 5.

90 James Lawson (1840–1915), former Hudsons Bay Company official, was a Victoria neighbour and the executor of Richard Carr's will. Given patriarchal practice at the time, Richard Carr gave his eldest unmarried daughter, Edith, control of the family home and forbade division or sale of the land, and he specified that Lawson provide allowances to his unmarried daughters rather than enabling independence. Thus Lawson controlled the purse strings for the Carr sisters. The Carr sisters eventually succeeded in having the conditions regarding the house and land removed, enabling Emily, Alice and Lizzie to build their own homes on land subdivided from the original Carr estate. Richard Carr's will is in BC Archives, GR-1052 B-08946/1230.

91 The doctor's surname is illegible in Carr's handwriting and also unclear in her sister Lizzie's diary. His identification (and the spelling of his name) remains uncertain at this date of writing.

92 The London surgeon who operated on Carr's foot was Arthur Corrie Keep (b. 1862), a cousin to Mrs. Redden.

93 Carr wrote several versions of this story—of Lizzie coming to England and the visits to doctors. In one version, she mentions "the Nurses Hill" as being her friends. The 1901 UK census does not have two unmarried sisters listed as nurses, yet given Carr's use of pseudonyms, it is possible that Hill was not the actual surname.

94 The specialist may have been the doctor who attended Carr when she was ill at the Crompton-Roberts home as he gave her his contact information.

95 Again, this is Carr inventing the name. The facility was the East Anglian Sanatorium in Nayland, Suffolk, a facility for the treatment of tuberculosis, which opened in 1901, run by Dr. Jane Harriet Walker (1859–1938), Harley Street, London. Walker pioneered the open-air method to treat tuberculosis. Carr did not have tuberculosis, but required rest and healthy country air. She did not appear have a fear of disease transmission, as her younger brother lived with it until his death in a California sanatorium at age 24 and Carr's mother lived at home with tuberculosis for many years until her death. But why she selected a tuberculosis sanatorium in which to regain her health is unclear, unless through personal connection and recommendation. Walker was a cousin of John W. Whiteley, Carr's art teacher in Bushey. For more detailed accounting of the chronology of Carr's illness and her decision to enter the sanatorium, see Bridge, *Emily Carr in England*.

96 Carr was actually 32.

97 Carr was 15 months at the sanatorium: January 1903 to March 1904.

98 The 1901 census for Bushey indicates several Lewis families, including at least one that took in boarders. Carr may be referencing a Jessie Lewis at 35 Windmill Lane.

99 Denying the love offered to her by Mayo Paddon (see note 52), who had followed her to England, was one of the most difficult things Carr did and may have contributed to her illness in England. During these years in England, several of Carr's female friends in Victoria married and some moved away, changing the dynamic between them, which to some degree may have caused Carr to re-examine her life trajectory.

100 It was the eldest unmarried daughter, Edith, to whom their father bequeathed the family home. Lizzie, Emily and Alice were still resident in the house, not yet having built their own residences on the family land.

101 They are Ethel Worlock (1875–1960), who married Captain Charles Slingsby Fall in June 1904 and lived in South Africa, and Edna Theophila Green (1873–1963), who married Edward Carew-Gibson in April 1901 and by 1904, lived near 150 Mile House.

102 The Ladies Art Club engaged Carr in January 1906. The newspaper announcement lists Carr's residence (as opposed to her studio) as 1067 Melville Street. *Vancouver Daily World*, January 19, 1906, 7.

103 Mrs. James Cooper Keith (1856–1837), was the "old Victorian" who would have remembered Carr as a young girl in Victoria and advised Carr about her attitude. Born in Victoria as Anne Jane, daughter of Hudson's Bay Company chief factor Roderick Finlayson and his Indigenous wife Sarah Work, after her marriage, Mrs. Keith moved to Vancouver in the 1890s. Her husband was a land developer and early member of the North Vancouver council. By 1906, Mrs. Keith was an influential Vancouver society matron.

104 Crofton House School was founded by Jessie Gordon in 1898. By 1901 the school was at the corner of Jervis and Nelson Streets, and ran with the assistance of her two sisters.

105 The studio was located in the Fee Block, Granville Street. After Carr's return from France she rented a studio at 1465 West Broadway.

106 Declaration of her age as 67 is a clue that this manuscript was created between December 13, 1938, and December 13, 1939.

107 This last paragraph is contained on a scrawled over page different from the "Growing-pains" scribblers. BC Archives, MS-2181 Box 3 File 7. Newspaper reports indicate that Emily Carr held large yearly exhibitions of her students' work in March 1907, 1908 and 1909, in addition to smaller, more frequent exhibitions. Tippett, *Emily Carr: A Biography*, 72–73.

108 This characterization, description and paternalistic perspective about someone of another culture was not unique to Carr but was common in this time period among individuals in the white-centric settler population.

109 This North Vancouver school was either St. John's Boys' School or the Chesterfield School, both founded by clerics. See Jean Barman, "Growing up British in British Columbia: Boys in Private School, 1900–1950" (Doctoral thesis, Vancouver: University of British Columbia, 1982) 507, 515. The girls' school was perhaps the North Vancouver School for Girls, on Lonsdale Avenue.

110 Here Carr's handwriting is illegible and transcription made difficult especially because we don't know if Carr is attempting to transcribe his name as she hears it or whether she is using a pseudonym mocking his physical appearance. In the "Alaska Journal" (their funny book), Carr gave him the nickname "La Totem," and in her illustrations he is tall and gangly. Might the name she gives him in this story be a play on words? His long arms (Domiarmus), and he was the most-tall-of-us (Muchtulous)? The Alaska Journal was recently located and published. See Silcox, *Sister and I in Alaska*.

111 *Indian* remains a legal term in Canada and the United States; however, it is largely no longer employed in social contexts. When Carr uses the term, she refers to Indigenous peoples of the Pacific Northwest. Indigenous Nations along the coast are geographically dispersed and have separate social structures, often different languages and distinctive cultural practices. For her time, Carr was well travelled along the Northwest Coast. In her art, Carr mostly represented Haida, Gitxsan and Kwakwa̱ka'wakw places and peoples. She also visited and represented Nuu-chah-nulth and Coast Salish territories and peoples. Carr's trip to Alaska was in Haida and Tlingit territory and she would have viewed Tlingit totem poles in Sitka.

112 In Carr's *Klee Wyck*, she mentions being inspired by an artist she met on her Alaska trip. American artist Theodore Richardson was one of several artists in Alaska whose work Carr may have seen. The identity of the artist(s) Carr met in Sitka has been a matter of some speculation and argument in the literature, beginning with Maria Tippett's uncited reference to Richardson (Tippett, *Emily Carr: A Biography*, 74). Jay Stewart and Peter Macnair, "Reconstructing Emily Carr in Alaska," in *Emily Carr: New Perspectives on a Canadian Icon*, edited by Charles C. Hill, Johanne Lamoureux, and Ian M. Thom (Vancouver: Douglas & McIntyre, 2006) presented a thorough reconstruction of her time in Alaska, including an alternate identification of the mystery artist. However, given that in this manuscript, Carr herself specifies the surname Richardson, speculation is now ended.

113 Englishman Charles Frederic Newcombe (1851–1924) and his family emigrated first to Hood River, Oregon. In 1889, in search of a milder climate, they moved to Victoria, where they built a family home on the Dallas Road waterfront, just a few blocks from the Carr family home. Newcombe was a physician but also a man of classical interests who became a collector of botanical and natural history specimens and cultivated an interest and indeed a career in procuring Indigenous cultural and ceremonial pieces for museums worldwide. He was considered an expert within white settler society and established professional relationships with anthropologists such as Franz Boas as well as developing a network of connections within Indigenous communities. See http://www.biographi.ca/en/bio/newcombe_charles_frederic_15E.html. The multi-disciplinary holdings at the Royal BC Museum are centred on material acquired from Newcombe or his son, William Arnold (1884–1960), who followed in his father's footsteps. W. A. Newcombe became a friend and helper to Carr, assisting with tasks for the house and framing and crating paintings for travel. Carr trusted him and appointed him one of her three executors, alongside Ira Dilworth and Lawren Harris. Newcombe purchased over 100 of Carr's early Indigenous sketches that had been placed on a disposal pile by Harris, thus saving these important works for posterity, for when he died, the province purchased his estate, including these Carr works. For further information on the history of the Royal BC Museum, see Patricia E. Roy, *The Collectors: A History of the Royal British Columbia Museum and Archives* (Victoria: Royal BC Museum, 2017).

114 This last episode is contained on a scrawled-over notebook page different from the "Growing-pains" scribblers. BC Archives, MS-2181 Box 3 File 7.

115 Sewinchelwet, known as Sophie Frank (1872–1939), was a basket weaver from the Skwxwú7mesh Úxwumixw (Squamish Nation) who met Carr in 1906, when Carr moved to Vancouver to teach art and set up a studio at 570 Granville. Frank knocked at her door, hoping to sell her some baskets. Carr bought some, and a lifelong friendship developed. Letters she sent to Carr are found in MS-2763 Box 3 Files 13 and 14 and MS-2792 Box 2 File 2. For biographical information, see Tarah Hogue, "Historical Contexts of Emily Carr and Sewinchelwet Sophie Frank," 2020, produced by Vancouver Art Gallery, podcast, 7:49, https://soundcloud.com/vanartgallery/lineages_and_land_bases_historical_contexts. See also the text of the 2018 Vancouver Art Gallery exhibition *Lineages and Land Bases* at https://vagallery.s3.us-west-2.amazonaws.com/wp-content/uploads/2020/01/07212409/VAG-lineages-Final-Didactics-2020.pdf.

116 Carr indicates in Chinook jargon that she has no money: ha'lo (ha'-lo), chika-min (chik'-a-min). See https://en.wiktionary.org/wiki/Appendix:Chinook_Jargon.

117 This story of Sophie combines text from the "Growing-pains" scribblers and the earlier manuscript in BC Archives, MS-2181 Box 3 File 7. Both manuscript accounts are much longer than included here; as many of the details are in Carr's story "Sophie" in *Klee Wyck*, they have not been repeated here.

118 Carr was a witness at the 1908 marriage of 26-year-old Winnifred Logan (1882–1955) to Charles Franklin Race in Vancouver. The young couple moved to Edmonton, and it was to them that Carr entrusted Billie.

119 The identity of this artist is not confirmed. It might possibly have been Ontario-centred Sydney Strickland Tully (1860–1911) who arrived in Victoria in 1910. She had studied in Paris and also knew Toronto artist Wyly Grier, who would sublet Carr's Victoria studio in 1912. She might have learned through him that Carr was going to France. For biographical information, see http://cwahi.concordia.ca/sources/artists/displayArtist.php?ID_artist=117.

120 English-born Henry William Phelan Gibb (1870–1948) lived in France for several decades and was greatly influenced by the French painter Paul Cézanne. By 1909 Gibb began to paint vibrantly coloured landscapes painted in a Fauvist manner and taught Carr the same. Gibb exhibited in New York in 1910 and 1911, and his star was in ascendance when Carr met him. Well-connected among his peers, Gibb moved in the same circles as artists Pablo Picasso and Henri Matisse and art connoisseur Gertrude Stein. His work is held in the Tate Gallery, the Towner Gallery and other British institutions as well as in the Auckland Art Gallery in New Zealand. For more detail on Gibb and Carr's time in France, see Kathryn Bridge, "Everyone Said Paris Was the Top of Art" in *Emily Carr: Fresh Seeing—French Modernism and the West Coast* (Vancouver: Figure 1, 2019).

121 Académie Colarossi in Paris offered integrated classes. Women and men studied alongside each other, unlike at most French academies at that time.

122 Carr's comment here about segregated classes is not true. The Académie Julian had integrated by 1897.

123 Scottish John Duncan Fergusson (1874–1961) enrolled at the Académie Colarossi in 1895 and returned to France each summer, eventually residing in Paris from 1907 to 1914. While there, he kept a studio and taught privately. Duncan Fergusson worked in oils and gouache, painting outdoor scenes and portrait and figure studies. By 1907 he was a confirmed Fauvist. In 1910 he began a series of female nude figure paintings, which marked the beginning of his own style, creating work with an emphasis on line, form and colour.

124 Probably Atelier la Palette directed by Jacques-Émile Blanche, a French painter who was a friend of Degas, Renoir, Whistler and others.

125 This was probably the American Girls' Art Club at 4 rue de Chevreuse in Paris. Mariea Caudill Dennison, "The American Girls' Club in Paris: The Propriety and Imprudence of Art Students, 1890–1914," Woman's Art Journal 26, no. 1 (Spring-Summer 2005): 32–3, http://www.jstor.org/stable/3566532.

126 Cook's Tourists' Handbooks were a popular series of travel guidebooks published in the nineteenth and twentieth centuries by Thomas Cook & Son of London. This line and the following four lines were unclear in the manuscript. It appeared one sentence was out of order; I reversed the sentences to aid comprehension.

127 Winnifred and Hjalmar Myrin from Gothenburg, Sweden, arrived in Canada in 1906, and their first son was born in Vancouver that year. They appear to have resided in Kamloops, Vancouver and Victoria before returning to Sweden ca. 1910.

128 Carr's writing here is difficult to transcribe. The S might be a G or an L, but the phonetics aren't immediately apparent to identify which Swedish town.

129 A sanatorium was constructed at Saltsjöbaden, a seaside resort just south of Stockholm in 1903.

130 The medieval canaled town of Crécy-en-Brie is now part of Crécy-la-Chappelle.

131 People in many areas of France gave bouquets of lily of the valley or dog rose flowers to loved ones. This custom was particularly common in the area around Paris known as Île-de-France. Families with children in country areas got up early in the morning and went into the woods to pick the flowers. Individuals and labour organizations in urban areas sold bouquets of lily of the valley on the street on May 1.

132 Scottish-born Harriet Melrose Hood (b. 1876), also known as "Bridget," married Gibb in 1903. In Growing Pains, Carr comments that they squabbled. The couple would separate in 1913, just a few years after Carr returned home. Gibb remarried in 1916.

133 Carr bought the parrot shortly before she and Alice embarked for Sweden. Apparently it was originally named Maria. See postcard, March 11, 1911, BC Archives, MS-02763 Box 1 File 7.

134 Presumably a reference to the small studio she attended briefly in Paris.

135 Gibb, following the lead of his friend Picasso, spent time in Spain ca. 1907 to 1910.

136 Born in New Zealand, Frances Mary Hodgkins (1869–1947) moved to England in 1901, then spent several years travelling in Morocco and Europe before finally settling in Paris by the end of 1908. Frances Hodgkins was the first female art teacher at the Académie Colarossi, hired in autumn 1910.

Hodgkins regularly spent summers in Brittany. When Emily Carr took lessons in Concarneau in 1911, Hodgkins and her class painted in watercolours by beaches and harbour areas, and in the walled medieval town. Hodgkins' interest in figure studies encouraged Carr to switch from her emphasis on landscape under Gibb.

137 Emily's studio was at 1465 West Broadway, Vancouver. Maria Tippett states that Carr moved in on February 1, 1912, having stayed earlier with Statira Frame and family. Tippett, *Emily Carr: A Biography*, 100.

138 Australian-born Edmund Wyly Grier (1862–1957) studied art in London, St. Ives and Paris before he moved to Toronto ca. 1892 where he became well established as a portraitist in the "traditional style." His commissions included politicians, corporate leaders and other notable contemporaries. He was commissioned by Victoria's Union Club to paint their president, and may have done so from Carr's studio as his base. In 1929 he was admitted to the Royal Canadian Academy of Arts and was knighted for his artistic contributions in 1935.

139 In Carr's lifetime, few books on Indigenous peoples, their arts or their culture existed for general audiences. Carr logically turned to her local experts like anthropologist and collector C. F. Newcombe and his son William, and to the museums that held monumental art and cultural pieces. She responded at an instinctual level to the Indigenous art forms, finding resonance despite a lack of context, so she tried to educate herself so that she might better understand and be an advocate. For all her good intentions, when Carr writes about Indigenous art and culture, she repeats what she has been told or has assumed. Her statements are not authoritative and at times employ pejorative terms. In 1913, she composed a lengthy "Lecture on Totems" that she presented to Vancouver audiences for a massive solo exhibition of paintings resulting from her six-week sojourn to Haida Gwaii and the Skeena River country the previous year. The paragraph here, in this book, demonstrates some similarities. The lecture is in MS-2181 Box 7 File 33. Carr scholar Gerta Moray provides more in-depth analysis in Gerta Moray, *Unsettling Encounters: First Nations Imagery in the Art of Emily Carr* (Vancouver: UBC Press, 2006), 34–72. For a general summary of Northwest Coast art and culture, see Aldona Jonaitis, *Art of the Northwest Coast* (Seattle: University of Washington Press, 2006) and Charlotte Townsend-Gault, Jennifer Kramer and K̲i-k̲e-in, *Native Art of the Northwest Coast: A History of Changing Ideas* (Vancouver: University of British Columbia Press, 2013).

140 Carr's commentary here reveals misinterpretation and conjecture. The sentence about slaves being carvers appears unsubstantiated. See Leland Donald,

Aboriginal Slavery on the Northwest Coast of North America (Berkeley: University of California Press, 1997) for context.

141 Carr exhibited some 75 of her French paintings in her West Broadway studio from March 25 through early April 1912 to popular press reviews with the exception of a letter to the newspaper editor to which Carr took particular umbrage. A year later she rented Drummond Hall on Pender Street and hung 200 works documenting Indigenous subject matter, including early pen and inks and her more recent works based on her 1912 trip to the Skeena area and Haida Gwaii. *Paintings of Indian Totem Poles and Indian Life by Emily Carr* opened April 16, 1913.

142 Victoria City Building Construction records list on February 1, 1913, at a cost of $5,000 "Studio & Apartments" at 642-646 Simcoe Street: https://vihistory.uvic.ca/search/searchbcd.php?start=0&form=basic&show=y. Lizzie Carr noted Emily moved into her Simcoe Street house on June 28, 1913. BC Archives, MS-2763 Box 1 File 5.

143 Online records show Carr crossed the Canada/US border November 16, 1916, headed to San Francisco. See https://www.ancestry.com/imageviewer/collections/1075/images/m1464_325-0391?treeid=&personid=&rc=&usePUB=true&_phsrc=gnv710&_phstart=successSource&pId=1639622. Tippett (Tippett, *Emily Carr: A Biography*, 124) states Carr returned in June 1917 but has no citation.

144 The 1920 US Federal Census lists Antolin Ravento age 45 who arrived from Spain in 1886 and was naturalized in 1895. He and his Colorado-born wife, Hope, age 33, were merchants of a basket shop at 13423 Sutter Street. Their residence was listed as 7144 Geary Street, San Francisco. The Directory of California Marketers lists the "Basket Shop and Antique Shop" supplying wooden flower and fruit baskets, Chinese lanterns, wicker furniture, etc.: https://www.ancestry.com/imageviewer/collections/6061/images/4293846-00710?treeid=&personid=&rc=&usePUB=true&_phsrc=gnv731&_phstart=successSource&pId=112299614, accessed August 2020; https://archive.org/stream/directoryofcalifoocali_3/directoryofcalifoocali_3_djvu.txt, accessed August 2020.

145 Union Square on Geary Street. The St. Francis Hotel is still standing.

146 This is another example of racial stereotyping in Carr's lexicon. She employs nomenclature created in the years of the United States Civil War but still in contemporary use during Carrr's lifetime. In Victoria a small Black population numbered within the settler population, arriving as early as 1858, when Governor James Douglas invited Black settlers to come north from the United States.

147 Eric Brown (1877–1937) was the first director of the National Gallery of Canada. He and his wife Maud were early supporters of the Group of Seven. Brown's visit to Carr's studio in 1927 led to her sending 25 paintings to the Canadian West Coast Art Exhibition of that year. By procuring a railway pass, he made it possible for her to travel to Ottawa to see the exhibition and also to know the painters and paintings of the Group of Seven.

148 Carr wrote about Eric Brown and going to Ottawa and meeting the Group of Seven in Toronto in "Rejected" in *Growing Pains* but that account is not nearly as full of detail as this earlier version.

149 Marius Barbeau (1883–1969), pioneering anthropologist, ethnologist, folklorist and ethnomusicologist, worked for Canada's National Museum and undertook several trips to British Columbia, especially focusing on the Skeena River Gitxsan (Tsimshian) people.

150 Frederick B. Housser (1889–1936) wrote *A Canadian Art Movement: The Story of the Group of Seven* (Toronto: Macmillan Canada, 1926).

151 Frederick Horsman Varley (1881–1969) became the head of the Department of Drawing and Painting at the School of Decorative and Applied Arts in Vancouver from 1926 to 1933.

152 Alexander Young Jackson (1882–1974), Arthur Lismer (1885–1969), James Edward Harvey MacDonald (1873–1932), Lawren Stewart Harris (1885–1970). For information on the Group of Seven at the time see Housser, *A Canadian Art Movement*.

153 Canadian painter and art critic Bess Housser (1890–1969), like her husband and Lawren Harris, was a theosophist. The Toronto-based Women's Art Club founded in 1887 became the Women's Art Association of Canada in 1930.

154 Tom Thomson (1877–1917) was a great friend of Lawren Harris. Despite a short career, his work is considered to be most influential both to members of the Group of Seven but also to Canadian landscape art.

155 Thoreau MacDonald (1901–1989) was an illustrator and designer.

156 Katrina Buell (1867–1938), like Carr, travelled to the United States, England and France for art education. She and Carr, along with J. W. Morrice, were the only Canadians represented in the 1911 Salon d'Automne exhibition in Paris. See Michael Polay, "1911 Exhibition at the Paris Salon," in *Emily Carr: Fresh Seeing—French Modernism and the West Coast* (Vancouver: Figure 1, 2019).

157 *Exhibition of Canadian West Coast Art: Native and Modern* opened in December 1927 at the National Gallery of Canada, Ottawa. See Charles C. Hill, "Backgrounds in Canadian Art: The 1927 Exhibition of Canadian West Coast Art: Native and Modern" in *Emily Carr: New Perspectives on a Canadian Icon*, edited by Charles C. Hill, Johanne Lamoureux and Ian M. Thom

(Vancouver: Douglas & McIntyre, 2006), 93–121, and Moray, *Unsettling Encounters*, 276–291.

158 Canadian National Railway.

159 Colonial governments had renamed many places Carr visited. Since the 1970s, Indigenous nations have been reclaiming historic place names. Today these places are Yalis, Gitanyow, Kispiox, Gitwangak, Gitsegukla and Haida Gwaii.

160 Carr's spelling of Indigenous place names is inconsistent, based at times on phonetics—what she thought she heard—and in other instances by spellings provided by anthropologists or museum object labels of the time. She generally spelled Skidegate as Skidigate.

161 This painting, titled by Carr as "Indian Church," is in the collection of the Art Gallery of Ontario. In 2018, as "part of a broader effort to eliminate culturally insensitive language from titles in its collection," the Art Gallery of Ontario re-titled it *Church at Yuquot Village*. This caused a stir among artists and art lovers. See https://www.cbc.ca/news/entertainment/renaming-emily-carr-painting-reconciliation-art-church-1.4674175 and https://www.theglobeandmail.com/canada/article-renaming-of-emily-carr-painting-spurs-debate-about-how-art-world.

162 In 1933, in the height of the Great Depression, *A Century of Progress International Exposition* opened in Chicago. The Art Institute of Chicago hosted a massive loan collection of "the greatest masterpieces" of western art. See http://livinghistoryofillinois.com/pdf_files/Official%20guide%20book%20of%20the%20fair%20Chicago,%201933.pdf, accessed November 29, 2020.

163 The Adler Planetarium opened in 1930, first one in the Western Hemisphere and featured the "Zeiss projector," https://en.wikipedia.org/wiki/Adler_Planetarium, accessed August 10, 2020.

164 In 1934, Bess Housser, upon hearing of her husband's infidelity, scandalously left him for Lawren Harris, who in turn left his wife, Trixie. Carr was not apprised of this event until some time lapsed, and she was horrified.

165 Helena Blavatsky, a controversial philosopher, occultist and author, co-founded the Theosophical Society in 1875.

166 From "Out of the Silence," by English poet James Rhoades (1841–1923). Emily quotes this also in a 1942 letter to Ira Dilworth. See Morra, *Corresponding Influence*, 156.

167 Raja Singham toured Canada and the United States as a representative of the Christian Mission of India. Carr's journal, *Hundreds and Thousands*, and Susan Crean, ed., *Opposite Contraries: The Unknown Journals of Emily Carr and Other Writings* (Vancouver: Douglas & McIntyre, 2003), which contains excised words from Carr's journals not included in *Hundreds and Thousands*,

provide much detail on the January 1934 interactions Carr had with him, his visits to her studio, her attendance at his lectures and their continued correspondence.

168 In Carr's *Hundreds and Thousands*, she used his real name, Henry. Artist Edythe Hembroff-Schleicher (1906–1994) who met Carr in May 1930 identifies the young man as her brother, Henry Brand (1913–1948). Hembroff-Schleicher, *Emily Carr: The Untold Story*, 129.

169 Younger than Carr, Scottish emigrant John Strathdee (1879–1948) owned this land and farmed it while his sister Elsie Strathdee (1881–1953), who lived in town, kept an eye on him.

170 As a source of income during the period from 1920 to 1936, Carr bred and raised purebred dogs, initially English bobtail sheepdogs and then Brussels griffons. One of Carr's favourites and a frequent sketching companion was her griffon Ginger Pop. The small, sturdy griffons have a comical face and huge personality, hence the comment.

171 Carr later rewrote this section about ghost plant (sometimes called "Indian pipe") to form one of the stories in a manuscript grouping she called "Wild Flowers," which was published many years after her death as Kathryn Bridge, ed., *Wild Flowers* (Victoria: Royal BC Museum, 2006). For a description of the plant, see https://www.natureconservancy.ca/en/what-we-do/resource-centre/featured-species/plants/ghost-pipe.html.

172 The mountains seen from Carr's campsite are the Olympic mountains, part of the Cascade Range of mountains that extend from southern BC south through California.

173 "Mrs. Crane" is a story in *The Book of Small* originally published in 1942. See Emily Carr, *The Book of Small* (Vancouver: Douglas & McIntyre, 2004).

174 Carr's last trip in her van was in September 1936, after she had moved to Beckley Street and no longer had her many animals.

175 Charles Shaw Band (1885–1969) was a philanthropist and collector, a friend of members of the Group of Seven and one of the earliest collectors of Carr's paintings. In 1945 he began several terms as president of the Toronto Art Gallery (later renamed the Art Gallery of Ontario).

176 Emily's sister Elizabeth (Lizzie) died August 4, 1936, of breast cancer.

177 The house Carr acquired is at 1266 Oscar Street.

178 At 316 Beckley Street (now Avenue) in James Bay.

179 John Batts, ed., *The Diary of English Art Critic Eric Newton on a North American Lecture Tour in 1937* (New York: Edwin Mellen Press, 1997). The art critic Eric Newton, then on the staff of the *Manchester Guardian*, was in Canada

on a lecture tour. While in Ottawa, he was asked by the National Gallery of Canada to visit Carr and make a selection of paintings for the gallery.

180 Although other stories about Crocker the crow exist, this one is different. Unusually, it is represented by a finished typescript alone, no drafts. BC Archives, MS-2181 Box 6 File 5. Carr mentions it by title in a letter to Ira Dilworth from October or November 1942, so it would have been written just prior.

181 The stories about Billie and Adam exist as typescripts in the BC Archives, MS-2181 Box 9.

182 This story exists in multiple typescripts with different titles and different details in the BC Archives, MS-2181 Box 6 Files 4 and 7. No one version was complete; Carr appears to have worked on each with no final version established. Perhaps it was tricky for her and she left it sit. I have blended the versions when they overlapped, trying to maintain Carr's atmospheric introduction of the two ravens with her telling of the unexpected experience.

183 Used by white settlers, "half breed" was a common appellation in British Columbia through the 19th to mid-20th century to describe offspring of liaisons between European and Indigenous people. For examples of Victoria families, see Sylvia van Kirk, "Tracing the Fortunes of Five Founding Families of Victoria," *BC Studies* 115/116 (Autumn/Winter 1997/1998: 149–179, and Adele Perry, *Colonial Relations: The Douglas-Connolly Family and the Nineteenth-Century Imperial World* (New York: Cambridge University Press, 2015).

184 This story exists as a typescript in the BC Archives, MS-2181 Box 6 File 9. The typescript has not only Carr's edits with pencilled insertions, but also more intrusive edits in pen by another hand—whose I do not know. I have endeavoured to maintain Carr's words, gently incorporating edits only when they are needed for clarity.

185 This story exemplifies Carr's stream of conscious writing in her scribbler. It begins describing her intention to find a cottage to live in beside a dairy farm but is interrupted by her pivot to describing how she experienced the variety of trees and natural features of the surrounding land. It was Edythe Hembroff -Schleicher, a young artist friend, who drove Carr to Telegraph Bay as she searched for a cottage to rent. Although the cottage was unavailable in May, it was for the month of July. The remainder of this vignette is about Carr's engagement with nature during her July rental of the cottage. Hembroff-Schleicher, *Emily Carr: The Untold Story*, 136–137.

186 Although Carr comments that she did not find Indigenous observers upsetting, as she did white settlers, she describes their actions in this story using paternalistic terms, making assumptions and projecting colonial stereotypes.

187 These stories exist as typescripts (several versions) in the BC Archives, MS-2181 Box 6 Files 5 and 7, and in them one can trace Carr's gradual refinement and polishing as she worked toward a final version. I have selected what I think are the strongest versions, which sometimes omit descriptive detail but are more coherent reads.

188 Established in 1890, the Royal Jubilee Hospital in Victoria grew with different wings and buildings over the decades prior to Carr's tenure there. There are still Garry oak trees on the site despite the additions of paved parking areas.

189 From her hospital bed, Carr writes to Dilworth about "an absolutely great healthy oak tree right in front. It seems so strong & grand to be in the middle of all we sick weak things." Carr to Dilworth, ca. October 10, 1943. Morra, *Corresponding Influence*, 238.

190 On December 30, 1943, Carr wrote to thank her friend Nan Lawson Cheney (1897–1985) for this cyclamen. Walker, *Dear Nan*, 401–402.

Index

Also from the Royal BC Museum

Henry & Self
An English Gentlewoman
at the Edge of Empire
Second edition, 2019

"Engaging, readable,
and pertinent."

—KELLY BLACK,
ORMSBY REVIEW

By Snowshoe,
Buckboard and Steamer
Women of the
British Columbia Frontier
Second edition, 2019

Winner of the 1998
BC Lieutenant Governor's Medal
for Historical Writing.

Emily Carr in England
2014

"What astonishes me about Bridge's book is the detail."

—DEBRA MARTENS

Sister and I
From Victoria to London
2011

About Kathryn Bridge

Kathryn Bridge's life in the worlds of archives and museums has her wearing the hats of archivist, historian and curator, balancing the academic focus of publications with public presentations and exhibitions. She worked at the BC Archives and Royal BC Museum in different and increasingly more senior positions over her career, retiring in 2017. As a curator emerita, Kathryn continues to centre her projects within the historical collections. She has written several books about Emily Carr and other historical women artists in British Columbia, and on mountaineer Phyllis Munday. In 2012 she earned her PhD, writing about children and childhood in settler society in western Canada. In 2019 she was co-curator of *Emily Carr: Fresh Seeing*, and she is currently writing about artist Sophie Pemberton.